Dennis Savini—Masterclass: Professional Studio Photography

Masterclass: Professional Studio Photography

Dennis Savini

rockynook

Dennis Savini
Editor: Gerhard Rossbach
Copyeditor: Jeanne Hansen
Layout and Type: Beat Rohrer, Dennis Savini
Cover Design: Beat Rohrer, Dennis Savini

ISBN 978-1-937538-07-1

1st Edition 2012
© 2012 by Dennis Savini

Rocky Nook Inc.
802 East Cota St., 3rd Floor
Santa Barbara, CA 93103
www.rockynook.com

Distributed by O'Reilly Media
1005 Gravenstein Highway North
Sebastopol, CA 95472

Library of Congress Cataloging-in-Publication Data

Savini, Dennis.
Masterclass : professional studio photography / Dennis
Savini. -- 1st edition.
 pages cm
ISBN 978-1-937538-07-1 (hardback)
1. Photography--Studios and dark rooms. 2. Commercial
photography. 3. Still-life photography.
I. Title.
TR550.S38 2012
779'.35--dc23
 2012022720

Contents

Introduction

Let me tell you how this book came to be. At many of the workshops that I have hosted with Sinar in Europe and Asia, I have noticed that many countries do not offer basic technical photographic training of the type offered in Switzerland and Germany. Photography is taught at art school in many places, but the technical side of the profession often remains neglected. Young photographers often have to teach themselves the basics or learn by assisting established professionals. Many end up being great specialists but lack the broad-based knowledge that can help them achieve success in other photographic areas.

Just like the foundation of a house, grassroots technical knowledge forms a solid professional base and is a major prerequisite for success in the freelance world. Good basic skills allow you to perform a job professionally and to satisfy your client's wishes. Confidence in your own abilities will increase your efficiency and, with it, your profitability.

Last but not least, technical skills form the basis for your own creativity—the freedom to experiment comes automatically after you have learned to handle your equipment instinctively. The more you know, the broader your repertoire will be and the more freedom you will have in your work. Acquiring solid, basic knowledge is the best investment you can make! While preparing the workshops detailed in this book, I found myself asking how to best communicate the subject matter to create a lasting impression. Turning my ideas into a book seemed like an obvious choice, but at first I wasn't sure how to proceed.

Because I love cooking, I am often inspired by great cookbooks, which gave me the basic shape for the book. If world-famous chefs can make their exquisite recipes intelligible to the public in book form, the same ought to be possible in the photographic world. I took a recipe-based approach and divided the photographic process into its individual steps: preparing the props, the image capture process, and computer-based post-production. I then added sketches of the individual setups and gave relevant technical details to enable the reader to cook up the same results. Each example is intended to be a basic recipe that you can adapt and improve according to your own personal needs. It is not obligatory to use the same equipment as I did. You should use whatever gear you are most comfortable with.

I very much hope that this book will help you improve your photographic knowledge and skills and that it will assist you in attaining increased professional success.

Dennis Savini is a professional photographer based in Zurich, Switzerland. He strongly believes that the future success of the photography profession is up to those who participate in the field, and he enjoys contributing his expertise through teaching. Dennis has been training apprentices since 1980 and teaches workshops for professionals in Switzerland and abroad. His experience teaching these workshops led him to realize how little importance is given to vocational training in many countries—a realization that inspired him to write this book. Since 2005, Dennis has been a partner and course instructor at cap-fotoschule, a photography school in Zurich, where he trains future professional photographers.

Thanks

I would like to thank all the trainees, students, and freelance assistants who, during the past 30 years, have helped me not only to implement my ideas and complete the job at hand, but who have also inspired me and given me fresh ideas along the way.

Special thanks are due to:
My teacher and mentor Hans Humm, a real old-school technician who spoke and explained little and forced me to find my own answers to the tricky questions I raised.

My long-time partner and business associate Irene Rüfenacht, who helped me build up my studio and constantly kept the daily grind of client contact, office administration, and photo lab work off my back when things got hectic. In the early days, it was extremely important to have a like-minded person around to share and discuss ideas with. I wouldn't be where I am today without her.

My Russian friend and photographer Boris Loginov, who never tired of pushing me to transform my hundreds of sample setups into a book. He called my folder of work sheets my "treasure chest"—a point of view that I hadn't considered before. Years ago, Boris was in fact responsible for starting the project whose results you are now holding in your hands. I hope this book helps you, just as I hope it answers one or another of the thousands of questions Boris asked.

Angel Penchev, my photographer friend from Bulgaria, who pulled some strings to turn the Chinese version of the book into reality and, as a consequence, got the ball rolling again.

Circle 24, the international network of photographers that has given me friendship and cultural exchange that transcends all borders—and especially Robert Schilder (Circle 24's founder), Tetsuro Takai, Emmo Italiiander, and Sandor Benkó.

My loving parents, who believed in me and gave me not only the all-important credit to start my own studio, but also a critical personality, the ability to analyze my own motives, and the belief in my own abilities. My father came to Switzerland penniless at the end of the 1950s and, in spite of the skepticism shown to most southern foreigners by the Swiss, managed to build a successful career. He was always my role model and guiding light.

Barbara Keller and Dominic Schneider at the "cap" school of photography and all the photo friends I have had the pleasure of meeting as a result of this wonderful job of ours. I hope we have managed to make one or two changes along the way that have changed our profession for the better. We're all in the same boat together, and it has always seemed natural to me to fight for our common goals. Any profession can survive and prosper only if it is capable of changing with the times.

And, last but not least, my partner Monique Rüsch. She gives me the strength and the calm to channel my energy positively and has enabled me to look to new pastures, change my studio, and renew my approach to my work. It is unbelievable how much energy happiness can unleash.

Thank you all for your inspiration!

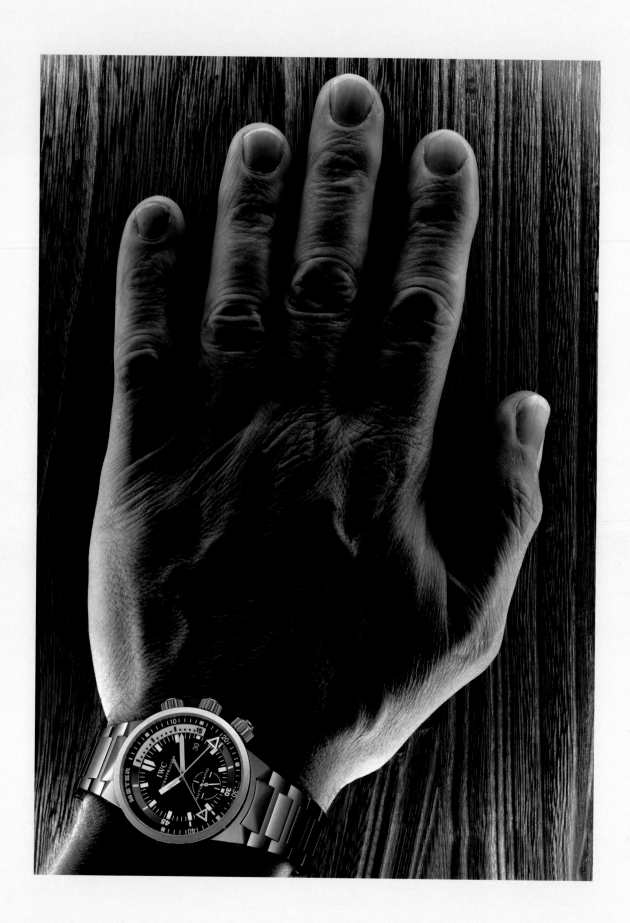

Studio Photography

An introduction to the technology and organization involved in running a photo studio, with a special emphasis on lighting.

Light and Lighting

Light is the essence of photography, so let's start by getting to know it a little better—not just so we can control it, but also so we understand it and can use it as a creative tool.

On the one hand, photography is made physically possible by light. A light-sensitive substance is activated by the light hitting it and records an image as a result. On the other hand, light is the most important compositional tool available to a photographer. Light produces shades of brightness and darkness, contrast, color, and mood. It gives depth to spaces and enables objects to appear three-dimensional. In short: light is absolutely essential to the photographic medium as a whole.

However, creating meaningful images using light in all its many forms requires a photographer's all-seeing eye and an artist's creative power. Everyday reality is incredibly rich and chaotic, and we need artistic tendencies to make choices and create order. The almost limitless number of ways in which we can use light to compose images is impressively documented by the history of painting. It is possible to study the wonderfully creative power of light from the golden age of Dutch genre and landscape painting through the Renaissance painters in Italy and England right up to the French impressionists. But I don't want to digress into the history of art, and the following sections are dedicated exclusively to the creative use of light in a photographic context.

The Need for Creativity

The word says it all: it comes from the Greek phos, meaning light, and graphis, which means to scribble or draw. Light is the life-blood of photography. Without light, there can be no photos.

Why do we have to be creative at all? Why do photographers interfere with the pure documentary form of their medium? In order to understand photographic perception, we first have to understand how human visual perception works. The pupil and retina, along with the rods and cones that enable us to see in black-and-white or color, initially form an imprecise image with spherical perspective that is sharp in only one place. These signals are passed on to the visual cortex in the brain where the raw image is checked, arranged, fine-tuned, and fleshed out. Memories are called up, comparisons are made, and our sense of smell is brought into play. In other words, we apply everything we know to analyze incoming visual data. Our initial perception of an image is a result of the interplay between our eyes and our brain. Visual perception is an extremely rapid and incredibly complex process that we cannot really control or predict. Naturally, our own experiences and our cultural background play a significant role in determining how we see the world around us, and this is why different people perceive the same images so differently. We often fall back on simple, generally accepted patterns, which is why cool or warm colors are universally perceived as such.

The visual arts—including, of course, photography—have to take these patterns into account, and visual language has to be comprehensible to be effective. The creative tools we use serve first and foremost to make the contents of an image intelligible, and only secondarily to convey a mood. Knowledge of the processes of perception is a necessary prerequisite for the successful use of creative tools. In addition to framing, perspective, and choosing the right moment, light is the most important tool that we have for creating meaningful images.

Natural Light

The most powerful and universal source of light is the Sun. Not only does the Sun provide our planet with light, warmth, and the ability to support life, it also offers a huge range of lighting opportunities. The daily spectacle of the endless lighting moods provided by the Sun never fails to astonish.

Colorimetrically speaking, sunlight comprises a continuous spectrum of white light that includes all visible colors, but the Sun also radiates ultraviolet and infrared waves that are invisible to the human eye. Sunlight itself is a constant phenomenon but is nevertheless affected significantly by the density of the Earth's atmosphere and the angle at which it enters the atmosphere. The color temperature of light varies constantly during the course of the day, from the red of the dawn to clear blue midday sky and back to red in the evening. Prevailing weather conditions and air pollution are additional factors that affect the color of ambient light. Our brains constantly compensate for variations in color temperature without us being aware of it, whereas a camera reacts to the same changes by producing color casts, especially if it is set to the usual default color temperature of 5600 K. Automatic in-camera white balance functions in a similar way to the human eye and automatically compensates for changing lighting conditions.

This raises the question of which system sees correctly, the human eye or the camera? How realistic is medium daylight with a temperature of 5600 K? Isn't such a number just a hypothesis that rarely occurs in the real world?

If we free ourselves of our hypothetical ideas of neutral light, we suddenly find ourselves confronted with a huge range of moods and colors that we can use to expand our creative range. Unconventional colors often produce more lively and natural-looking scenes than strictly neutral ones. Can you imagine a neutral sunset or a winter mountain scene without the slight blue shimmer of the snow?

It is the color of light that gives a day contrast and expression, and it enables us to feel cold and warmth and thus to experience invisible phenomena on an emotional level. It is a photographer's job to observe and interpret this spectacle with wakeful eyes. Natural light is an endless source of inspiration that we image-oriented studio photographers need to keep our creative ideas fresh. When I see a unique moment in nature I always try to capture it with my inner eye so that I can recall it when it is needed.

These three photos were taken in Shanghai. They perfectly demonstrate how radically the mood of the prevailing light can change in the course of a day. Shanghai suffers from heavy smog that swallows up a lot of stray light, causing significant color casts. It is virtually impossible to capture neutral colors in such an environment. These images were all shot on January 2, 2009, using a Nikon D3 and a daylight white balance setting.

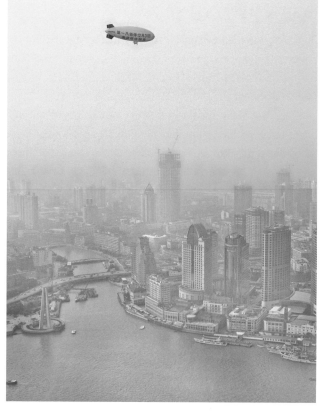

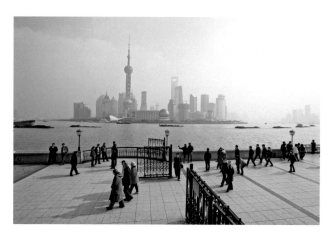

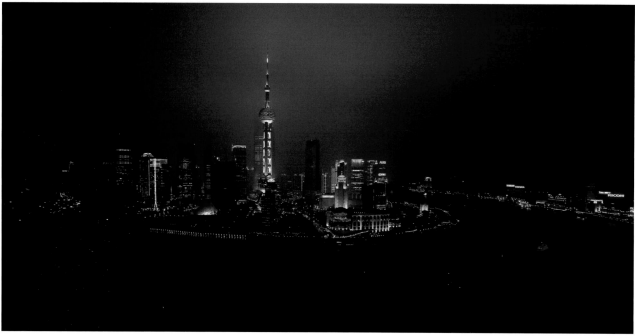

Artificial Light

In addition to the natural light provided by the Sun, we have a broad range of artificial light sources at our disposal. Any light source that delivers a continuous spectrum can be used effectively in a photographic context, whereas those that produce a discontinuous spectrum (such as most fluorescent tubes) leave gaps in the spectrum and don't reproduce all colors consistently. The result is often an incurable color cast. Light sources that produce a pure line spectrum, such as the sodium or mercury vapor lamps often used in industrial buildings and for street lighting, produce monochromatic light and are not suitable for color photographic purposes. It is also extremely important to take the differences in color temperature of various light sources into account.

These range from candlelight (approximately 800 K), through incandescent light (approximately 2800 K) and flash (5500 K), to hydrargyrum medium-arc iodide (HMI) light (6000 K). Color temperatures can be accurately measured with an appropriate measuring device, and experience will teach you how they affect the look of an image. You can balance the effects of varying light sources with in-camera color temperature settings or with correction filters to alter the color of the lights. As already mentioned, a camera's auto white balance setting can be very useful for calculating the median white balance value for a specific scene and keeping color casts neutral.

Mixing daylight and artificial light sources produces cold/warm contrasts and a lighting mood that we generally accept as natural and nondisruptive.

But remember, the variety of available light sources represents an enormous potential that we can actively use to influence the mood of a composition to fit our own ideas.

Light as a Conveyor of Mood

In addition to the ones already mentioned, there are other factors that influence the mood of an image. As well as its color temperature, the type of light being used can strongly influence the effect of an image and is another aspect of lighting that we can use to deliberately manipulate our viewers' visual expectations.

To put it in general terms: if we want to communicate a clear, hard message, we use clear, hard lighting. If we want to produce a pristine, positive feeling, we are more likely to use a bright, embracing composition to get our message across. Bright colors and a well-lit scene communicate positive, optimistic feelings; darker tones and high contrast produce tension and drama in an image.

A photo of a cup of coffee can be composed to generate warm feelings and suggest the taste of roasted coffee beans on the viewer's tongue, and using blue-tinged light to photograph objects made of steel makes the cold touch of the metal highly tangible.

We are just as receptive to the warm, dark tones of a rustic interior as we are to the bright, cool look of a glass office tower. However, product and catalog photography, art reproduction, and documentary photos often demand strictly neutral colors. In situations like these, it is not our job to communicate a message, but rather to provide a reproduction with color and form that are as close to reality as possible. In such cases, it is essential to match the white balance settings as closely as possible to the light source we use.

Shaping a Subject with Light

With the exception of stereoscopic photos, the flat, two-dimensional nature of traditional photos seems unsuitable for viewing with human perceptive skills. However, we are once again helped by the visual knowledge stored in our brains that enables us to imagine the third dimension in a photo. It is nevertheless helpful—and for unknown objects, essential—to capture a subject's depth photographically. Light and shade are useful spatial indicators, even when perspective and proportion offer clues of their own to the nature of an object. Because the third dimension is missing in the photographic world, we have to simulate it ourselves.

In nature, light becomes brighter and colors become paler toward the horizon—a phenomenon that is particularly obvious in the mountains, where chains of peaks recede into the distance and produce a feeling of seemingly endless depth.

This type of spatial representation is a well-known feature of still life compositions. Increasing brightness opens up a space, making the objects within it appear close and tangible. If we use a background, we reduce the intensity of its color so it doesn't compete for our attention with the subject in the foreground.

Dark backgrounds produce the opposite effect and close a space. This makes the entire composition appear more compact and concentrated. Dark surfaces automatically steer the viewer's attention toward the (brighter) subject and hold it there. Using a horizon light is an interesting combination of both approaches and gives images a highly three-dimensional look.

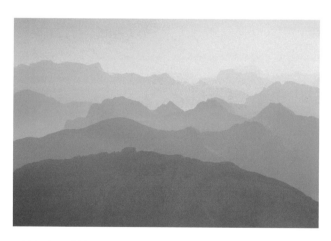

This shot of distant mountain peaks demonstrates how the tones in the image become brighter with increasing distance. Natural phenomena such as this help us learn to perceive depth.

This still life is based on the effect described on the left. The depicted space opens up toward the rear, and brightness increases with distance from the camera. This composition gives the image a feeling of extended depth, which is enhanced by the cropped foreground elements that guide the viewer's eye into the frame.

These two photos are composed entirely with the effects of light and shade. I used a Fresnel spot positioned about 2 m (6.6 ft) from the subject to produce hard, directional light and a hard shadow. I also used tracing paper with holes cut in it to partially soften the light and darken the scene. I used a Sinar p2 4x5 camera with a 300mm Sironar-N lens and the negative layer of Polaroid Type 55 P/N sheet film. I simply let the film stand without fixing it and dried it a little using a hair dryer before scanning the images. The textures in the negative come from the dried Polaroid developer paste.

Shaping a Subject with Light and Shade

Specialized lighting techniques can be used to define shapes and make them distinguishable from one another. We can enhance a scene by ensuring that less important elements disappear into shadow while important parts remain well lit.

This way, we can guide the viewer's eye and transform apparently complex scenes into simple, easily readable compositions. Shadows allow our eyes to rest, while light attracts and steers them.

The size of a light source and its distance from the subject are also important compositional factors. The smaller and more concentrated a beam of light is, and the farther it is from the subject, the harsher the contrast between light and shadow in the resulting image will be. The opposite is also true; the closer and broader the light source is, the softer its overall effect will be.

The size and position of a shadow depends on where the light creating it comes from. Light sources that are placed to the side of the subject or behind it produce large areas of shadow, and frontal light produces small shadows and a two-dimensional feel in the resulting image.

The degree of softness of a shadow depends on the type and size of the light source. Soft light produces soft shadows, and hard light has the opposite effect.

Lighting Materials and Textures

The sense of touch is missing in the photographic world. We cannot touch the object we see and are thus unable to physically divine its true nature. Here too, light plays an important role.

The material and texture of an object's surface can be clearly emphasized with the right lighting, and it can convey the impression of physical presence, despite the fact that we are actually talking about a two-dimensional photographic print.

Well-defined textures generally require the use of a lateral accent light, although a frontal ring flash can also be used to emphasize the texture of fabrics. Soft materials like wool require harder lighting; harder materials, such as glass and metal, can be better portrayed using soft lighting effects.

This ancient Iranian stone is covered in hieroglyphics. I used a strong lateral light to emphasize the texture of the glyphs and of the stone itself.

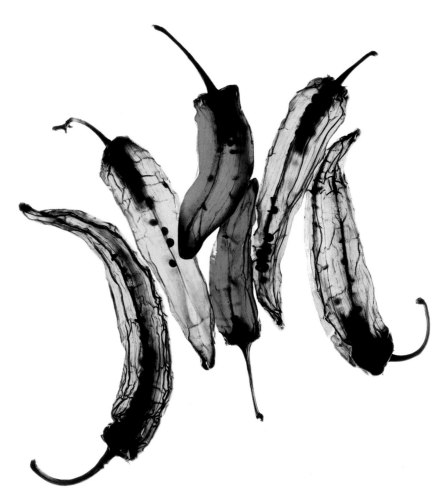

Photographing these chili peppers to make them appear translucent emphasizes their colors and the texture of their skins.

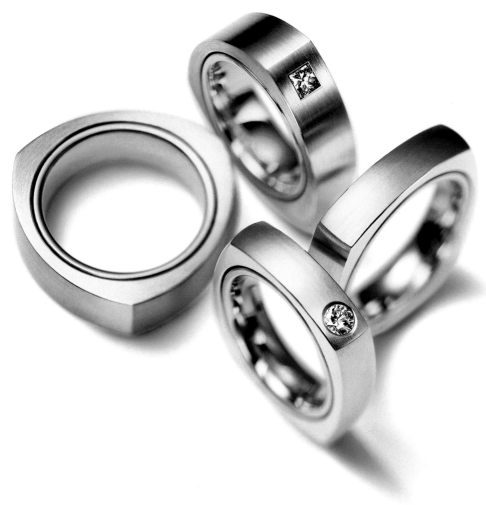

Wedding rings present the dual challenges of using a macro lens and combating unwanted reflections from using a light tent. The Angle of Incidence = Angle of Reflection rule can be used constructively to produce exactly the right highlights and gradients. I nearly always use frosted diffusion sheeting, such as FOBA Trans-Lum, when lighting jewelry shoots. This type of setup is described in detail in the "Watches & Jewelry" chapter.

The Most Important Rule

Angle of Incidence = Angle of Reflection is the single most important rule governing lighting technique. What it means is that light rays hitting an object will be reflected at the same angle on the opposite side of an imaginary plumb line positioned at 90 degrees to the object's surface.

Clearly, this phenomenon is easiest to observe in shiny objects such as glass, gold or metal, or polished floors. Surfaces that are located at the angle of reflection appear brighter—an effect that I use in many of my photos. It is part of my visual philosophy to work with, rather than against, the laws of optics, allowing me to use natural effects to my own advantage.

I often shine my lights through frosted sheeting and use a ceiling reflector or other broad white surface to light a subject. Such soft, indirect highlights are reflected at the object's inherent angle of reflection or in the surface of the object itself, producing individual highlights and gradients. Softboxes distribute light evenly and produce a smoother overall effect.

Studio Photography—*Light and Lighting*

Studio Lighting

Flash or incandescent light? Daylight or artificial light? White or black backgrounds? These simple questions are not always easy to answer and often require a lot of forethought.

Working in a Daylight Studio

Daylight is the most natural source of light there is, but it is not always available and it can vary in its quality, brightness, and color temperature. Direct sunlight is not suitable for most photographic purposes, whereas indirect, diffuse daylight that enters a scene through a window is perfect for many types of photography, including food shots and portraits. The higher the room and the larger the windows, the more natural-looking the resulting light will be, especially if the windows are constructed to allow light to reach the subject from above. The color temperature of daylight changes constantly, so it is never really neutral. However, this characteristic underscores its charm when compared with the sterile nature of studio light.

Daylight is great for mixing with studio light, either as a main light or fill light alongside daylight-colored studio flash. The slight differences in color temperature between such pairs of light sources provide natural-looking colors that are directly comparable with location lighting. Pure daylight studios do exist, although they are rare. They are constructed with very large windows and require the use of correspondingly large diffusers to soften the incoming light. Working in such a studio limits you to working in the daytime, but, as a result, it greatly enhances your family life!

Otto Kasper's daylight studio in Rielasingen, Germany, was specially built to allow the photographer to use large amounts of daylight in his compositions. The large windows on the north side of the building cover the entire height of the structure and part of the roof. Large fabric diffusers allow the photographer to soften the incoming light, and black curtains serve to deaden unwanted stray light and reflections. This is a great example of how to use daylight creatively. A controllable light source of this size is virtually impossible to find anywhere else. In the setup shown here, lamps and studio flash are being used to provide additional accents.

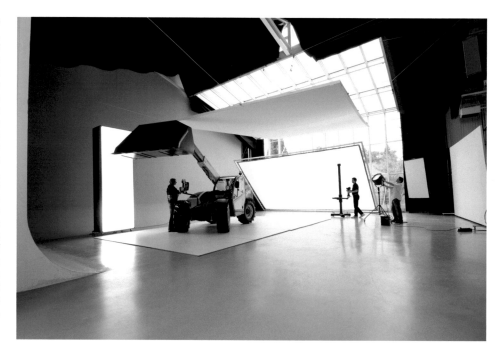

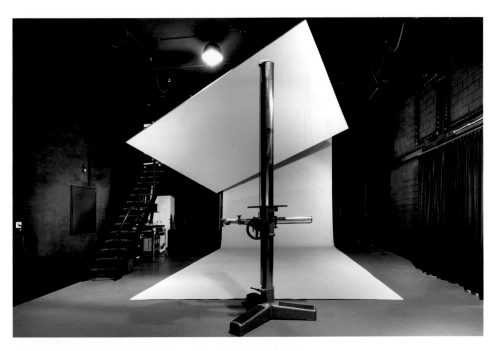

My current studio is my fourth one, and it is the first one that I have decorated entirely in black. The space measures 10.5x8.5 m (34.4x27.9 ft) and is 5.5 m (18.0 ft) high.

The large 4x6 m (13.1x19.7 ft) reflector is suspended centrally from the ceiling and can be raised, lowered, and moved freely using a gantry crane. It is constructed of white-painted canvas mounted on an aluminum frame.

There are brackets mounted on the ceiling at regular intervals that can be used to mount a custom camera support with a tiltable head. There is a mechanical 16x5 m (52.5x16.4 ft) roll of white-painted Novilon that serves as a floor or a background. The studio has no daylight, so all light has to be artificially produced and directed.

Working in a Windowless Studio

I am often asked if I prefer to work in daylight or windowless studios. Over the past 20 years, I have worked in three daylight studios, where it is essential to be able to cover the windows with opaque black curtains to facilitate long exposures, shots with dark backgrounds, and other low-key photos. In the past I used daylight for 10 to 20 percent of my work, especially for food and interior shoots, but most of my work involved the use of lighting setups that were specific to the job at hand when daylight alone could not provide adequate light.

A daylight environment is much more pleasant to work in than a dark, artificially lit room, and it is necessary to reduce the amount of ambient light only when you are post-processing on a computer.

While a daylight studio has a built-in light source that can be used without additional setup work, a windowless studio requires you to know exactly which types of light you want to use and what gear you need to produce it.

Five years ago I moved to a new windowless studio that is painted entirely black. Both daylight studios and windowless studios have their own advantages and disadvantages, but the biggest difference in my new studio is that I have to produce and shape every last ray of light artificially. In such a situation, it is essential that I have a clear idea of the lighting effects I want to achieve before I start to work. My studio provides no natural light and absolutely no stray light that I can use to create accents and highlights. The big advantage of working this way is that I always retain complete visual control of the situation.

Generally, a windowless studio requires more effort when it comes to lighting. The ceiling needs to be higher than an equivalent daylight studio to give you room to use large-scale reflectors when constructing softer lighting moods. The most useful tool for shaping light in a dark studio is a large white-painted canvas mounted on a lightweight frame, which can be used in many ways to produce indirect lighting effects. Overhead reflectors suspended from the ceiling are very useful and should be centrally located on a vertically adjustable mount to give you maximum maneuverability. An alternate way to mount a ceiling reflector is with pulleys at each corner, which then allows you to rotate it around its own axis and position it at whatever angle you please. A ceiling reflector should be as large as the studio space allows, while of a size that can still be rotated and positioned freely. The one in my studio measures 4x6 m (13.1x19.7 ft), and the studio itself is 8.5 m (27.9 ft) wide and 10.5 m (34.4 ft) long. Such a studio needs to be at least 3.5 m (11.5 ft) high. Mine is 5.5 m (18.0 ft) high, which gives me plenty of room to position my ceiling reflector and any subsidiary overhead and lateral lights.

Large softboxes used with boom stands are useful alternatives to ceiling reflectors. The major difference is that a softbox always produces the same even light, whereas a reflector can be used to produce a variety of different effects with various light-shaping tools or to reflect light from different sources. A reflector can even be used with multiple lamps to construct light-to-dark or cool-to-warm gradients. The softness of the light you produce can be precisely controlled by varying the distance between the light and the reflector.

Generally speaking, a reflector is more versatile than a softbox when it comes to producing various lighting moods.

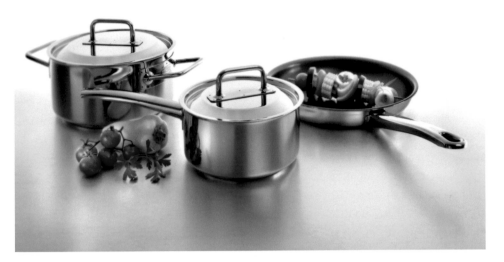

Three examples of setups lit using a ceiling-mounted reflector.

In the first example, the reflector was used to evenly distribute the light from a strip light, giving the three brushed steel pans a soft shine. A fill light and a couple of accent lights positioned to the left produced highlights in the sides of the pans and lit the vegetables in the foreground.

In the photo on the left, I used a reflected color gradient. The strip light I used produced pure incandescent light, and I used a flash with a magenta filter to produce the contrasting color.

In the small photo, I used a neutral reflector effect with just a little fill light in the foreground.

The Varying Character of Light

In addition to direct or indirect light sources, you can influence the characteristics of a light source with various shaping tools, such as reflectors, softboxes, Fresnel spots, umbrellas, and a ring flash, to name just a few.

Lighting equipment manufacturers are constantly introducing new types of lamps and light-shaping tools that promise to produce light with an ever wider range of characteristics. Some of these tools are truly unique and produce a type of light that is otherwise difficult to duplicate. If you are on the lookout for a specific type of light source or lighting mood, acquiring a specialized tool can often be a worthwhile investment. Manufacturers provide a lot of examples of how their products work, and most photographers have different requirements anyway, so I won't go into detail on any specific products here. You will find details of which tools I used and why in the workshop chapters later on, along with visual examples of the effects they produce. The following sections are intended to give you an overview of the various types of light sources and shapers that are available.

General Lighting Guidelines

The size of a light source should be proportional to the size of the subject. If the light source is smaller than the subject it is illuminating, the light will appear harder and will cast a large shadow; the opposite is true of a light source that is larger than the subject. Different rules apply for spotlights, which are designed to produce a small, concentrated source of light. Things also look different when you are creating deliberate reflections in shiny surfaces. These follow the Angle of Incidence = Angle of Reflection rule and thus require light sources that are much larger than the subject itself.

The gradation of the light you use will also affect the visual sharpness of the resulting image. Generally speaking, the softer and more diffuse the light that reaches the subject, the softer and less well defined the image detail will be. Conversely, targeted light produces images with plenty of sharp detail and reproduces textures that are simply not visible if they are illuminated with soft light.

The shape of a light source also influences the effect it produces. Rounded light sources produce more even shadows than angular ones. Linear lamps and strip lights tend to produce soft light along their long side and a harder light from their short side. Adjustable focus reflectors, such as those manufactured by Briese, can be used to produce light with various characteristics.

Softboxes

If you decide to use a softbox, remember that rounded shapes produce softer shadows than rectangular or square ones. Circular light sources of any type produce shadows that are evenly formed from the center outward—often called umbra shadows. Angular light sources produce shadows that spread less evenly. Linear light sources produce shadows with similar characteristics to their light beams, with softer effects along the long side and harder effects along the short side. This variance can also be a source of interesting lighting effects.

Gels and Diffusers

Transparent gels are good alternatives to softboxes and are just as flexible to use as the ceiling reflectors described earlier. Gels are mounted in front of the lamp, so the distance between the gel and the lamp, the type of reflector, and the direction the lamp is pointing determine the degree of softness and the character of light it produces. Gels are available in varying degrees of opacity that can be used to vary the softness of the light. Make sure you use fireproof gels of a neutral color for light diffusion. The fabrics used to cover softboxes can also be mounted on frames and used as gels. They have the added advantage that they can be washed, folded, and put away when not in use.

Targeted Light

Fresnel spots, projectors, and floodlights can all be used to produce hard light with well-defined shadows—i.e., as an alternative to sunlight. These types of lights can also be used for film and stage applications. They are often used to place accents in scenes that are otherwise lit with soft light sources. Shadows produced this way can be used as integral parts of the composition, although you can just as effectively emphasize the texture of your subject with a separate accent highlight.

Ring Flash

A ring flash produces frontal light that hits the subject head-on and produces a circular shadow. In addition to this unique main light effect, it can also be used as an effective front-fill light. A ring flash produces highly detailed images and is great for emphasizing the texture of fabrics. It is often used in fashion shoots to produce a paparazzi-type look.

Fiber-Optic Light

This type of lamp is made up of a light source attached to a flexible bundle of glass fibers. It is perfect for applying light in places that are otherwise difficult to reach, and the light source itself can be freely positioned at a distance from the subject. The size of the light beam produced depends on the thickness of the fiber bundle, which ranges from just a few millimeters to more than two centimeters. The HoseMaster (see the example on page 27) has a continuous xenon light source with a daylight equivalent color temperature and measures 13 mm (0.5 in) thick by 5 m (16.4 ft) long. It has a second shutter mounted in front of the lens so it can be used for light painting applications. Light painting is the art of using light as a kind of brush to paint the light into a photo bit by bit. This approach requires you to have a very precise idea of how you want your finished image to look before you start. There are also fiber-optic flash units available that consist of two or three permanently mounted bundles of fibers.

Artificial Light or Daylight?

Deciding when to use daylight or artificial light depends on the nature of the subject. I prefer

to use flash for portraits, people shots, and moving subjects. Due to the relative weakness of modeling lights built into studio flash units, continuous light is usually more practical for large-scale studio shoots of furniture or cars. The advantages of using continuous light come at the price of heavier gear, a larger energy bill, and hotter lamps. Continuous incandescent lamps and accessories originated in the movie industry and are constructed very differently than studio flash gear designed specifically for photographic use.

Many photographers swear by continuous light because they can see exactly how the shot will look while they are setting it up, whereas flash photographers have to judge the effect of flash using the modeling lights built into their flash units, which can vary in quality and color. It is particularly difficult to judge the effect of accessory light shapers using modeling light, although experience can help you guess how a finished scene will look. The differences between modeling light and full flash are virtually negligible in softboxes and other indirect lighting. Studio flash gear has a better power-to-weight ratio, and its output can be more finely adjusted, than most continuous light sources. Additionally, flash color temperature is generally more consistent over long periods of time.

Tools for Shaping Light

A standard reflector, when used directly, produces relatively hard light and well-defined shadows with clear edges. Reflectors are available in standard, wide-angle, and telephoto models that differ in the way they distribute light within the frame. A beauty dish is a larger reflector that produces softer light. Most reflectors can be fitted with honeycomb attachments for producing directional light, or diffusers for producing softer effects.

Umbrellas enlarge a light source and invert it so it is indirectly applied. White umbrellas, like the one shown here, produce softer light than silver-coated ones. If you are using a large umbrella, you will need to use a wide-angle reflector to produce a sufficiently large cone of light. The bright hot spot in the center of the umbrella is clearly visible. Umbrellas are easy to put up and take down and are easy to transport, making them perfect for location work.

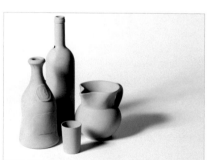

This octagonal 100 cm (39.8 in) Rotalux softbox has a nearly circular shape and produces soft light with a pleasant core shadow and a softly dispersing penumbra. This model can be used with or without its removable internal and external diffusers to create a variety of lighting moods. In addition to product photography, a softbox like this is great for portraits, too.

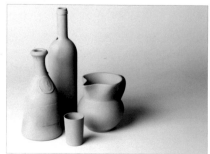

 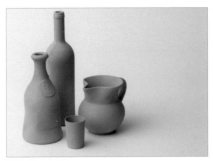

Here, a ceiling reflector was suspended at an angle above the subject and was lit using a single lamp with a wide-angle reflector. The light reaching the subject is very soft. The light source is about 3 m (9.8 ft) wide and is much too large for such a small subject. The result is a soft, poorly defined image. This type of lighting can be fine-tuned with various light shapers and by varying the distance between the lamp and the reflector, making it much more suitable for use with larger subjects.

 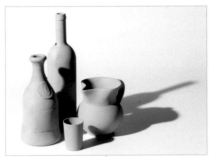

A Fresnel spot has a small flash tube mounted behind a spherical mirror and a Fresnel lens that concentrates the light it produces. The light is highly directional and produces hard shadows. The flash tube and the mirror can be moved within the lamp body to produce angles between 10 and 60 degrees. This enables the photographer to illuminate both compact and wider scenes.

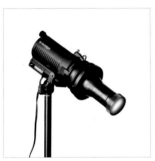 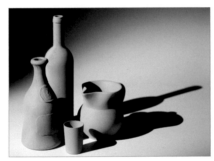

A projector attachment has a built-in lens that produces a highly concentrated beam of light with an angle of spread between about 2 and 10 degrees. The model shown here is a Dedolight with a tungsten head. The problem with projector attachments for flash is the sometimes very different nature of the modeling light compared with the flash itself. Tungsten heads produce results that are much easier to judge in advance.

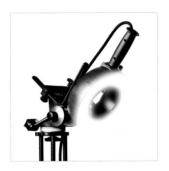 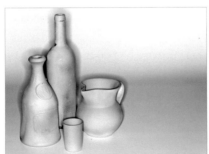

A ring flash is usually mounted directly on the camera lens and produces light that is aligned directly with the photographer's line of sight. The resulting shadows surround the entire subject, and the main bulk of the light illuminates the center of the object. The subject becomes darker toward its edges, especially if it has a curved surface, which often produces a highly three-dimensional look. The closer the subject is to the background, the smaller the outline shadow will be. If you are shooting a subject that rests directly on a surface, it will be free of shadows.

 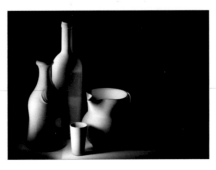

Fiber-optic light is available as a separate attachment for studio flash units or as a self-contained continuous light source for light painting applications. The lamp shown here is a HoseMaster with a continuous daylight xenon source. This particular lamp is very efficient and is used to paint light into a photo. This approach can be used to produce lighting moods that are extremely difficult to create using conventional lamps. The HoseMaster requires the use of a second shutter in front of the lens so the photographer can operate the shutter while painting.

Viewpoints and Perspective

The photographer's viewpoint is often a subject of too little consideration. It is, however, extremely important; it determines the way we perceive a photographed object.

Shooting Angle and Angle of View

Before we go any further, I should mention that the shooting angle and the viewing angle have to be the same to produce natural-looking perspective in a photo. The shooting angle is a product of the relationship between the subject distance and the size of the image area; the angle of view depends on the distance between the image and the viewer. Bringing these two factors into equilibrium is more difficult than it might seem due to the enormous variations in the size, shape, and viewing conditions of published images. It is nevertheless important to understand the rules involved and to apply them as often as possible.

Let's take a look at an example. Suppose you are shooting an indoor scene using a wide-angle lens. If the resulting image is printed large and can be viewed from close up, the viewing conditions will be largely the same as those under which the image was captured, resulting in a realistic feeling of space and undistorted perspective for the viewer. However, such a photo will normally be reproduced at a size that is too small for the viewer to get up close, and it will appear to have a distorted perspective as a result. What this means is you should consider the eventual print size and the likely viewing conditions while you are composing an image, if you want the result to have natural-looking perspective. Ideally, the ratio of subject distance to subject size will be the same as the ratio of viewing distance to print size. The viewing angle for a double-page magazine spread can be as much as 90 degrees, and an advertising poster on a street is usually viewed at 10 degrees or less. Small product shots for a catalog are generally captured with a small angle of view; magazine spreads will usually be viewed at an angle of view equivalent to that of a standard lens—that is, 40 to 50 degrees. If you are deliberately using differing shooting and viewing angles to produce a heightened spatial effect, it is important to remember that these differences will exponentially exaggerate the visual effect of the finished image. A wide-angle shot viewed at too small an angle of view (i.e., from too far away) will appear to have extreme perspective, and a telephoto shot viewed from up close will look even more spatially compressed than it actually is.

The viewer's position relative to the center of an image also plays a role in how it appears. The apparent perspective in an image is different if it is viewed from the side or from above or below, rather than head-on along its central axis. The frescos in the church of the Santissima Trinità dei Monti in Rome are an impressive example of how artists deal with this phenomenon. Because the viewing angle from the nave is so unusual, painting the arched roof of a church is a task that requires tremendous skill. The correct use of perspective that allowed painters to produce realistic-looking scenes on church walls and on the inside surfaces of domes first came into use during the Renaissance period. The objects and figures in these paintings are strongly distorted lengthwise to compensate for the extreme differences in viewing distances that exist within each image.

A box of eggs photographed with three different lenses. The image at top right was captured using a standard lens. In this case, the perspective appears distorted because we are viewing the subject from above in the foreground but laterally toward the rear. The egg box would appear more natural if it were printed with a diagonal length of about 50 cm (19.7 in).

The image directly below was shot with a 24mm lens and makes the egg box look convex. This image would require a print with a diagonal length of 100 cm (39.8 in) to make the viewing angle the same as the shooting angle so the image would look natural.

The image at below right was shot using a 200mm telephoto lens. Here, the shooting angle and the viewing angle are well balanced and give the shot a natural-looking perspective.

Photos: Christian Künzi

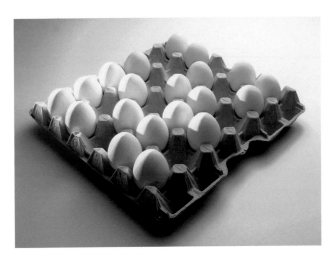

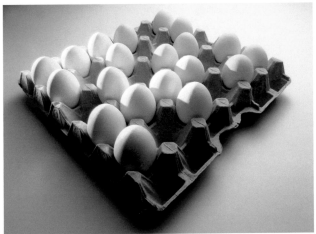

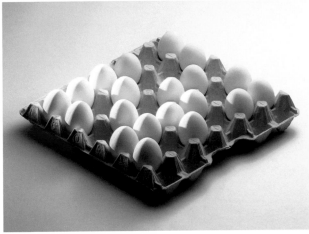

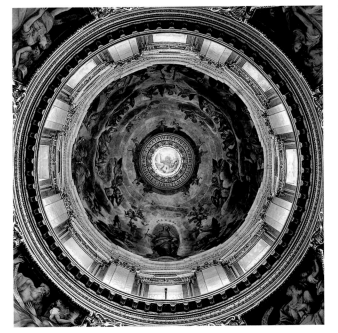

The paintings in the dome of the Trinità dei Monti in Rome are an impressive example of how to harness the rules of perspective. This type of painting demands highly skilled execution on the part of the artist due to the very unusual viewing angle (from directly below) and the enormous differences in viewing distances between different parts of the image.

Studio Photography—*Viewpoints and Perspective*

Subject Distance

The subject distance is often determined by the nature of the subject itself. If you photograph an object from too close, you will find that some details suffer from an odd-looking perspective, and a view from above will nearly always produce converging lines that are difficult to correct later. If you want to avoid producing converging lines, you will have to use a lower viewpoint, which usually means shooting from farther away.

Photo A shows a perspective of the neck and bottom of the bottle that gives it an odd, distracting look. In this case, the photographer chose a viewpoint half way up the bottle, which looks down at the lower half of the bottle and looks up to the upper part. The fact that the bottle was photographed from too close also has a negative effect on the image.

Photo B was taken from much farther away and balances out the differences in viewpoint to produce a natural-looking image. The viewpoint for this shot was slightly above the bottle, giving the image a consistent perspective. The elliptical shapes formed by the bottom and shoulder of the bottle contribute to the natural look of the image.

A

B

I often use long focal length lenses for still life work to give the subject a clean, undistorted look. An added advantage of this approach is that the camera is located farther from the subject and doesn't get in the way while I work.

Larger subject distances can also be helpful when you are photographing multiple objects because the differences in size between objects become less apparent—a boon for every product photographer whose job it is to reproduce the subject in as realistic a manner as possible. The exception is, of course, if you wish to deliberately use an unusual perspective to enhance the effect of a photo. The perspective you choose also determines the proportions within the finished image, as illustrated by the six photos on page 31.

A final bonus of using long lenses and long subject distances is that the camera is much less likely to be reflected in shiny objects, such as jewelry. If the camera does end up being reflected in the subject, the reflection will be much smaller and therefore easier to cover up or retouch.

Every job has its own specific requirements and there are, of course, many creative factors that will influence your choice of camera position. These are described and illustrated in the workshop sections later in the book, so I won't go into any more detail at this stage.

45mm lens
This lens is equivalent to a moderate
35mm-format wide-angle lens.

90mm lens
This lens is approximately equivalent to
a 70mm lens used with a 35mm camera.

150mm lens
This is equivalent to a 110mm
full-frame lens.

45mm lens
In this and the following two examples,
I used parallel front and back tilt
movements on my view camera to ensure
that the vertical lines remained vertical.

90mm lens
With tilt movements.

150mm lens
With tilt movements.

This sequence of images illustrates the positive perspectival effects of
increasing the subject distance in a product photography situation.
The versions shot with wide-angle and standard lenses show distinct
perspective distortion; it is only when we use a longer lens and a greater
subject distance that the image begins to look more natural.
This effect is even more obvious when we use front and back tilt
movements to correct the converging vertical lines.
The corrected image shot with a 150mm lens is the most natural looking.

Studio Photography—*Viewpoints and Perspective*

Cameras and Lenses

For many years, the view camera was the tool of choice for most still life photographers. The large image format enabled us to carefully compose our images and delivered the high image quality demanded by clients and agencies. The rise of digital photography has changed all that.

Cameras

The major distinguishing characteristic of the view camera is its ability to control the position of the focal and lens planes, which can be independently adjusted in every direction using the camera's front and rear standards. The large negative format also offers much greater resolution than 35mm or medium-format cameras.

I spent many years shooting exclusively in 8x10 format, and I often felt like a painter at his easel when confronted with the camera's huge focusing screen. Large-format photography is hard to master, and it involves enormous costs for film and development. However, the reward for coming to grips with all the technical difficulties is incomparable image quality. The most popular format in my early days was 4x5, which offered a good compromise between portability and view camera flexibility.

The reproduction ratio offered by view cameras was much greater than that offered by today's formats (38x48 mm, for example). The reduced depth of focus when working with small subjects (50 cm/19.7 in and less) at closeup distances (between about 1:5 and 3:1) makes heavy demands on the flexibility of focal plane settings. This problem is made trickier by the fact that the optimum aperture at close distances is larger. I often had problems overcoming this type of challenge when using my large-format camera.

The optimum aperture is the one that delivers the best possible compromise between maximum depth of field and diffraction blur. Stopping down beyond the optimum aperture leads to decreasing image sharpness, making it the minimum usable aperture for close-range photos. The increased resolution of current camera backs also allows us to select the "cc high" setting (see the table below), where cc stands for the diameter of the resulting circles of confusion.

Reproduction Ratios and Optimum Apertures

MASSSTAB	1:10	1:6	1:5	1:4	1:3	1:2	1:1	2:1	3:1	4:1	5:1	6:1	10:1
FORMAT													
24 x 36 mm													
u normal 0,033	45	42	41	39	37	33	25	16	12	10	8	7	4,5
u hoch 0,015	22	20	19	18	17	15	11	8	6	4,5	3,7	3	2
45 x 60 mm													
u normal 0,06	81	77	75	72	67	60	45	30	22	18	15	13	8
u hoch 0,03	41	38	37	36	34	30	22	15	11	9	7	6	4
60 x 90 mm													
u normal 0,075	102	96	93	89	84	75	56	36	28	22	19	16	10
u hoch 0,04	54	51	50	48	45	40	30	20	15	12	10	9	5
100 x 125 mm													
u normal 0,1	135	128	124	119	112	99	75	50	37	30	25	21	14
u hoch 0,05	68	64	62	60	56	50	37	25	19	15	12	11	7
130 x 180 mm													
u normal 0,15	203	192	186	179	168	149	112	75	56	45	37	32	20
u hoch 0,07	95	89	87	83	78	70	52	35	26	21	17	15	9
200 x 250 mm													
u normal 0,2	271	255	248	238	224	199	149	99	75	60	50	43	27
u hoch 0,1	135	128	124	119	112	99	75	50	37	30	25	21	14

The size of modern image sensors has all but eliminated the problem; I now rarely have to work at true closeup distances. However, the ability to adjust the focal and lens planes to achieve the desired focus effect is less significant at these types of reproduction ratios. Smaller reproduction ratios give you more depth of field, and the smaller optimum aperture allows you to stop the lens down further. Nevertheless, the sharpness achieved by using smaller apertures is not the same as the type of sharpness produced by using the optimum point of focus, and smaller apertures produce images that are, in fact, simply less unsharp than they might otherwise be. In challenging situations, the flexibility of a view camera is clearly superior to the fixed nature of a modern digital camera. Medium-format digital cameras have no built-in movements and are built to precisely match the optical characteristics of high-resolution digital backs. This degree of precision is not easy to achieve in a view camera due to the nature of its construction. As a result, medium-format digital cameras are slowly but surely supplanting large-format cameras. Additionally, digital color reproduction and the range of available tones now exceeds those that can be produced using traditional film, giving the digital medium the edge when it comes to overall image quality.

Having spent more than 25 years shooting with the Sinar large-format system, and the past six years using the 22-megapixel Sinarback 54H, I have recently had to change my ideas. Current digital backs have more than twice the resolution of the Sinarback 54H, so I tested all the available systems and backs carefully before making a decision. All the systems I tested offer extremely high build quality and excellent handling, so my decision rested on additional factors such as the location of the distributor and the quality of dealer service, the available software, and the manufacturer's future prospects. At the end of the day, I decided to use the Hasselblad system, which handles well and works in tandem with the smart, practical Phocus software package. The 50-megapixel back of the Hasselblad H4D produces image quality that is equal to, or possibly even better than, 8x10 slides.

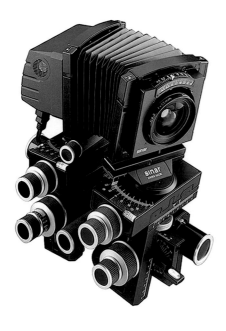

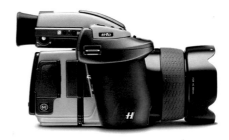

Left:
The Sinar p3 view camera fitted with the 54H digital back. The lens board and the film/sensor plane can be independently shifted, tilted, and swiveled, allowing the photographer to adjust focus according to the tenets of the Scheimpflug principle, that is, the plane of focus can be adjusted to fit the individual requirements of a specific shot instead of remaining perpendicular to the optical axis.

Above:
The fixed-focal-plane Hasselblad H4D, shown here with its 60-megapixel back.

View Camera Movements

A variable plane of focus and perspective control make the view camera an indispensable photographic instrument.

The view camera's ability to alter the position of the plane of focus according to the Scheimpflug principle is a great advantage over conventional fixed-body cameras. The concept is named after Theodor Scheimpflug, who discovered that photographing a nearby object in focus requires the body of the camera to be extended further than when photographing a distant object. In a fixed- body camera, the plane of focus is always perpendicular to the optical axis of the lens, which means an increased depth of field can be achieved only by using a smaller aperture. In a view camera, the lens plane can be tilted and swiveled to adjust the angle and position of the plane of focus, thus enabling the photographer to keep the near and far points of an image in focus without having to stop down the aperture.

The principle can be expressed as follows: when an oblique tangent is extended from the image plane, and another is extended from the lens plane, they meet at a line through which the point of focus also passes, resulting in an image plane that remains in focus. In other words, we use the view camera to position the plane of focus so that all objects within the

This composition required adjustment to the plane of focus in order to capture both pairs of glasses in focus. This was achieved by tilting the front standard forward.

Camera: Sinar p2
Lens: 210mm Nikkor AM ED
Tilt: 8 degrees
Film: Fuji Velvia

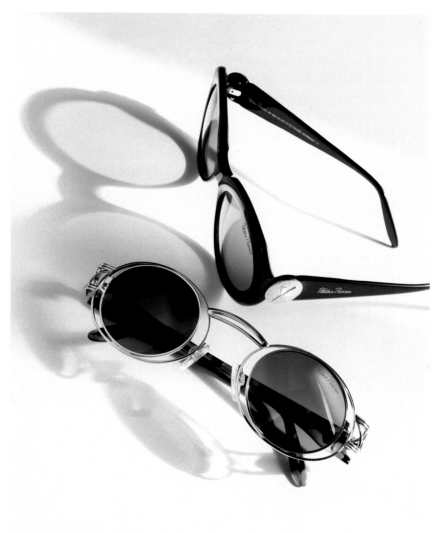

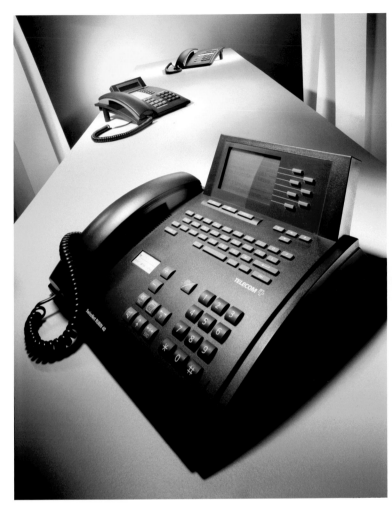

field of view are reproduced in focus without having to alter the aperture. We can adjust the plane of focus at will, and our options are limited only by the image circle projected by the lens and the mechanical limitations of the camera itself.

This flexibility can also be used to deliberately keep certain image areas out of focus, giving the in-focus parts of the image extra emphasis. Again, the ability to position the plane of focus at an angle to the normal plane of focus is the deciding factor when applying effects like this.

The second major factor that distinguishes the view camera from its fixed-body counterparts is its ability to alter perspective by adjusting the position of the image plane. Normally, if we photograph an object from above, below, or the side, the lines in the resulting image converge toward infinity. The view camera's movements enable us to counteract this effect to a certain degree, although an accepted rule of thumb says that converging lines cannot be completely eliminated without producing obvious perspective distortion for angles of view that are less than or equal to 20 degrees. Trying to compensate for greater angles of view usually produces unnatural-looking results.

Three examples of planes of focus.

Main image:
The front standard was tilted forward to align the plane of focus with the tabletop. As a result, all three telephones are in focus.

Above right:
The front standard was adjusted vertically and swiveled to the right, producing a plane of focus that runs vertically from the bottom right to the center left of the frame.

Below right:
The front standard was positioned vertically to produce a vertical plane of focus that leaves the entire background out of focus.

An example of the creative use of
limited depth of field produced using
the Scheimpflug principle.
The lens plane was positioned nearer to
vertical than the image plane and was rotated
6 degrees to the right, producing a plane of
focus that runs diagonally through the frame.

Camera: Sinar p2
Lens: 210mm Nikkor AM ED
Aperture: f/5.6
Camera movements: Front standard was tilted
15 degrees and rotated 6 degrees to the right

Another example of the creative use of
Scheimpflug-based adjustments. The lens
plane was positioned nearer to vertical than
the image plane, producing a plane of focus
that runs vertically through the subject,
leaving the rear elements out of focus.

Camera: Sinar p2
Lens: 210mm Nikkor AM ED
Aperture: f/5.6
Camera movement: Front standard
was tilted 9 degrees

The Scheimpflug Principle

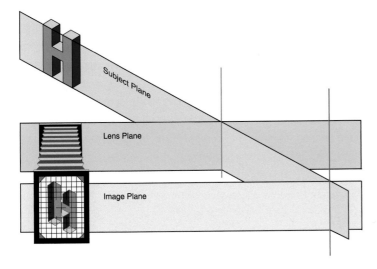

The subject plane is located at an angle to the direction of view. Because the lens plane and the image plane are perpendicular to the direction of view, the three planes do not meet at a single point. This means that the entire subject plane will not remain in focus. To achieve sharp focus for the entire subject plane, it is necessary to use a smaller aperture.

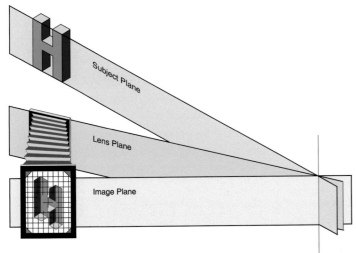

If the lens plane is rotated so that all three planes intersect at a single point, the entire subject plane will be reproduced in focus without having to use a smaller aperture. View camera movements made according to the Scheimpflug principle enable the photographer to position the plane of focus at will, restricted only by the optical and mechanical limitations of the equipment being used. The image plane remains static so the perspective is not altered.

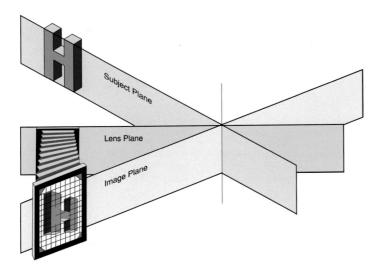

In this example, all three planes once again intersect at a single point, but the image plane was adjusted too, altering the perspective in the finished image.

Limitations of the View Camera

View cameras were originally designed for use with large-format film and are very large. Modern view cameras, such as the Sinar p3, are built to suit the reduced size of digital image sensors. The digital backs used with such cameras have a separate mount so the photographer can still use the camera's focusing screen. Alternatively, the back can output a live view image to a computer monitor. I prefer to use a reflex viewfinder.

All view camera movements cause the image plane to be shifted either away from its central position or tilted away from vertical, which means that some light rays enter the camera at an angle. Digital image sensors use microlenses positioned in front of each pixel to increase light sensitivity, and they are particularly susceptible to the optical aberrations caused by nonperpendicular light rays. This significantly reduces the type and magnitude of movements that can be usefully made with a digital view camera.

Alternatives to the View Camera

Hasselblad cameras can be used with a tilt/shift adapter mounted between the camera body and the lens. The adapter contains additional lens elements and acts simultaneously as a 1.5x teleconverter, but it is not compatible with all lenses in the Hasselblad range. The movements the adapter allows are not really comparable with those that can be made with a view camera and are limited to 18 mm of shift and 10 degrees of tilt. Additionally, the lens elements tend to cause chromatic and spherical aberrations at wider apertures; the only thing that helps to eliminate them is stopping down by three f-stops. If you can live with these limitations, the HTS adapter is a usable alternative to a view camera. Tilt/shift adapters with a similar range of movements are also available for most high-end full-frame digital cameras.

The Hasselblad HTS 1.5x adapter unfortunately produces axial color aberrations at wide apertures.

Left:
The complete image, captured with an HC 50mm lens and the HTS adapter set to 9 degrees of tilt.

Above right:
Shot at f/5.6, this enlargement clearly shows cyan double images.

Below right:
Shot at f/16, the aberrations have disappeared and the image looks sharper.

Comparing the Alternatives

A comparison of the various systems is a logical step. We need to compare not only the mechanical and optical differences, but also the overall impression created by the images they produce. Not all adjustments make sense just because they are possible, and the look of a finished image is the most important aspect of a photographer's work.

This example shows a typical tabletop subject photographed from about 20 degrees of elevation. The uncorrected version of the image (on the right) shows converging lines, and the subject is visibly narrower toward the bottom.

The three alternative images below show corrections made using a full-frame camera with the Hasselblad HTS tilt/shift adapter and a Sinar p2. The effect of the HTS adapter is sufficient to produce a natural-looking image, and the p2's extensive movements are, in this case, more than needed.

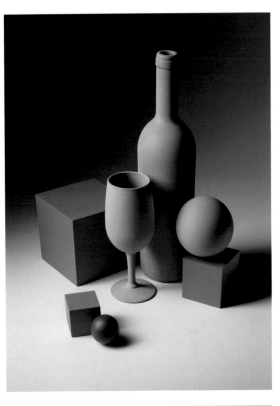

A typical tabletop studio setup, with the subject photographed from about 20 degrees of elevation. The vertical lines converge strongly, in spite of a relatively large subject distance of about 130 cm (51.2 in) and a medium-length (85mm) lens. The objects also appear narrower and slightly compressed toward the bottom.

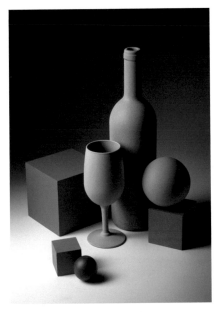

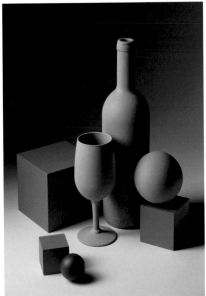

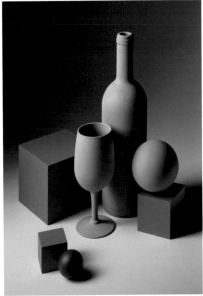

The same shot, this time captured with an 85mm tilt/shift lens set to maximum (11 mm) downward shift. The converging lines haven't completely disappeared, so the image still looks slightly distorted. We could still use more camera flexibility.

This version was shot using an 80mm Hasselblad lens and the HTS 1.5x adapter set to maximum (18 mm) downward shift. The converging lines still haven't been completely equalized, but they are less obvious and the image looks more natural. This is the most usable version, and the image appears optically correct.

This version was shot with a Sinar p2 fitted with a Hasselblad back. I used 40 mm of downward shift, made possible by using a 90mm Grandagon lens with an angle of view of 105 degrees. This arrangement completely eliminates the converging vertical lines but produces significant longitudinal distortion in the sphere and the cubes. This image goes beyond the limits of justifiable adjustments.

Increasing Depth of Field Digitally

There are often situations in which even view camera movements aren't sufficient to capture the entire depth of a subject in sharp focus. Increasing the depth of field by using adjustments to the image and lens planes is limited to two levels, and we can increase image depth in the third dimension only by using a smaller aperture. However, there are still cases—especially in the macro world—where stopping down doesn't provide sufficient depth of field, either due to the maximum optimum aperture or simply because the subject includes too much three-dimensional detail. This is where Helicon Focus comes into play. This ingenious software, developed by a Ukrainian scientist, merges sequences of images taken with different planes of focus into a single image with enhanced depth of field. The program analyzes the individual source images and merges just the in-focus parts into a single image that is completely focused. The program is uncannily accurate, and the results rarely require retouching.

The source images have to be identically framed and must be focused at regular intervals to cover the entire depth of the subject. This usually results in 8 to 20 images, depending on the nature of the subject and the aperture you are using. After you have saved your source images as 8-bit TIFF files and numbered them in sequence, you can load them for rendering. The software shows the individual sharpness masks it creates during the rendering process and gives you a graphic view of the individual parts as it pieces them together. The sequence of the separate planes of focus doesn't affect the process, and the program even automatically compensates for the differences in reproduction ratios that the different focus settings cause. All you have to do is ensure that neither the camera nor the subject moves while you are shooting!

A screen shot of Helicon Focus captured during the rendering process that merges the nine individual source images into one. The image clearly shows that the software analyzes, masks, and mounts each image. Each grayscale tone represents the mask for a single source image. The process is fast; it merged nine 90 MB images in about three minutes. The program also has a built-in retouching tool for correcting the slight errors that sometimes occur during the merge process.

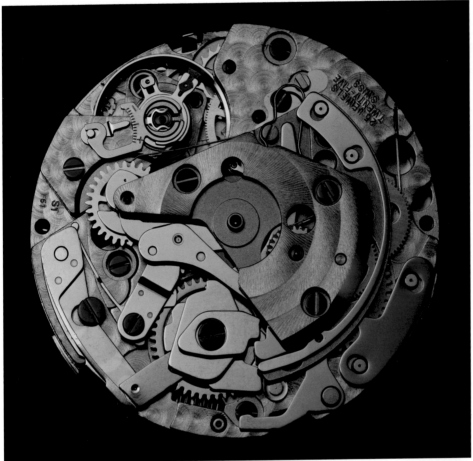

Helicon Focus rendered this image of a watch movement from nine separate source images. The precision of the program's analysis is amazing, and it even automatically accounted for the differing depths in the mechanism. The few errors it did produce were easy to retouch.

Enlargements taken from images 1, 5, and 9 of the original sequence.
Image 1 is in focus in the near foreground, and image 9 is in focus only at the rear.
The differences in image size caused by the changes in focal point are clearly visible, but the program handles such discrepancies effortlessly.
In the end, it required nine separate source images to capture the entire 8 mm (0.3 in) depth of the watch movement in sharp focus at a reproduction ratio of 2:1.

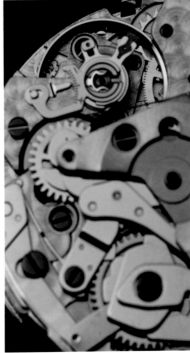

Studio Photography—Cameras and Lenses

Lenses

The lens is the most important part of a camera. A good lens can make an average camera perform better, but a poor lens makes it impossible to produce great images, even if you attach it to a high-end camera. It is essential to choose your lenses carefully.

It is an open secret that digital lenses have to perform better than ones designed for analog cameras. A digital camera back with a 36x48 mm (1.4x1.9 in), 50-megapixel sensor contains pixels that measure 6 microns, and the sensor resolves many more line pairs per millimeter than conventional analog film. Legacy lenses were designed for use with film and don't fulfill the demands of the digital photographic world.

In other words, only modern lenses can take advantage of the increased resolution provided by today's digital camera backs. Any chain is only as strong as its weakest link, so it is always a good idea to use a camera system that is designed from the ground up to work as a unit. A well-integrated digital system produces consistently great results that are often better than their large-format analog counterparts.

Digital technology has simplified still life photography and, in my opinion, improved it, and digital image processing offers almost limitless additional creative possibilities. But let's get back to lenses. Which focal lengths are best for still life applications?

Even with the 22-megapixel Sinarback 54H, I nearly always used the same lenses as when shooting on film—a 210mm f/5.6 Nikkor AM ED, a 480mm f/8 Rodenstock Apo-Ronar for closeups and macro shots (jewelry, watches, etc.), and a 300mm Schneider Symmar-S for standard range work. I also used other wide-angle lenses with focal lengths all the way down to 75mm if the layout required extreme perspectives. I always test lenses thoroughly before making a purchase, and my earlier choices paid off when I made the switch to digital. The reproduction quality I always insisted on gave me lenses that still fulfilled my most critical demands, even with the high-resolution Sinarback 54H.

It was only when I began to use the 50-megapixel Hasselblad back that my older lenses began to reach the limits of their resolution and made an optical rethink necessary. My new favorite lens is my 120mm macro. This lens delivers a natural-looking perspective at magazine-page size and produces very sharp results right down to closeup distances. But I also like using the 210mm and 80mm Hasselblad lenses, often with spacers to help me get up close. I am not a big fan of the HTS tilt/shift adapter, which produces obvious color aberrations at wider apertures and can be effectively used only when stopped down. The problem is that I need the adapter's capabilities most when I am shooting at a large aperture and shallow depth of field, so it is not much use to me.

For location food shots, I often use a Nikon D3 fitted with an older 105mm f/4 Micro-Nikkor—unfortunately, the newer f/2.8 model produces too many axial color aberrations. I also use the excellent newer model 45mm and 85mm tilt/shift Nikkors. I prefer the results my D3 produces to those I get with my D3x or my Hasselblad when I am shooting on location in available light using high ISO values. The D3 is simply unbeatable in mixed and low light situations. Digital imaging technology has opened up a whole new world of possibilities in these kinds of situations.

I photographed this can for an article on recycling. To make the shot look hypersharp, I used my 480mm Apo-Ronar, which always delivers great closeup results on my Sinar view camera. I used a Fresnel spot positioned at top left to give me hard light and strong shadows on the ground. This setup makes even the finest textures highly visible and accentuates the overall sharpness of the image. Hard light generally produces sharper-looking images than diffuse light. I used a blue-filtered soft light reflected from my ceiling reflector to illuminate the top of the can.

I like to use my Nikon D3 with tilt/shift lenses on location. This photo was taken with the 85mm PC-E tilt/shift Nikkor. I set up the plane of focus perpendicular to the subject plane to get the foreground in focus and keep the background blurred. A large aperture emphasized this effect. I particularly like to use wide-aperture lenses or my tilt/shift lens for this type of shot.

Running a Studio

In contrast to fashion photographers who often work on location, still life photographers generally need to have their own studio. Running your own studio has distinct advantages but requires quite a lot of organization.

Efficient organization not only ensures that you make a profit, it also gives you the freedom you need to stay creative.

It is important to have a place where all your gear and accessories are stored and that has enough space to build the often complex setups that a working photographer needs. The size of the space you choose depends on the type of photography you do—a jewelry photographer, for example, doesn't need a space that is big enough to park a car. On the other hand, a furniture photographer will need extra space for props and possibly even a carpenter's workshop nearby, a catalog photographer needs shelves to store large numbers of products, and a food photographer requires a working kitchen to get the job done properly. As you can see, there is no such thing as a typical still life studio. The more highly developed the market for a particular subject, the more specialized the photographers who serve that market will be. In less well-developed markets and in smaller countries like Switzerland, professional photographers tend be all-rounders who specialize in a number of subgenres. Nevertheless, everyone has his or her own skills and favorite subjects, and it is important not to work in too generalized a fashion if you want to be sure of producing high-quality work. Sticking to a small number of specialties also reduces your equipment costs to a manageable level and helps to amortize expenses more quickly.

Whether they are just starting out or are well into their careers, many photographers share studio space to reduce costs. Most photographers don't actually shoot every day, and administration, meetings, and post-processing take up almost as much time as the shoot itself. A rented studio simply costs money and isn't being used while these other jobs are being done, so it makes sense to share a space with others, even if it requires more careful planning and thoughtfulness on everyone's part. Alternatively, you can simply rent out your space on off days to recoup some of your costs—the income isn't regular, but this approach keeps your own studio time flexible. I have been sharing a studio for the past five years and have found that it works very well. Sharing requires you to have a flexible and reliable partner who appreciates having his or her own space but doesn't need to use it all the time. I share my studio 60/40 with my partner; you can work out your own plan depending on your own needs and habits. Because of this arrangement, I can afford a large studio in a central location, which also helps keep my clients happy.

Studio Administration

I try to keep administrative work at the lowest possible level that still allows me to work efficiently. I am not afraid of coming to grips with office software if it helps reduce effort in the long term, but I only spend as much time as I really have to using it. I continually remind myself that I earn money in the studio and nowhere else. A little talent and an organized approach helps minimize office tasks and maximize studio time.

Making quotes and estimates is a time-consuming task, but keeping an eye on costs contributes significantly to the success (or failure) of a project. My income simply has to cover my studio and personal costs. Many highly talented photographers aren't interested enough in money and suffer economically as a result. You need to have artistic and monetary talent to survive as a freelance artist, especially in these hard economic times. I survived the past 15 years by continually improving my organization so that I could cover my costs, even in times of shrinking fees and a half-full schedule.

It is important to not rest on your laurels; instead, keep an eye on the competition and know an opportunity when you see it. It is unrealistic to expect market conditions to always remain stable, and change is the real driving force in the economy as a whole.

Experience Counts

The feel for the process that I have developed over the years makes it possible for me to produce excellent work in an efficient way, and this experience is what makes it possible for me to stay afloat in a market full of young, talented photographers who are full of fresh ideas. However, I am able to apply my experience to the present only because I have actively reflected and worked on it. Experience helps you have new ideas and make the right decisions only if you think hard about what you do and why, and, where necessary, introduce changes and improvements into your work.

When I started out in the freelance world 20 years ago, I created a couple of useful tools to help me compensate for my own lack of experience. My aim was to identify and correct as many commercial mistakes as possible within my first two years.

My Work Sheets

My main tool was—and still is—my work sheets. They contain all relevant details of a job, including a sketch of the setup and a Polaroid (or, these days, an uncorrected print of a test image), and they have proved their worth from day one right up to the present.

Over the years I have collected a huge number of these work sheets. They have become part of my subconscious and, apart from some of the finer details, I am sure I could recreate all of the setups they describe. My work sheets have also proved their worth when it comes to looking after long-term client relationships. For example, a client for whom I have been shooting jewelry for more than 12 years always uses long-term advertising campaigns, so my older work sheets enable me to precisely reproduce any of my previous setups, giving the resulting images a consistent look. The work sheets also enable my assistant to prepare a setup without me having to help, giving me time to pursue other important tasks.

Of course, nowadays there are much more technically refined ways to record studio set-ups than writing them by hand and storing them in ring binders on a shelf. For example, SLR is a wonderful iPhone/iPad app for drawing and storing 3-D studio setups digitally. Strobox is an iPhone-only app that does the same thing with a less fancy interface. Unfortunately, neither tool covers all the light-shaping tools I would like to see, and the options for changing things like the background pattern are limited. The best tool I have found is Lighting Setup, a custom Photoshop PSD file that we used to create the illustrations in this book.

One of my work sheets. On the left is an empty sheet that I still use today to record the details of my shoots.

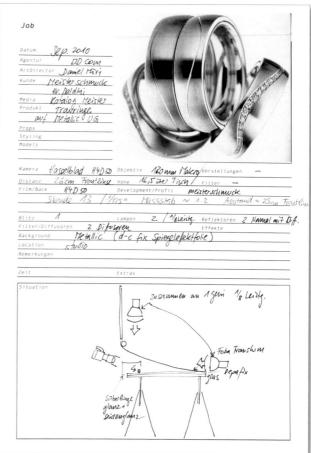

The SLR iPhone/iPad app is a fun tool for illustrating studio setups in 3-D. The app also shows the effect of your chosen lighting setup on a digital model.

The Strobox iPhone app has a less punchy interface, but you can save your diagrams in the app's built-in library or e-mail them from within the app.

Costing Sheets

The other tool I have always used to increase my own efficiency are costing sheets. These have space to list the individual elements of a job on the left side and two columns of figures on the right side. The left-hand column of figures contains the numbers that I include in my estimate (which are usually the figures that end up on the invoice), and the right-hand column contains the real costs associated with each item. In the beginning, the right-hand column often differed significantly from the left-hand one, either because I forgot to factor in smaller tasks or because I incorrectly estimated the effort involved in a job. Within two years of setting up my first studio, I had extended my costing sheet to include all the items I had initially forgotten or overseen and, in time, the two columns began to agree more often.

I try to keep my estimates and invoices as clear and transparent as possible, and I have developed individual tables that I can insert when necessary. The main tables are titled Pre-production, Photography, Post-production, Styling/Props, Models, and Expenses. In an estimate I include only the ones that are relevant to the job. I just enter the number of hours or any third-party costs, and the sum is calculated automatically. This building block system makes it quick and easy to produce diverse estimates. I use the same template for my invoices, and just add a new title and sales tax. The tables can be individually edited if necessary.

This approach helps me keep an eye on all the costs involved in a particular job and ensures that I make the correct charges when the job is finished. It also helps me estimate how far I can tweak my numbers if a client asks for a discount. If you don't know what a job costs you, won't be able to correctly work out the consequences of a change in price. This flexibility at the estimate stage gives me a real competitive edge in today's hard-fought market, and it has helped me win a lot of contracts, even if they involved slightly reduced margins.

My estimate and invoice sheets are modular and are made up of individual tables.

The invoice on the left is for a simple job that involved just photography and a little post-production.

The one on the right is more complex; it contains tables for photography, pre-production, models, post-production, and expenses. The final table contains the sum of all the others.

This layout gives the client a clear overview of the individual elements of the job as well as the job total.

I am using my original Swiss invoices here as an example but I am sure you will get the idea.

The Creative Side of Photography

It is generally believed that creativity is a random process and that creative acts simply happen out of the blue. This idea is, in my opinion, a dream that has nothing to do with reality. Like any other type of work, being creative involves effort—first and foremost of the mental variety.

Ideas and Concepts

The creative process takes place in three distinct phases. First comes research, followed by consolidation and classification of the resulting material, and finally the creation of a coherent and functional working concept.

Research is the foundation of every visual concept. It brings all the information relevant to a job together without making any value judgments. Research is directly comparable to the foundation of a house in that it provides a stable base for high-quality work but remains invisible in the finished product. It is the cornerstone on which a creative idea can be built. Research also involves deciding what to leave out of a project.

The second phase involves sifting through the information collected during the research stage and reducing it to an essential core on which the concept can be built.

The final phase, then, involves using the concentrated information you have collected to develop a message and the images that will convey it. This phase requires imagination and inventiveness, and it is important not to limit yourself by considering the costs or practicality of your initial ideas. Sketches help reduce three-dimensional ideas to two-dimensional images and give shape to your ideas.

Because there are so many creative ideas around, it is important to use them sparingly. Ideas that don't serve the overall concept of a shoot should simply be left out. Photography is a language, and the more precisely it is spoken, the easier it is to understand.

Originality and expressiveness are the two major qualities that the final concept should posses, and it is only after you have decided on the idea you want to implement that you need to consider costs, timing, and the feasibility of your ideas. The result should be the best possible compromise between creativity and viability.

Work of any kind produces waste, so don't be surprised if the creative process produces a lot of ideas that end up in the trash. Filtering ideas to find the best ones is the only way to achieve great results. One good idea makes up for a whole bunch of bad ones.

Concepts for image sequences often come into being in a similar way, and it is relatively easy to develop an idea for a single image into a series after you have found a defining theme. Research for an image sequence involves looking for and capturing similarities, both in the content and the composition of the images. When you have settled on the elements you want to include in every image of a sequence, it is important to not change them if you want your sequence to look consistent.

Of course, the compositional elements you use in a sequence must suit the job at hand. Try to avoid spreading your ideas too thickly—too many spices cancel one another out. True masters of their craft know when to leave out an irrelevant detail to avoid overloading an image.

Visual Language

The visual language in an image often provides important visual signals to the viewer, similar to the way a person's clothing or a company's corporate image conveys a message. When I am shooting photos for company reports I feel like a commissioned tailor on the lookout for the right clothing for the client. I always try to get to know the client as well as possible and to create a unique and unmistakable suit that the client feels good about wearing.

If this approach succeeds, it usually provides me with the basis for a long-term client relationship. A company report is like a visiting card that illustrates the spirit and the substance of a company, and the value of an effectively laid out company report is often underestimated. Banks and other investors study company reports carefully every year, and the visual appearance is an important factor in the world of corporate relations. One of my industrial clients received a new ranking of 5 instead of 47 due to the new, convincing look of the company report. This kind of success is often the root of a productive, long-term relationship, and I was given total creative freedom by the advertising agency that was responsible for 12 annual reports.

A sample image from a series of 12 company reports that I illustrated for a large Swiss company. I tried to breathe new life into the obviously industrial products by taking them out of their normal environment and making them part of a new colorful world. The overall style is highly illustrative and involves a lot of collages. The photos were captured using an analog process, and I cross-processed the slides before printing them.

You can develop an effective visual language only if you get to know the client's ideas and requirements very well while still taking your own style of work into account. You need experience and a high degree of flexibility, but the rewards are meetings with interesting people and an entry ticket into new and fascinating worlds. As a studio photographer, I enjoy the variety offered by a location shoot. When I am shooting in a strange place I prefer to take the situation as it comes rather than trying to recreate a studio-like atmosphere on location—an approach that often helps to keep a shoot lively and authentic.

One of my best clients is a group of banks and financial advisors from Liechtenstein. I often shoot people-based situations for them that include employees of the company. I generally have plenty of time to plan and prepare these shoots, and I often end up using my Nikon D3 as well as my Hasselblad and a compact BX 250 Ri flash unit from Elinchrom.

The aim of this particular session was to portray the people involved in the course of their work. The rooms we used were perfect for the purpose, and I included a fair amount of the architecture in the photos. I used subtly colored lighting to enhance the mood of the shots while keeping the overall look natural. I used flash only as a fill light, often bounced off the walls. I directed the participants very little and, after I had brought them into position, I simply let them act naturally.

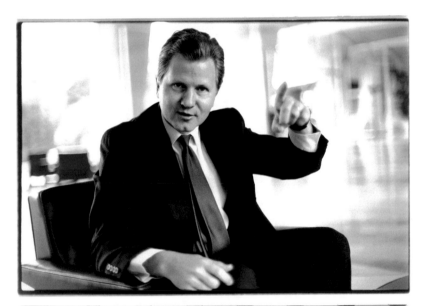

Four images shot for the commercial arm of a Belgian pharmaceutical company. I was allowed to take only one camera and one lens through the various air locks that led to the genetic engineering lab, so on the spur of the moment I had to adjust my shooting plan. I decided to use my Nikon F4 and a 50mm f/2 lens, which enabled me to keep distracting background details blurred while focusing on the more important elements in each scene. I pushed the Ektachrome slide film I used to ISO 1600 so I could use just the available light and simultaneously create the unusual grainy colors in the images.

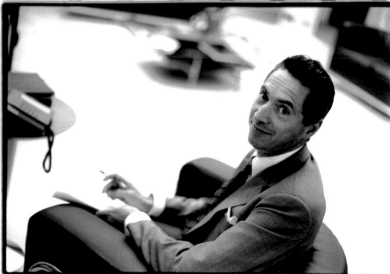

Two of a series of eight portraits taken for the Swiss stock exchange supervisory committee. This job involved photographing a number of important people from the European financial world.

In fact, the job ended up being more difficult than photographing Hollywood film stars! Some of my models had less than 10 minutes to spare and were not especially cooperative. I wasn't allowed to choose the location or survey the locations that were selected for me, so I simply had to make the best of the situation as it was. In the end I decided to use what I call the paparazzi method of shooting. I moved around quickly among my subjects, snapping away with my Nikon and a 50mm f/1.2 lens, trying the whole time to attract each person's attention at the right moment. I used Tri-X Pan rated at ISO 800 and printed the results to include the edges of the negatives.

Client Contact

It is essential to maintain contact with your clients and the market in general. A little advance knowledge and some initiative make this a simpler job than you might think.

Working with Advertising Agencies

I am often asked by up-and-coming photographers whether I stick faithfully to the ideas and layouts suggested by the agencies I work with, or if I allow myself the freedom to include my own ideas in a shoot.

Working with an agency involves teamwork, although the roles within the team are clearly defined by the agency. Sometimes a photographer will be asked to join the team because the message the client wants to communicate requires a particular image style. In such cases, the photographer can play a more active role, although the client will usually have agreed in advance to a visual direction suggested by the agency's art director. If this is the case, you will need to be sensitive enough to fulfill these demands without turning the job into a one-person show. The way this type of job works is comparable to an orchestra. The art director takes the role of the conductor, and the photographer is one of the soloists. It is essential that everyone involved know their part if the orchestra is to sound good on that day.

I believe that every good photographer has an unmistakable signature style that can be just as effective in a supporting role as in a starring role. I have learned a lot from various art directors over the years, and I have definitely developed my own visual language with their help. I like to work in a team, and the only negative experiences I have had when working with agencies have been when a member of the team skimped on the preparatory work. That brings us neatly back to the subject of visual concepts—in cases where things went wrong, the agency was responsible for the first, second, and sometimes even the third phase of the creative process. However, when a team works well together, it is capable of producing much better results than each of its individual members. Don't underestimate the effort involved in developing your own concepts and visual ideas.

I have always tried to strike a good balance between agency work, direct client contact, and editorial jobs, and this way I get to use all of my abilities in equal measures.

Putting a Portfolio Together

However you present your portfolio, make sure that you value your own work highly if you want your client to do so, too.

Nowadays, physical portfolios are becoming something of a rarity. In recent times, I have found myself presenting my work mostly on the Internet, via e-mail, or on my iPad. For many years, heavy leather-bound 11x13.4 in portfolios were the standard presentation tool for most photographers. Today, most of us e-mail PDF presentations, with contents that suit the job in question, to the client in advance of a meeting. Many agencies expect you to produce a suitable portfolio within hours of receiving a request so they can suggest a suitable photographer to the client. A website illustrated with current work is also a standard part of a contemporary photographer's marketing material.

It is only later that I actually get to meet the client and present prints of my work. Portfolio prints should be large and of the best possible quality. Modesty is a virtue, but it is simply not required at this stage. You have to convince the client that you are the best person for the job

and that you can deliver appropriately high-quality results. You should display confidence without appearing arrogant when meeting a client.

A portfolio should consist of a large amount of personal and/or artistic work, but don't forget to include some of your best published images. You can keep the commercial part relatively short because you can be sure that the client already knows your work. If you are not sure which approach to take, it is best to leave out your commercial work altogether and let your best artistic images speak for themselves. Using large-format portfolio shots makes an impression, but remember that your portfolio has to be portable, even in bad weather. Oversized portfolios can be a hindrance if they have to be sent to agency offices by courier. You can assume that agents work with portfolios from a number of photographers and are not interested in employing Sherpas to help them do their job! The 11x13.4 in standard has established itself as a good compromise between size and portability. Remember, too, that you will have to keep your portfolio current. There is simply no way around it—you have to have a top-quality portfolio if you want to get top-quality jobs.

An alternative to a traditional portfolio is a custom printed photo book. These are available with high-quality bindings in a range of standard and custom sizes, and they can even be produced as part of a color-managed work flow to ensure that the prints contain authentic colors. Photo books look highly professional and are often cheaper to produce than a traditional portfolio. The only real drawback is that they cannot be updated after printing. The latest alternative approach to portfolio building is the iPad. An iPad is small enough to carry with. you at all times, but it delivers sufficient image quality for client presentations.

This 11x13.4 in portfolio is from House of Portfolios in New York, available with a leather or waxskin cover and custom-embossed name stamp. This portfolio is practical but exudes quality. It is expandable to fit the needs of the current job.

Printed photo books are a great alternative to traditional portfolios and are available in a huge range of formats and finishes. Make sure the provider you choose supports a color-managed print work flow and offers high-quality paper and cover options.

Clamshell boxes are a popular presentation tool. They contain individual prints mounted in custom mats. The slightly cumbersome handling makes this type of portfolio more appropriate for presenting in an artistic environment.

The iPad is a fantastic portable presentation tool but, due to its size, it is suitable only for use in small groups of up to three people. There are many dedicated portfolio apps available.

An iPad can turn an accidental meeting with a potential client into a spontaneous presentation. Its digital nature also means that I always have a wide range of sample images with me that I can use to illustrate work that covers a broad variety of themes. However, due to its comparatively small size, the iPad is only really useful for small meetings, not for large-scale presentations

Creating a Web Presence

The Internet has been an important part of most marketing strategies for a number of years now, and nowadays it is indispensable. A photographer who wants to work has to be visible on the Internet. Mailing advertising cards or brochures, or organizing e-mail campaigns, involves a lot of effort and is inefficient. Not only that, but the age of the attention span appears to be well and truly over; if you don't catch exactly the right moment, all your efforts will be wasted. It is hard enough to recall all the things that happen in the course of a single day, and the web has become a kind of simultaneous reference book and search engine for everything that moves or interests us. The Internet is the single most important advertising platform on which we need to be not only present, but also visible! There are various criteria that your web presence needs to fulfill in order to make it productive and to put you in touch with new clients.

Speed is of the essence in today's web-based world. Your website needs to be clear and uncluttered. Small amounts of text allow your website to be indexed and make it visible to search engines.

The following is a summary of what you need to look out for when building a website:
→ Google searches for text. Text is an important element, especially on your home page.
→ The reason you want to be found should be visible in writing on the main page!
→ Header keywords are not particularly useful because Google searches the entire text.
→ Don't use an introductory video because most people simply click past them.
→ Don't use Flash; stick to HTML.
→ Keep the look and navigation simple, and don't use music.
→ Keep the information clear and concise, including your contact details, which should be included on the main page.
→ Include a downloadable PDF portfolio with your contact information. Keep the PDF small with images no larger than 100 dpi. Don't use watermarks.
→ Keep the main focus of your work clear—less is more!
→ Consider the type of contracts you want to win and how to underscore your personal strengths.
→ Include a personal portfolio with a maximum of 20 images. The first three are the most important. Most people look at 5 or 10 images at the most.
→ Don't use private or vacation photos.
→ Keep your website current; update it at least every three months.
→ Make sure your contact information can be copied so potential clients can get in touch with you easily.
→ Include a concise resume that lists only information that is of interest to potential clients.
→ If necessary, include a short mission statement.
→ Include a link to your Facebook page if you have one. This can help keep client contact regular and remind the market of what you are up to.

Location and Market Orientation

If the mountain won't come to you, you must go to the mountain.

An ideal location for your business is as close as possible to your clients. In rural areas, your clients are more likely to be small and medium-sized companies, whereas in industrialized areas you are more likely to be near large corporations, so you will need to adapt your approach accordingly. Your choice of location will also depend on how far you are prepared to travel to work, and remember: a studio in town is sure to cost more than a comparably equipped one outside the local urban center.

The demands of the market are one important factor; your own talents and aptitudes are the other factor that will influence the type of work you end up doing. What are your favorite types of subject, and what do you shoot best? What talents do you have, and what successes have you already chalked up? How do you see yourself developing, and where do you see potential in your part of the market? It is essential to have a realistic idea of your own abilities and to draw appropriate conclusions when deciding how to approach your work. As demonstrated in the following diagram, a thorough analysis of two areas—The Market and Me—will reveal the true opportunities that are available to you.

But you are not alone. The market is full of competitors, and if you don't offer something unique in a market segment that is already covered by someone else, it will be extremely hard to win new clients—unless you make low prices your unique selling point. It is, of course, preferable to offer an individual service that is different from any others on the market. These considerations add The Competition circle to the diagram. Although you should be on the lookout for the greatest possible intersection between yourself and your market, you should make sure that you produce as little intersection as possible between your work and that of your competitors. It is not easy to find the optimum solution, but it is essential to keep these factors in mind if you want your business to succeed.

A unique service that the market demands and that you love to provide is the key to success!

Product Photography

Mastering the interplay between materials and dimensions, form and perspective requires a high degree of craftsmanship and provides raw material that can fill a photographer's entire life.

How to Take Perfect Product Shots

It's true that you have to be something of a materialist to have fun doing product photography, but then who ever said that pure craftsmanship can't be fun? I consider this particular genre to be one of the key photographic disciplines. You have to be in control of perspective, lighting, and camera movements, as well as the form and color in your composition, if you want to achieve first-class results.

Let's start by taking a look at perspective. Using the tips and examples from earlier in this book, you should be able to select the right viewpoint for your subject without too much trouble.

Authentic reproduction is always the main priority. You should choose your perspective to produce an image that keeps a product natural looking, and the camera's point of view shouldn't distract the viewer from the object itself. As already mentioned, it is important to account for the angle of view for the finished, published image when composing a shot.

What this means is that longer lenses are generally preferable in the context of product photography because they don't emphasize perspective and thus give an image a natural look. Even when you are photographing multiple objects, longer lenses tend to keep the relative sizes of objects looking acceptably consistent.

Lighting

The lighting in a product photo should be designed to produce an image that gives a clear impression of the subject's form and material nature. The three-dimensional nature of an object is best emphasized using the interplay between light and shade, both in the subject itself and in the background. A three-dimensional look can be produced using lateral, frontal, or back light.

In order to clearly indicate the nature of the material an object is made of, we need to use a whole range of special tricks and techniques. For example, glass requires light that emphasizes its transparency, while chrome or steel needs to shine, and wool has to look soft and inviting. These three examples demonstrate just how broad the choice of lighting styles can be. The spectrum ranges from direct, hard ring flash and spot light to broad, diffused light from a reflector. Product photography as a genre is too diverse to set out rules governing the best light to use. It is this variety that makes product photography so demanding and varied, and breaking the basic rules of the game can be a productive alternative in some situations. However, the following sections use typical everyday situations to illustrate the basics of product lighting.

The Camera

Product photography is definitely a view camera domain. The need to enhance depth-of-field effects using the Scheimpflug principle or make perspective corrections using camera movements demand the use of a view camera or tilt/shift lenses. A view camera offers a greater range of movements and lenses with image circles that are large enough to accommodate them. Tilt/shift lenses have larger image circles than their fixed counterparts, but they are at best a compromise when compared to the flexibility offered by a view camera system.

If you shoot images with sufficient resolution, you can correct perspective errors later at the image processing stage—an alternative that, in my opinion, receives unnecessarily bad press. Correcting perspective digitally involves reinterpolating the image data—a process that reduces the overall image quality. However, mild adjustments made to high-resolution image data won't be visible in the finished image. Camera movements themselves produce image anomalies too, especially when working with low modulation transfer function (MTF) values at the very edges of the image circle. And remember, digital image sensors cannot perfectly capture and process light rays that hit them at an angle. These factors make digital perspective correction a usable alternative to camera movements.

Product photography presents many manual and technical challenges. You never stop learning, and you can always improve your skills!

Insufficient depth of field is a different matter. Objects that have great inherent depth cannot always be photographed completely in focus just by stopping down the aperture, especially if the plane of focus is perpendicular to the camera's direction of view or in closeup situations. We cannot solve this problem optically without moving the lens plane so that it more closely matches the camera's direction of view. The only other solution is to shoot a sequence of images focused at different depths throughout the subject and merge them into a single image with enhanced depth of field using focus stacking software, such as the excellent Helicon Focus, which even accounts for changing reproduction ratios caused by changes in focus when merging images. To create a successful focus-stacked image, make sure that at least one of your source images covers every single detail that you want to display in focus. This approach can be complex and time consuming, but it is the only available solution for creating full depth-of-field images in macro situations where lens movements cannot compensate for the inherently shallow depth of field. This technique can, of course, be used only for static subjects because both the camera and the subject have to remain perfectly still during shooting.

Origami

I photographed these folded paper artworks for a high-tech company that wanted to depict its diligence and ability to solve complex problems.

I had to handle these delicate paper objects very carefully to avoid bending or creasing them. They were created by a US artist who sent them to us via courier—it was a miracle that they arrived safely! I photographed each (10-inch) object individually against a white background. I typically use white FOBA TT Plast for this type of job because it has no texture of its own and has a matte white surface. The objects were suspended with white translucent thread and floated just above the background. During RAW processing, I adjusted the white point to emphasize the primary colors against the bright white background. I selected the objects using a narrow radius and selected the shadows using a softer 40-pixel radius before inserting them into the final composition. I inserted the shadows on a separate layer so I could add some slight grain. This made them look more natural and prevented banding artifacts at the transitions between the colors and the background.

Technical Data

Camera:	Sinar p2 Format: Sinarback 54H, 22 megapixels
Lens:	Rodenstock 300mm Sironar-N
Exposure:	f/22, 1/30 second
Lighting:	1 Fresnel spot
	1 octa softbox
	1 lamp with a honeycomb filter
Background:	White FOBA TT Plast
Comments:	Individual objects selected and combined in a photomontage with individual shadow layers

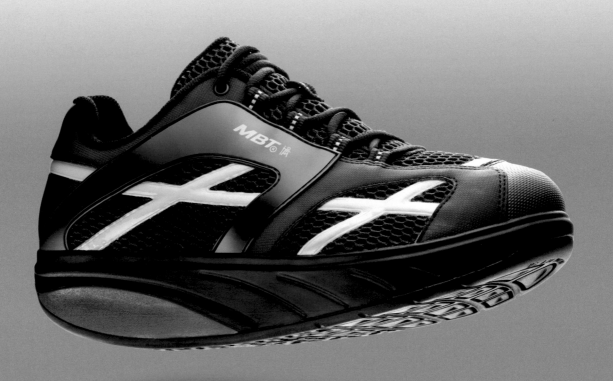

MBT Shoe

Shoes are inherently unspectacular and are tricky to photo-
graph in a way that makes them look good. Imperfections
resulting from the manufacturing process have to be re-
touched during post-processing.

MBT shoes have a special rounded sole with a prominent inlay made of a soft red material.
They are designed to activate your leg muscles even if you are standing still. I selected
a low camera angle and decided to shoot the shoe suspended in midair to give the sole
and its inlay a prominent position in the composition. For the shot itself, I placed the shoe
on a Plexiglas cylinder that raised the subject about 7 cm (2.8 in) above the white back-
ground. Later, the cylinder was removed digitally. I also used a FOBA articulated arm to
stabilize the shoe. This allowed me to vary the basic setup while photographing eight dif-
ferent shoes, each in three separate positions. I used lighting that emphasized the shoe's
unusual shape. This included an additional narrow silver reflector to reflect the top light
onto the sole. The white background produced reflections of its own that underscored the
patterns in the tread. I added the gray/white background gradient (part of the company's
corporate identity) later during post-processing. I had to retouch a lot of details to get the
shoe looking the way it does in the image reproduced here. Good retouching should be
invisible in a finished image, and getting a feel for different materials and how to perfect
them digitally requires experience. Always retouch to enhance the look of a detail rather
than just painting over it.

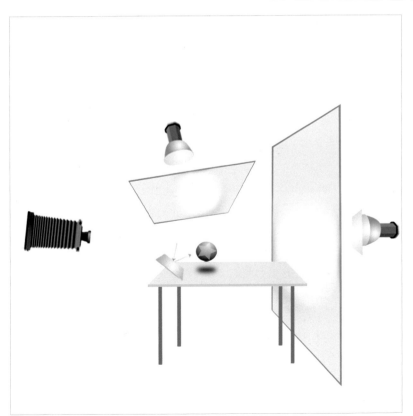

Technical Data

Camera:	Sinar p2
Format:	Sinarback 54H, 22 megapixels
Lens:	Rodenstock 240mm Sironar-N
Exposure:	f/22, 1/30 second
Lighting:	2 lamps
Background:	White FOBA TT Plast
	2x4 m (6.6x13.1 ft) fabric diffuser
	(softbox material)
Comments:	Background gradient added
	later

The setup I used for this and the other shoe shots was basically the same and required only some adjustments to the silver reflectors from shot to shot.

This photo shows the shoe from a frontal point of view. You can see the large diffuser panel with the background light at the back and the smaller (80x120 cm/31.5x47.2 in) diffuser above the stage, also lit from behind. My Sinar p2 with its Sinarback 54H and my laptop with the Sinar CaptureShop software can be seen in the foreground.

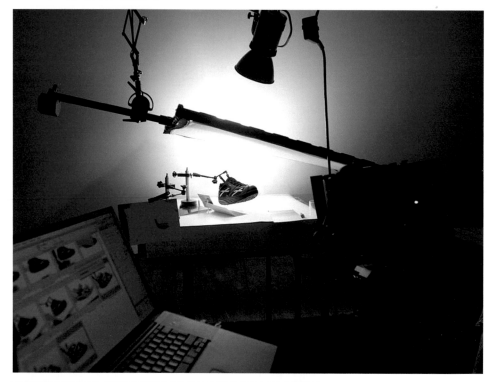

I used a Plexiglas cylinder and a FOBA articulated arm to get the shoe to float. The two silver reflectors below and to the left of the shoe reflect the main light to illuminate the sole and the side of the shoe.

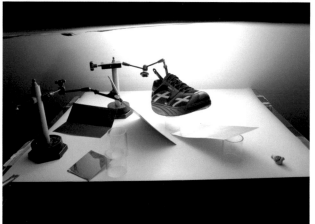

This closeup shows the effect the reflectors have on the composition. The shade behind the heel keeps this part of the shoe darker. The articulated arm and the Plexiglas support don't impinge on the shoe and disappear completely when the shoe is selected digitally.

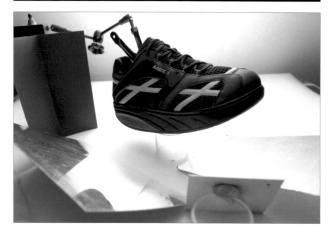

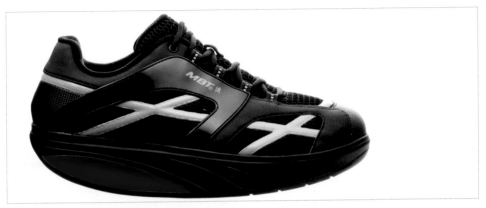

The selected base shot. Flaws in the shoe become visible only in the 100 percent view, although the specks in the plastic strip with the MBT logo are clearly visible even at this low magnification.

The specks in the plastic strip were very obvious due to its shiny nature, and the contrast between the shiny and matte parts was too abrupt. I used a mask and the Airbrush tool to remove the specks, and I added a gradient to equalize the dark/light contrast. I also harmonized the dimples below the logo using a gradient and added a small highlight reflection just above the sole.

I copied intact parts of the netting to cover up the parts that showed flaws. I also cleaned up the edges of the netting to differentiate it clearly from its surroundings. There are other small flaws visible at this magnification, but I discussed what to change and what to leave unaltered with the client. It is important to not perform any retouching steps that go beyond the requirements of the job.

I selected the grooves in the sole using paths and gave them extra emphasis by increasing the contrast between the light and dark areas. The sole is a very important part of this high-tech shoe, and its characteristics had to be clearly defined in the final image.

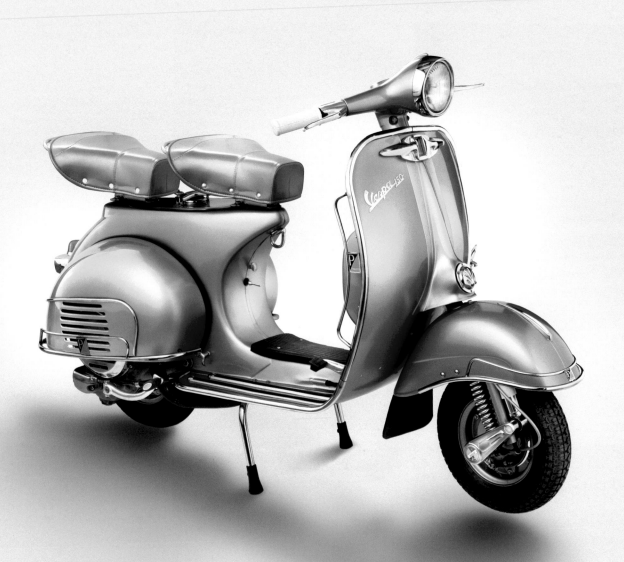

Vespa Oldtimer

Restored Vespas from the 1960s are a hot trend. With a friend, I built a configurator for his website that customers can use to display all the available color combinations.

Technical Data

Camera:	Sinar p2
Format:	Sinarback 54H, 22 megapixels
Lens:	150mm Sironar-N
Exposure:	f/22, 1/30 second
Lighting:	5 lamps
	1 softbox Background:
	White wood board
Comments:	Subject selected digitally, background added later

The shape of a Vespa is not easy to photograph. The shiny metallic paint and the huge number of curves in the bodywork reflected the entire studio, including the ceiling. When you are capturing a complex shiny object, you have to include the space around it, which then has to be appropriately arranged. In this case, that meant positioning lamps just about everywhere, including above the subject. A flexible ceiling reflector enabled me to target and modulate the overall light and the accents in the shot. I also used a number of additional lamps and vertical reflectors to the left, the right, and at the back to add highlights in important places. Each lamp was positioned individually to produce just the right effect. This is a great example of the Angle of Incidence = Angle of Reflection rule, which in this complex case ended up being like a game of 8-ball with lamps.

Post-processing involved making precise selections for the colored and chrome parts of the scooter using paths. This enabled us to use the same shot for all the different color variants. The shadow was photographed separately and was added in later, along with the background.

Shooting Steps

The Vespa reflected light in every direction, and the entire studio was reflected in its paint, making setting up the lighting extremely complex. I used a daylight studio when I did this job, which made things even more tricky. I ended up setting up walls and reflectors all over the place and using indirect, reflected light wherever possible. I used a large diffuser lit from behind and a softbox above the subject to light the saddle. The scooter was raised above the floor so I could illuminate the tires. I had positioned eight lamps by the time I was happy with the overall effect.

No, that isn't my assistant (child labor is illegal in Switzerland!). The little girl is the art director's daughter. She was fascinated by my view camera and, until we found something else for her to do, she spent a lot of time trying out its movements for herself.

I had to photograph the Vespa in various configurations. The chrome trim, various saddles, and spare tire were all captured using the same basic setup for use during post-processing. Because we wanted to produce images in a number of different colorways from shots of a single scooter, we chose one with a neutral base color. A black or white scooter would have been much more difficult to colorize later.

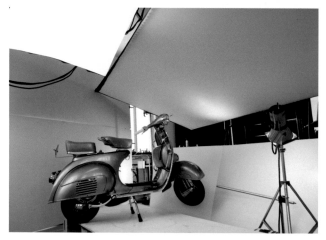

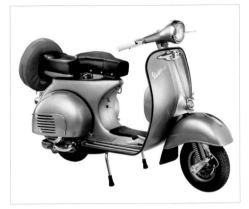

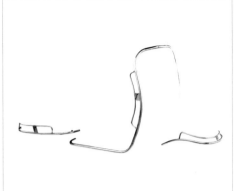

The post-processing for this job was more time consuming than the photography itself. After I had selected the scooter and performed some basic retouching, all of the vehicle's details had to be selected using paths. Each individual area of color also required its own precise, path-based selection. When we were done, we were able to use layers to piece together each separate colorway like a puzzle.

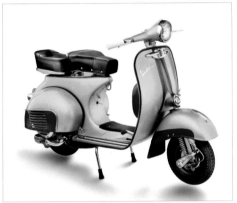

We also created a small number of two-color Vespas, which meant we had to select and isolate the parts of the bodywork that were to receive the second color. We were then able to color these on a separate layer.

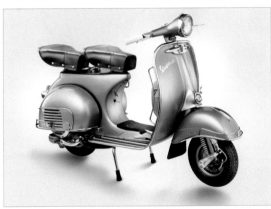

Finally, we selected a few of our favorite color schemes for printing as a postcard, which we then mounted on a new digital background. The illustration below left shows the 24 basic color schemes. For each of these, the customer can swap out the saddle, the chrome trim, and the spare tire with separate layers. A second color for parts of the bodywork can also be selected with layers. You can check out the resulting configurator at www.vespas. ch, where customers can put together their own dream Vespa.

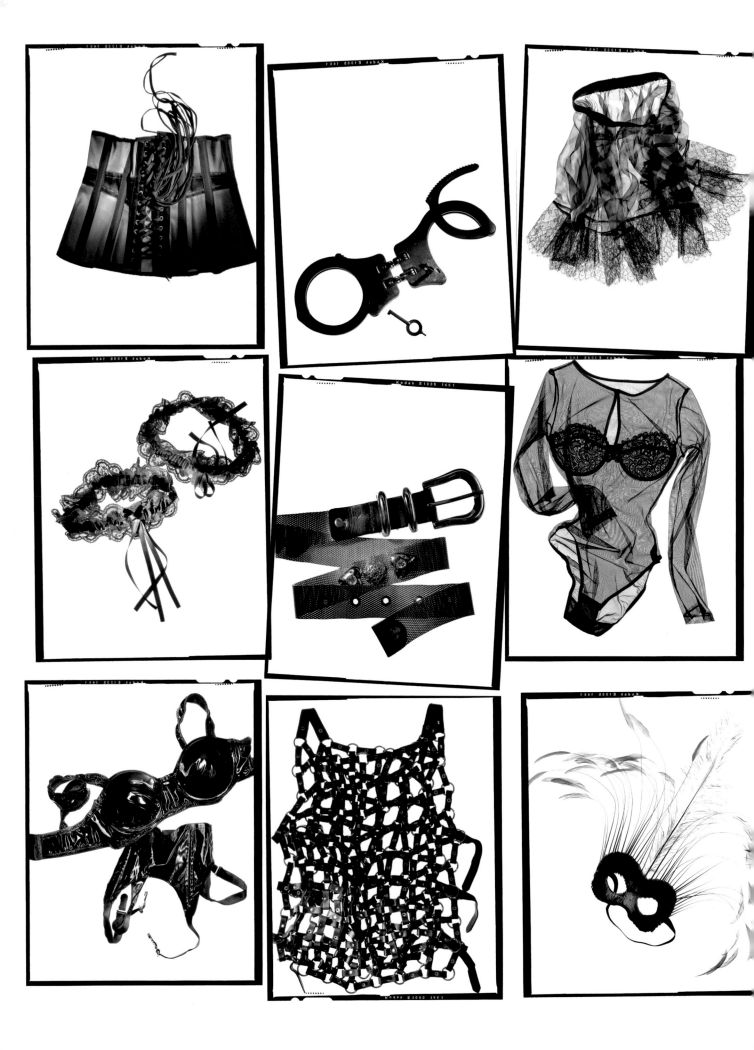

Lingerie

This series of erotic lingerie photos was commissioned as a background projection for a fashion show. The main emphasis in these photos is on the shapes and the white space surrounding each object.

I was fascinated by the different shapes and, particularly, by the transparency of these objects, which I tried hard to emphasize. The shapes looked best against a pure white background, so I placed the objects on a glass plate about 80 cm (31.5 in) above a sheet of white paper. I shaded the paper background with black cards to avoid stray light and to prevent the subject from being unintentionally lit by the background lamps. I used a lamp with a dense honeycomb filter to illuminate the details and accentuate their textures.

I framed the shots so I could include the edges of the negatives as part of the composition, so I had to be careful not to frame too tightly and cut off parts of the subject. In each of these shots, the white negative form of the areas surrounding the subject is just as important as the subject itself. The sum of the parts is a collection of exciting and interesting shapes.

I added the frame edges during post-processing. While I was processing this sequence, I noticed that the colors were distracting and that the images had a much more pronounced graphic effect in black-and-white, so I converted the files to monochrome as a final step.

Technical Data

Camera:	Sinar p2 Format: Sinarback 54H, 22 megapixels
Lens:	210mm Nikkor AM ED
Exposure:	f/16, 1/30 second
Lighting:	2 lamps with diffusers 1 lamp with a honeycomb filter
Background:	Plate glass White paper
Comments:	Scanned film frame edges were added later

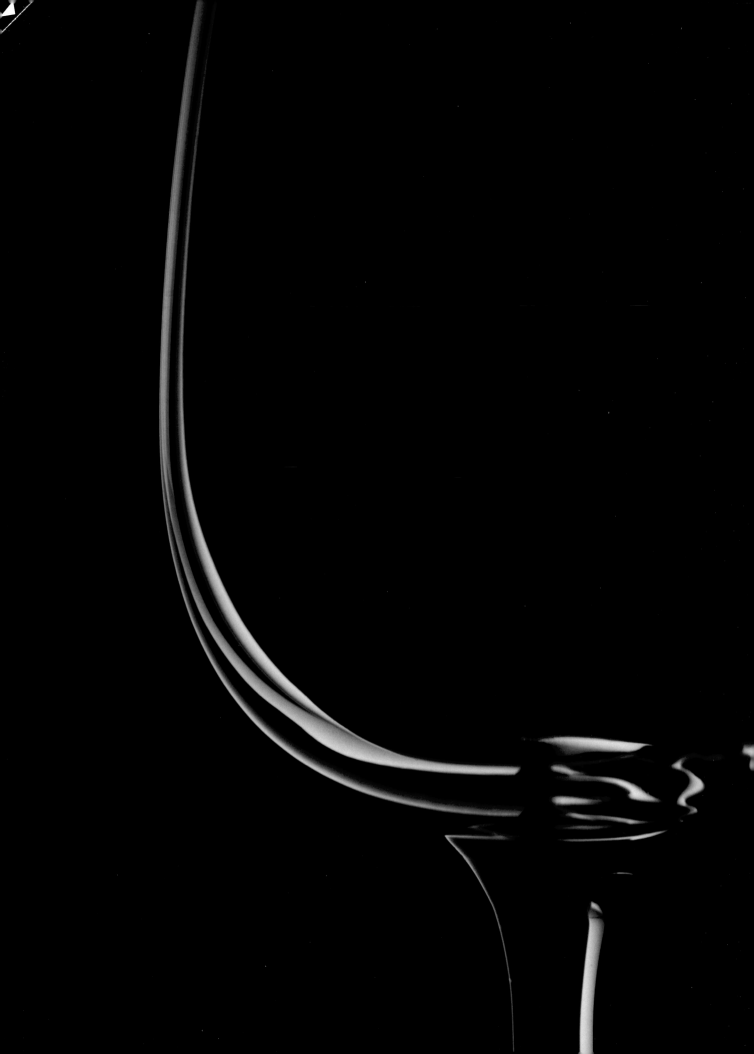

Wine Glass

Low-key photos attract a viewer's attention by holding details back. The trick with this type of shot is to use light sparingly to bring the essence of the subject to the fore.

Riedel wine glasses are known among wine connoisseurs for their wonderful shapes and extremely thin glass. They don't just look great, but wine tastes better when drunk from them, too. I found this Bordeaux glass particularly attractive and photographed it in an almost abstract way that highlighted its shape and the reflection on the surface of the glass. I used black velvet for the background and a single blue neon tube placed to the left about 70 cm (27.6 in) behind the glass for lighting. I placed the tube in line with the side wall and left it within the field of view to ensure that the reflection fell exactly on the edge of the glass—once again following the Angle of Incidence = Angle of Reflection rule.

Thanks to the adjustable blades in the Sinar Mask 2, I was able to conceal the neon tube in the finished image. I also used black shades to reduce the amount of stray light from the tube and keep the background completely black.

Technical Data

Camera:	Sinar p2
Format:	Sinarback 54H, 22 megapixels
Lens:	Rodenstock 480mm Apo-Ronar
Exposure:	f/45, 60 seconds
Lighting:	Blue neon tube, 1 m x 15 mm (3.3 ft x 0.6 in)
Background:	Black velvet
Comments:	Sinar bellows hood and Mask 2

Bordeaux Wine Bottle

"As simple as that!" I felt I had to include a perfectly photo-graphed wine bottle as an example of a subject that crops up time and again and to demonstrate some of the basic prin-ciples of photographing glass.

This bottle of up-market Sauternes wine is a good example of a bottle shot. The neutral color of the glass and the appealing tone of the wine make it all the easier to capture in an attractive fashion. A green bottle filled with red wine photographed this way would require much more light from behind to bring out the color in the liquid.

The setup was relatively simple. The bottle was placed on a tripod in front of a sheet of FOBA Trans-Lum. Tabletops are less appropriate for this kind of shot. Two lamps behind the sheeting produced the gradient within the transparent part of the bottle, and another narrow piece of opal sheeting lit from behind was used to produce the highlight on the front right-hand edge of the bottle and to illuminate the label.

The power of the front and rear lights was adjusted to create a pleasing balance between the degree of transparency and the solid form of the bottle. In cases like this, the rear light can gen-erally be dialed up a little stronger than the front accent light, but it shouldn't be bright enough to cause any overexposed highlights.

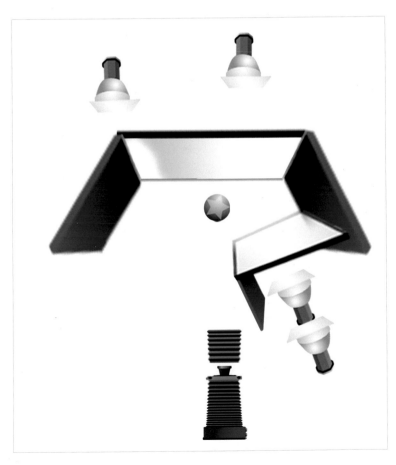

Technical Data

Camera:	Sinar p2
Format:	Sinarback 54H, 22 megapixels
Lens:	Rodenstock 480mm Apo-Ronar
Exposure:	f/32, 1/30 second
Lighting:	4 lamps
Background:	FOBA Trans-Lum frosted sheeting
Diffuser:	FOBA Trans-Lum frosted sheeting
Comments:	Camera positioned vertically with both standards shifted in parallel

Stainless Steel Stew Pot

"Help! Stainless steel!" I hear my colleagues cry. Shots like the one reproduced here are tricky to capture well, but once again our friendly formula Angle of Incidence = Angle of Reflection comes to the rescue and helps us position our reflections and accents accurately.

A stainless steel pot is like a mirror that reflects in all directions at once, so for this shot I had to transform the entire studio space surrounding the subject into a huge light tent. My idea was to convey the roundness of the pot and to give the cool metal some life by using alternating dark and bright highlights. The bright highlights look even brighter alongside the darker ones and give the metal a classy look.

To create these effects, I set up four diffusers around the subject and lit them at different strengths. I also set up a shade between two of the diffusers. I chose the camera position first and then set up the lights to accommodate it. After the other lights were positioned, I brought the ceiling reflector into place to give the lid a nice dark-to-light gradient. The only remaining black hole occurred where the camera was reflected in the lid, which I retouched by copying a highlight from the main body of the pot and inserting it in the appropriate place.

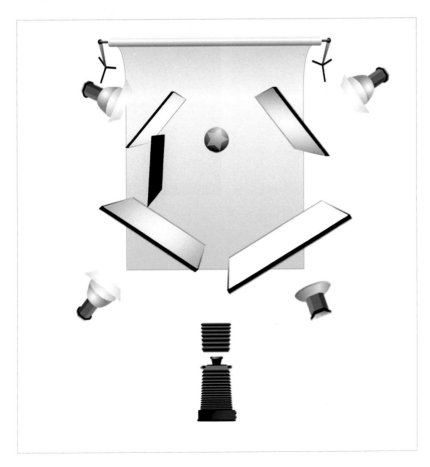

Technical Data

Camera:	Sinar p2
Format:	Sinarback 54H, 22 megapixels
Lens:	Rodenstock 480mm Apo-Ronar
Exposure:	f/32, 1/30 second
Lighting:	5 lamps
	3 with standard reflectors
	1 with a telephoto reflector
	1 with a wide-angle reflector
Background:	White paper
Comments:	Ceiling reflector (not illustrated) lit indirectly. Parallel vertical camera shift to prevent the vertical lines from converging.

The setup for this shot was huge compared to the size of the subject. I used white-painted Novilon sheeting for the backdrop and placed the pot on a cardboard roll to separate it from the floor and give me space to set up my lights without having to work around a tabletop. Four diffusers lit from behind with a range of reflectors formed an arena around the central subject. I used my ceiling reflector to light the lid of the pot indirectly. I then used black shades to clearly differentiate the highlights produced by the diffused lamps.

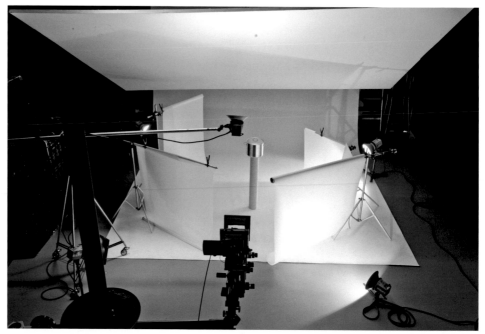

These two illustrations show the setup from the side and the camera, with its parallel vertical shift. This movement prevents the formation of converging vertical lines.

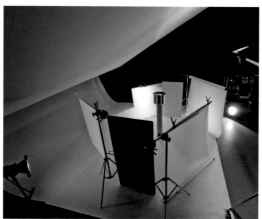
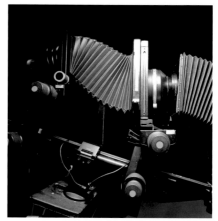

Here, you can clearly see how the light was distributed throughout the frame. I positioned all the diffusers at the angle of reflection so they were reflected directly in the pot's surface. The support was simple to retouch and, because its diameter is smaller than that of the pot, the reflections in the rounded lower edge were clean and required no further retouching.

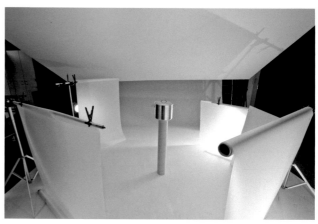

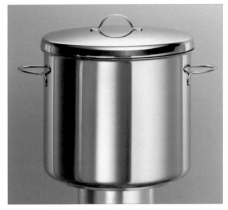

The original unretouched shot was already fairly clean. The bright and dark highlights are distributed in a way that suggests roundness. The first correction I made was to add a color balance adjustment layer that altered the overall look toward cyan to underscore the metallic nature of the subject.

I then outlined the pot using a path that I transformed into a selection. Paths can be used to create precise outlines of complex objects, and they are the tool of choice for this type of selection. Don't forget to select the insides of the handles, too!

After it was selected and separated from the background, the pot appeared slightly too dark. I counteracted this effect by brightening the midtones using a curves adjustment layer. I also strengthened the cyan tone in the color balance adjustment layer. To cover up the reflection of the camera in the lid of the pot, I drew a path on that portion of the lid and used it to copy a section from the front of the pot; then I used the Transform tool to fit the copied selection to the rounded edges of the lid. The final step involved cleaning up a few minor imperfections, such as the one you can see here on the bottom right just below the lid.

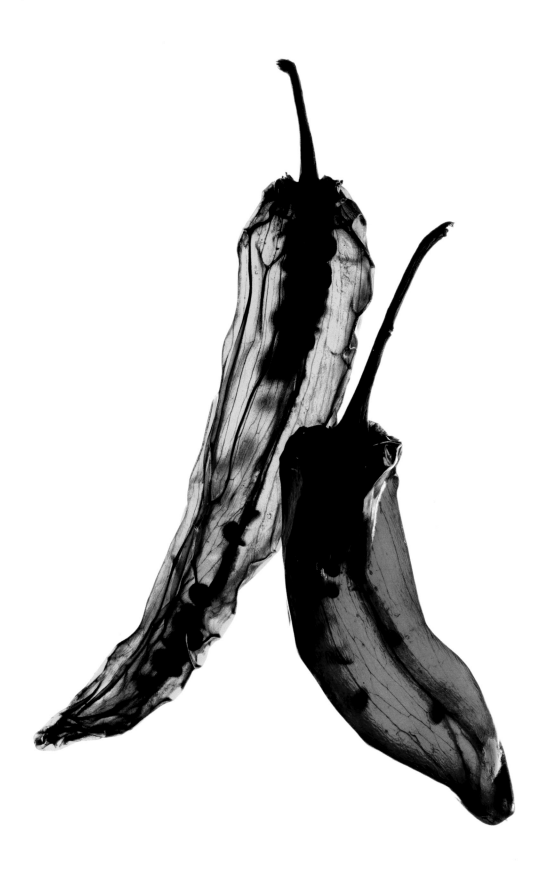

Two Hot Companions

Once again, I forgot to clean up the kitchen following a strenuous food job, and a bunch of chilies had turned transparent in the intervening days.

When lit from behind, the transparent skin revealed the insides of the chilies. Because they had been lying on a radiator, the chilies had also become shriveled, giving them a really interesting texture. I built an impromptu light table using frosted Plexiglas, like the kind used in FOBA light tables, and shone a single lamp through it from below. One lamp was sufficient to light this small setup evenly. In an open setup like this, the chances are relatively high that stray light will enter the lens, so I used shades to limit the field of light coming through the table. Too much stray light would have reduced the subject contrast, which would have spoiled the high-key effect of this particular shot. I used a macro lens with extremely good reproduction characteristics to highlight the very fine textures at closeup range. I applied the Lightroom C41 cross-process preset to give the images plenty of contrast and the rich colors that make them so pleasingly graphic.

Technical Data

Camera:	Sinar p2
Format:	Sinarback 54H, 22 megapixels
Lens:	210mm Nikkor AM ED
Exposure:	f/22, 1/30 second
RAW process:	C41 cross-process
Lighting:	1 lamp
Background:	Frosted white Plexiglas
Comments:	Additional shades were used

Product Photography

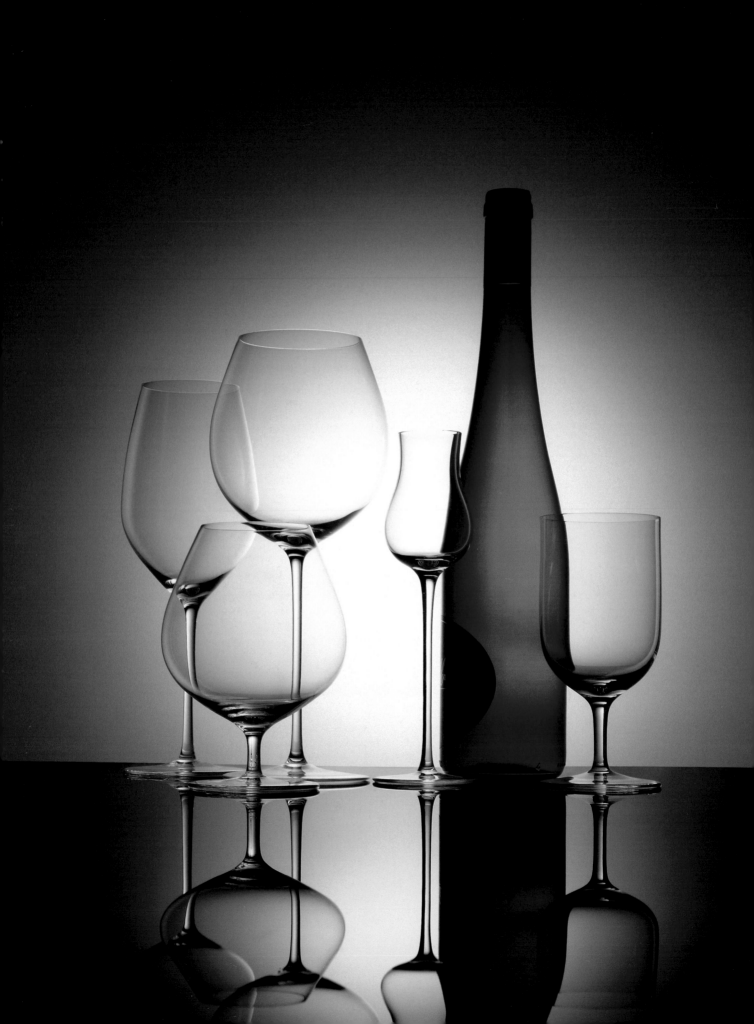

Bottle and Glasses

This shot is from a series produced for a point-of-sale poster. I wanted to capture the look of the transparent glasses on a shiny surface. The dark green bottle provides contrast to the fine tones present in the glasses.

Glasses are both transparent and reflective, and I wanted to accentuate both of these characteristics in this shot. The lighting setup was extremely simple, with just one diffused lamp positioned behind a layer of FOBA Trans-Lum sheeting. White Plexiglas would do just as well, but it is more difficult to hold in place. I used a sheet of black Plexiglas for the stage, which gave me a simple, direct reflection of the subject and contributed a darker tone to contrast with the bright highlights in the glasses.

I used a medium wide-angle lens and positioned the camera just above the level of the Plexiglas stage to create a one-point perspective with horizontal lines that converged toward the horizon. Applying parallel shift movements to the camera enabled me to move the edge of the stage toward the bottom of the frame and shift the main subject into the center of attention. The slight green-blue tone in the glasses was produced by affixing a colored filter to the lamp. Because drinking glasses reflect everything around them, shots like this are simpler to capture in a windowless, black-painted studio. Although it involves a fair amount of effort, you can, of course, use black gobos or curtains to darken a bright studio.

Technical Data

Camera:	Sinar p2
Format:	Sinarback 54H, 22 megapixels
Lens:	Rodenstock 90mm Grandagon
Exposure:	f/22, 1/30 second
Lighting:	1 diffused lamp with a colored filter
Background:	FOBA Trans-Lum white translucent sheeting
Surface:	Black Plexiglas
Comments:	Camera positioned just above table level with vertical shift to prevent converging vertical lines

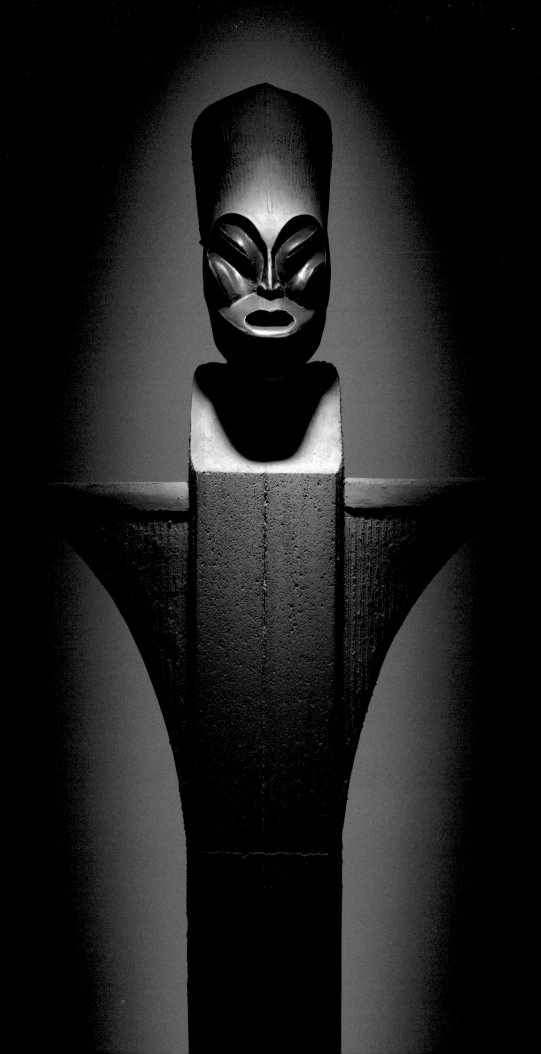

High Priestess

This impressive sculpture looks much more spectacular when lit theatrically than it does bathed in balanced light. This setup accentuates the subject's main characteristics but doesn't reveal all of its secrets.

Together with the artist, my assistant Urs Gisler and I tried all sorts of lighting setups for this shot and came to the conclusion that this theatrical approach was the best way to accentuate the form and character of the sculpture.

In this type of shot, it is essential to leave sufficient space between the subject and the background so you can adjust and fine-tune the strength and color of the light for both elements separately and selectively.

We gave the blue-green background a bright stripe to differentiate it from the subject, which we lit neutrally. By the way, colored filters attached to a lamp can be just as effective as colored backgrounds. We used a layer of mild Rosco diffuser sheeting to soften the hard light from our Fresnel spot and the main light, and to produce finer transitions in the background. We added slight grain to the background during post-production to prevent it from contrasting too highly with the raw texture of the sculpture's surface.

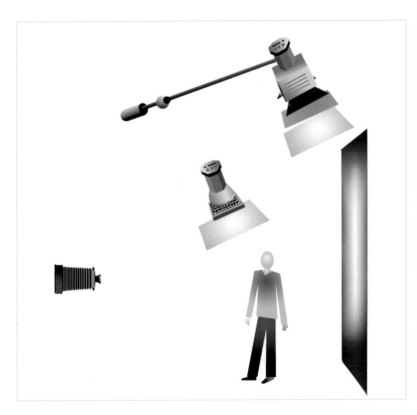

Technical Data

Camera:	Sinar p2
Format:	Sinarback 54H, 22 megapixels
Lens:	Rodenstock 300mm Sironar-N
Exposure:	f/22, 1/30 second
Lighting:	1 lamp with a medium honeycomb filter
	1 Fresnel spot with a colored filter
Background:	Gray paper roll
Comments:	Mild Rosco diffuser sheeting mounted in front of the Fresnel spot and the honeycomb filter

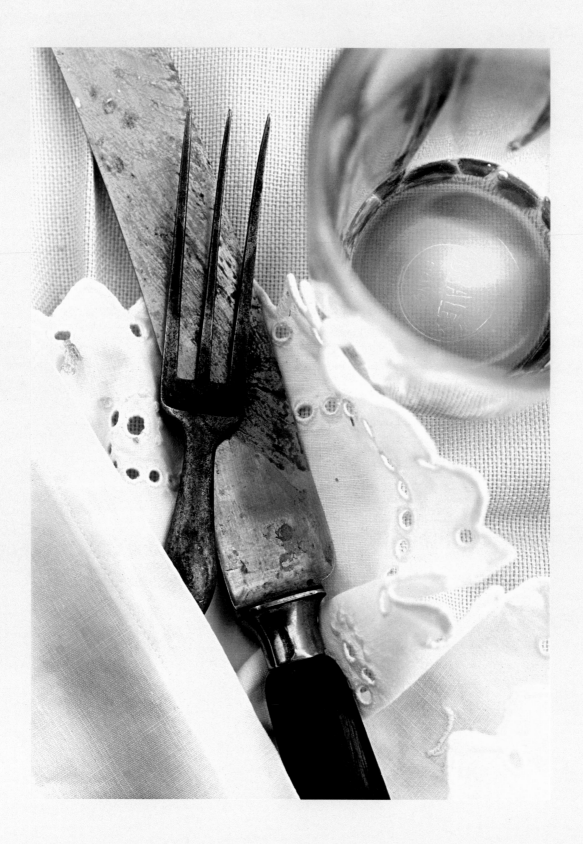

Still Life

Telling a story, evoking feelings, and communicating thoughts all in a single image—that is what still life photography is all about.

A Still Life Tells a Story

Still life photos are an extension of the product photography genre. Images of objects are enriched by embedding them in atmospheric surroundings and enhancing them with backgrounds and additional objects. Such photos go beyond pure representation and can evoke an entire story in a single image.

The art of producing a great still life involves provoking thought while giving viewers space to develop thoughts of their own. Shooting still lifes requires you to combine storytelling talent with artistic and compositional skills. The ability to perform this balancing act convincingly but in a unique way is the signature of a great still life photographer.

Rules of Composition

The composition of shapes and colors is the central element of any still life. Composition is a highly personal matter and ensures that every photographer has an unmistakable individual style.

I often use the golden ratio in my compositions. This simple rule automatically produces interesting, suspenseful compositions. However, diagonal compositions like the ones shown below are also a good basis for creating dynamic-looking images. I often begin a shoot with no particular pattern in mind and simply allow the image to compose itself. This approach frequently results in images that adhere to a recognizable compositional rule. I believe that the search for visual tension and harmony naturally produces pleasing compositions.

I used a diagonal composition for this series of Polaroids. Important visual elements in each image either follow or form the diagonal of the frame. This common element gives the sequence coherence. The images were taken with a Sinar 8x10 large-format camera and Type 804 Polaroid film.

Composing with Color

For every still life photographer, it is extremely useful to study color theory and to learn about the rules governing color contrast, although you still have to combine knowledge with experience and develop your own instinct for color harmony and contrast if you want to take great photos. I won't go into any theoretical detail here, because there is already a wealth of great literature on the subject available, but I will give you a few visual examples to whet your appetite.

A small but important point is that perfection is the archenemy of spontaneity, and still lifes that are composed with perfection in mind often end up looking stiff and unnatural. Just as in life itself, it is the little imperfections that give a still life verve and vitality. Dare to be imprecise!

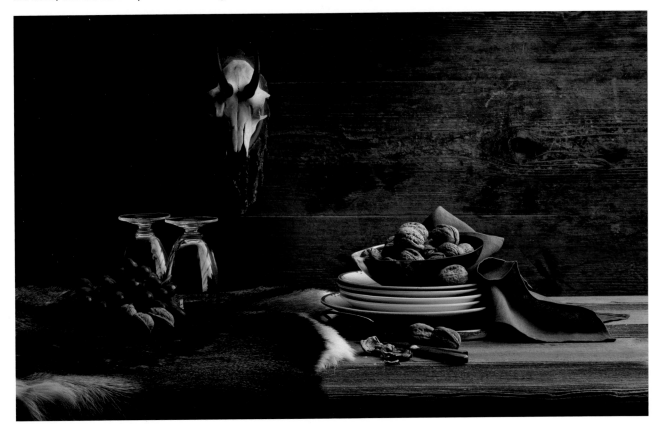

This double-page editorial spread was designed to evoke an autumnal Alpine hunting lodge atmosphere. I contrasted the various brown tones with the blue-tinted light of a fall day, the dark grapes, and the blue napkin. Remember to allow for the fold in the middle of the page when you compose double-page spreads! Shot with a Hasselblad H4D-50

Lighting Moods

While product photography concentrates on producing neutral images with authentic colors, the lighting in a still life is usually designed to add an atmosphere that kindles emotions and associations in the viewer. In fact, a neutral look can be detrimental to the effect of a still life. The right feel and lighting for a still life image no longer depends on the nature of the subject itself, but rather on the story we want the image to tell. We can select the tone of the light we use from the huge body of experience that we constantly feed in our daily observations of life around us. If mood-based lighting is to be effective, it has to have a strong effect on our collected memories—and it will if it is perceived as being plausible and authentic. Composing the light for a still life requires empathy. I always try to stick to reality when setting up my lights, because nothing detracts more from the effect of an image than lighting that looks perfect in the studio but doesn't exist in real life. Product shots often owe their effectiveness to perfect lighting and clean surroundings, whereas a still life lives and breathes through the mood of the lighting and the little imperfections that keep it looking real.

Still life with Lavazza coffee for an American Express Gold Card advertising campaign. This shot was designed to appear spontaneous in a documentary style, and it was intended to suggest that the card can be used anywhere, anytime. The gold tint suggests the gold color of the card. Shot using a Sinar p2 and cross-processed Fuji Velvia film. Even if it doesn't look like it, this photo is most definitely the result of a studio shoot!

Focus Effects

In contrast to the field of product photography, in which the subject is usually portrayed in sharp focus, still life is a genre that can benefit from the use of blur as a compositional tool. The implications of blurred detail can provoke new thoughts and emotions in the viewer. Once again, imprecision can serve as a springboard to authenticity better than a perfectly composed and focused reproduction of a subject.

Bunch of flowers with motion blur. This spontaneous shot was created by rotating the camera around its optical axis during the exposure. Shot with a Hasselblad, 80mm lens, and Vericolor NC film, 1/15 second at f/22

Lead Letters

Reminiscent of a skill that has all but died out, this still life was shot using an 8x10 Sinar on Type 804 Polaroid black-and-white film.

Whenever I find wonderful things like this set of lead printing letters at a flea market, my instinct is to immediately grab my camera. In this shot, soft, natural-looking light that could come from a nearby window seemed to produce the right sort of atmosphere. I placed frosted sheeting above the table and lit it from behind. The resulting backlight gave the letters plenty of sharp detail and contrast, which I brightened slightly with a Styrofoam reflector. I used vertical axial tilt to limit the depth of focus to an area close to the letters and blur the background, completely separating the subject from the background.

I decided to use Type 804 Polapan film because it has a tonal range that perfectly suits the subject. It's such a shame that this particular stock is no longer being manufactured. Nowadays, you can use RAW development software to simulate this and a whole range of other film and Polaroid-style looks.

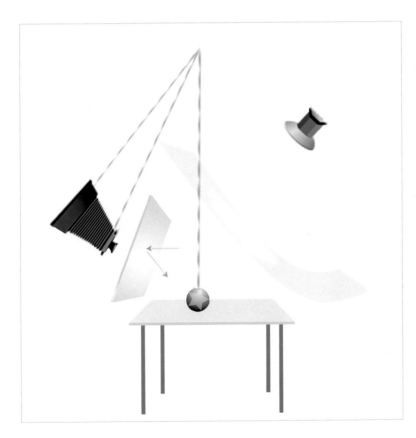

Technical Data

Camera:	Sinar p2
Format:	8x10 film
Lens:	Rodenstock 300mm Sironar-N
Exposure:	f/5.6, 1/30 second
Lighting:	1 lamp with a wide-angle reflector
	1 reflector panel
Background:	Sheet metal
Light tent:	FOBA Trans-Lum frosted sheeting
Comments:	Camera movements/Scheimpflug principle used to limit the plane of focus to include just the letters

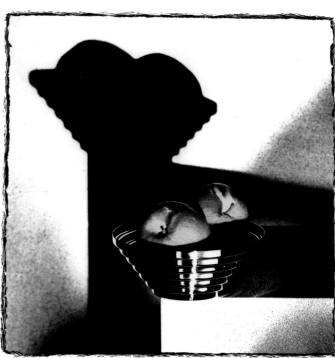
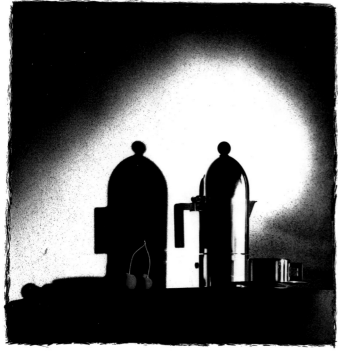

Alessi Tableware

Light and shade are the defining factors in this series of Alessi tableware product images. The use of infrared film was an unusual choice, as were the etched frames that I used. The colorized, blue-toned, black-and-white prints produce a surprising and unusual look.

I used a single Fresnel spot as my light source and positioned it differently for each shot. I shaped the hard light it produced with barn doors to produce zones of light and shade or a direct beam like the one in the image shown at bottom right. I lit the food elements directly to give them adequate definition and to make them easier to colorize later. The infrared monochrome film I used has no antihalo layer and thus disperses the incident light rays directly within the substrate, producing the halo effects in bright areas that are typical of this type of film. I gave the black-and-white images a blue tint and hand colored the food elements with translucent egg white glaze. This technique required some practice, but the fascinating results were worth the effort. I etched the frames into the edges of some black lith film using a graphic artist's knife, and I photographed them separately. Each print is a unique, lovingly created original.

Technical Data

Camera:	Sinar p2
Format:	4x5 film
Lens:	Rodenstock 240mm Sironar-N
Exposure:	f/22, 1/30 second
Lighting:	Fresnel spot with barn doors
Background:	Granite texture sprayed onto wood
Film:	Kodak monochrome infrared
Comments:	Hand-colored, blue-tinted monochrome prints

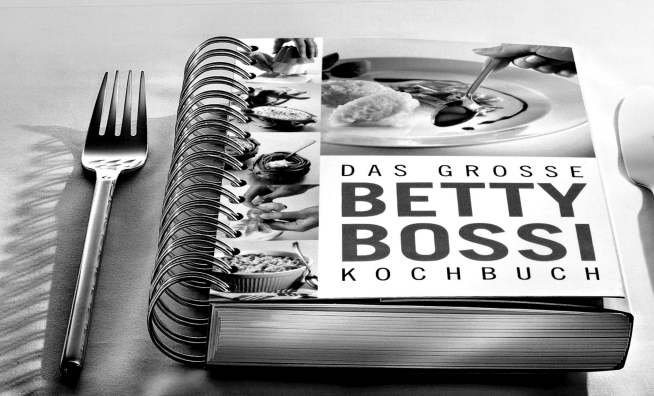

DAS GROSSE
BETTY
BOSSI
KOCHBUCH

Food for Thought

This admittedly somewhat dry-looking shot was used to advertise a big new basic cookbook. A simple, bold setup was order of the day, but the lighting nevertheless had to give the shot atmosphere.

A tablecloth with the same color as the plate shown on the book's cover provided the background, and the fold symbolized the edge of a table. The book and the cutlery finished the simple place setting.

The upper and lower portions of the image were to be left empty for adding text later, so the viewer's attention had to be focused entirely on the center of the frame. I lit the book using a spotlight aimed at a very low angle from back right. An additional lamp with a short reflector bounced off the ceiling produced a soft backlight, and another with a light blue filter created the slightly blue-tinted mood. I lit the vertical part of the fabric from the right to prevent it from looking too dark. This shot is a good example of how to turn a rudimentary scene into an event using just subtle light and shade effects and mildly two-toned lighting.

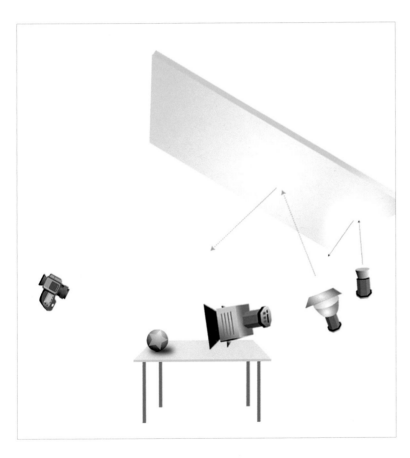

Technical Data

Camera:	Hasselblad H4D
Format:	50 megapixels
Lens:	Hasselblad 80mm HC
Exposure:	f/32, 1/30 second
Lighting:	1 bounced lamp with a short reflector
	1 bounced lamp with a wide-angle reflector and blue LEE 1/2 CTB filter
	1 Fresnel spot
Background:	Turquoise fabric
Comments:	Blur added at top and bottom of the frame during post-production

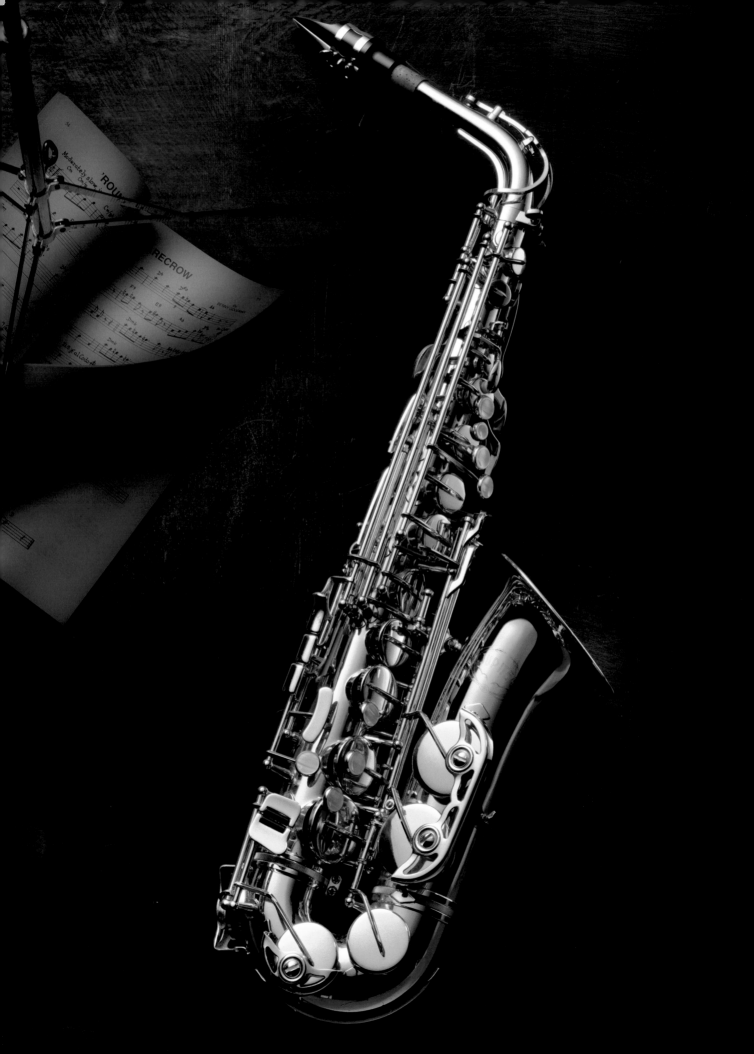

Alto Saxophone

Musical instruments like this alto sax—with its many delicate, shiny parts—make great photographic subjects. I gave this shot atmosphere by adding a music stand and a score, and I placed the entire scene on a blue-toned metal background to give it a jazzy feel.

My ceiling reflector is a great tool when it comes to lighting large shiny objects. Its large size means that it covers the angle of reflection for virtually all reflections produced by the subject, and I can create a pleasing gradient in exactly the right place using just one lamp. I used two small gold and white accent reflectors below and to the right to produce some extra gold-colored highlights in the upper part of the instrument and some white accents in the wonderful curves lower down. The instrument reflects itself, making it appear a deeper gold lower down, so I used two different colored reflectors to balance the overall color.

I darkened the entire studio as far as possible to prevent the surroundings from being reflected in the saxophone. I photographed the music stand and the score separately and added them later digitally.

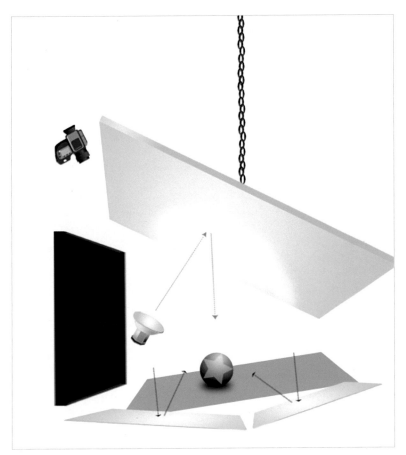

Technical Data

Camera:	Hasselblad H4D
Format:	50 megapixels
Lens:	Hasselblad 120mm HC Macro
Exposure:	f/32, 1/30 second
Lighting:	1 lamp with a wide-angle reflector
Background:	Metal sheet
Comments:	One gold accent from the right, and one white accent from below right, for the highlights on the instrument's right-hand side

Rendezvous

I created this shot for fun. I tried to imagine two lovers missing a date in Paris. For props, I chose an old edition of the *Le Monde* newspaper, a used coffee cup, a smoked cigarette, and a pocket watch.

It's not always easy to find the right props to tell a story. You need to feel your way into the scenario until you can almost smell the atmosphere you want to create. A still life has to evoke feelings in the viewer that make the scene seem real. This shot was set up to make the slightly lost feeling of a missed date, the stale smell of a smoked cigarette, and the nervousness caused by waiting in vain seem tangible.

Clean, clear light would have been exactly the wrong way to create this type of atmosphere, so I tried my hardest to make the mood seem hazy and sad. I used a mixture of yellow and brown-tinged light to symbolize the odor of missed opportunity. I used two lamps partially filtered with yellow and green, reflected from above, to produce the soft, indirect effect I was looking for.

I adjusted the plane of focus to lie at an angle to the image plane and to run from bottom left to top right. I processed the resulting RAW image with a bleach bypass filter effect to reduce the color saturation and increase the depth of the blacks. A little added grain enhanced the sad, lost feeling of the image.

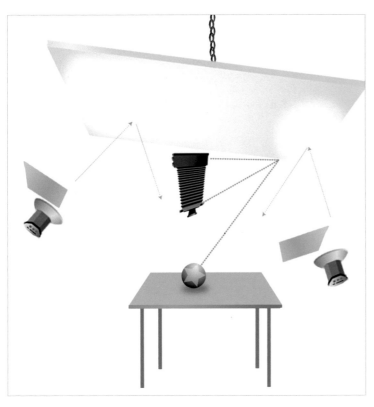

Technical Data

Camera:	Sinar p2
Format:	Sinarback 54H, 22 megapixels
Lens:	Rodenstock 240mm Sironar-N
Exposure:	f/5.6, 1/30 second
Lighting:	2 lamps with partial colored filters
Background:	Newspaper
Comments:	Processed in Lightroom with a bleach bypass effect and added grain

Romantic Living

We photographed a series of interiors for a paint manufacturer, with each scenario relating to a particular range of colors. This English country house look was perfect for the pastel shades, and we lit it with soft, natural-looking light.

A setup like this requires extremely precise planning if you want your large team of assistants, painters, carpenters, furniture movers, and stylists to work efficiently without any expensive off time in the studio. We worked in a huge studio that had sufficient space to set up three scenes simultaneously and store the furniture and props that were not currently in use. I had measured and drawn up each shot in advance, and my sketches were also used to order and purchase all the relevant building materials and props. The painters and carpenters worked from my sketches and set up the next set while we lit and photographed the previous one. The third (already photographed) set had to be approved by the client before we could break it down. This way, we were all busy all of the time and nobody had to wait around doing nothing. The sketch below was the one we used to set up the photo reproduced on the previous page.

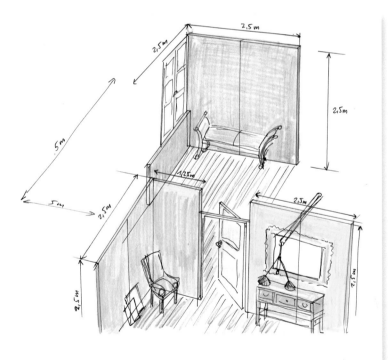

Technical Data

Camera:	Sinar p2
Format:	Sinarback 54H, 22 megapixel
Lens:	Rodenstock 150mm Sironar-N
Exposure:	f/32, 1/30 second
Lighting:	Fresnel spot with barn doors 5 indirect lamps with wide-angle reflectors, 2 of which were bounced off the ceiling
Comments:	Artificial light component produced by a pendant lamp

Farben:

farn ca. 10 qm
biskuit ca. 5 qm
feige ca. 10 qm

Boden:

Dielenboden geweisst 25 qm

Maltechnik:

Wände in pastellig, luftiger Technik
White Wash mit Lebensspuren

Beleuchtung und Athmosphäre:

Helles Tageslicht eines Sommertages

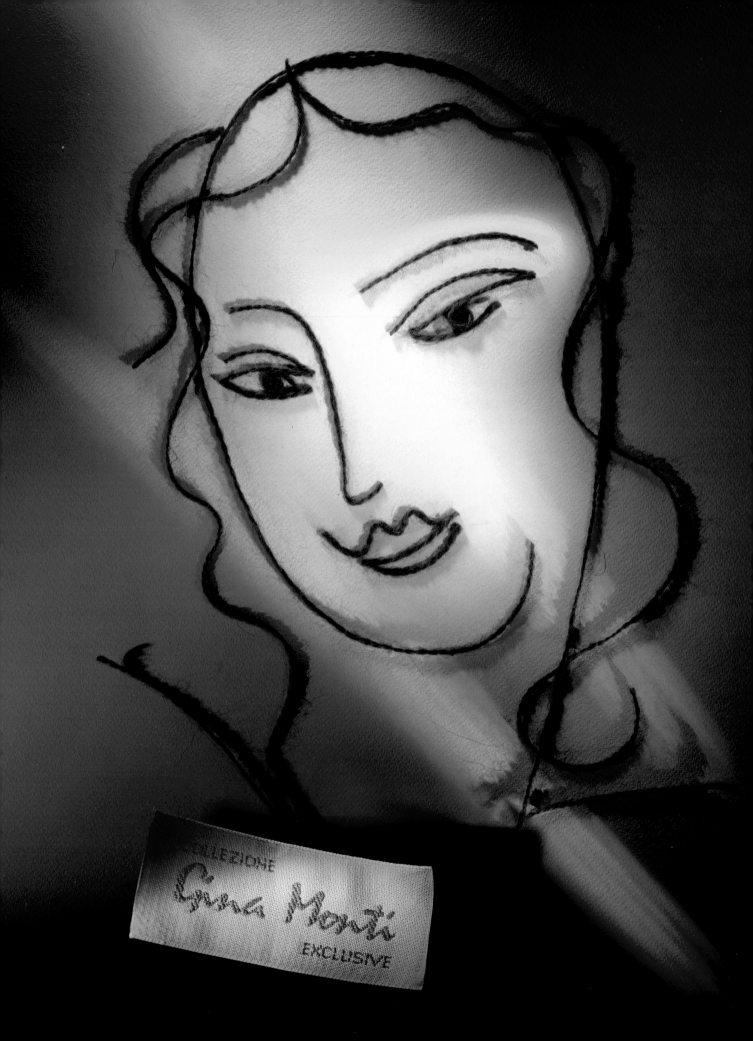

COLLEZIONE

Gina Monti

EXCLUSIVE

Hommage à Matisse

The subject of this advertisement for the fashion company Gina Monti consisted of just a piece of paper, some thread, and the company's fabric logo. Dedolights transformed this simple tableau into a colorful spectacle.

The idea to simulate a Matisse painting using thread arranged on watercolor paper was a fine one, but the initial neutrally lit results looked quite dull. The agency involved had imagined something much more colorful, inspired by the real works of Matisse. I used a whole bunch of Dedolights fitted with colored filters to liven up the image. Dedolights are small theater spotlights with halogen bulbs. They can be fitted with projector attachments and masks and can be used to create highly directional light that can be precisely directed and shaped. I used one lamp with a blue filter as my main light and the others—with red, yellow, and orange filters—as accents. In the places where the light cones met, additive color synthesis produced new colors to add to the spectacle. The multicolor approach gives this image a highly three-dimensional effect, although it is, in fact, flat.

Technical Data

Camera:	Sinar p2
Format:	Sinarback 54H, 22 megapixels
White balance:	Incandescent
Lens:	Rodenstock 150mm Sironar-N
Exposure:	f/16, 4 seconds
Lighting:	5 Dedolights, 4 with projector attachments
	Various colored filters
Background:	Watercolor paper
Comments:	A glass was placed in the light beam and a yellow lamp was used to accentuate the scatter effect

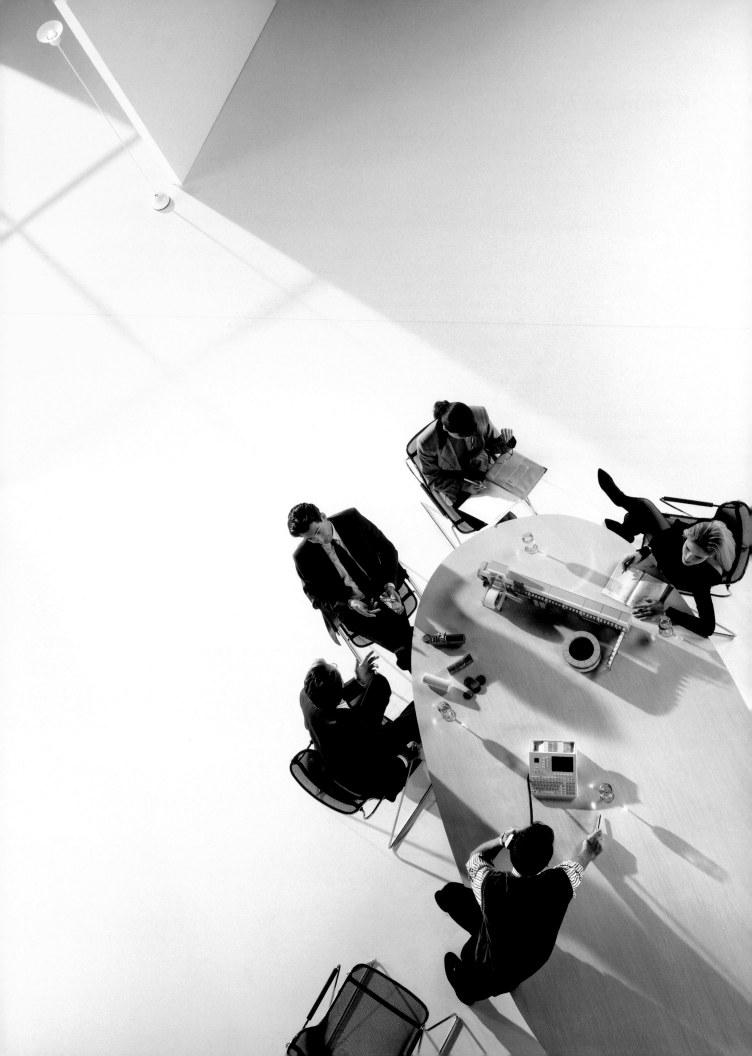

Business Meeting

A meeting is photographed from above, for a change. The table, which forms the stage for discussions, is emphasized and is placed in surroundings that contribute meaning. You guessed it—a still life!

I set up this shot using five models in a large rented studio with an 8 m (26.2 ft) ceiling. The studio had no moving gantries, so I had to attach the camera to the ceiling girders. The hardest part of this job was attaching myself and the camera so high up. Any mishaps wouldn't have been good for my health or that of the models!

While I was busy up above, my two assistants set up the lights according to a prearranged plan. We had to shoot three completely different setups in the course of the day, so we had to work quickly. Good planning is essential under circumstances like this.

We used a lot of equipment, including 11 generators with a total of 44,000 watts, two Fresnel spots with 8,000 watts each (one to light the table, and one to produce the window frame effect), and eight additional lamps to produce a finely distributed network of highlights. Four of these lamps were bounced off the ceiling reflector. The crew included me, a stylist, two assistants, a makeup artist, two clients, and the art director from the advertising agency, who, along with our five models, all had to be kept happy and fed. I felt like a one-man production company with a catering firm attached and had to concentrate hard to get the actual photography done. If possible, it is preferable to have a shoot manager look after the organization and leave you free to do the work you are being paid for.

Technical Data

Camera:	Sinar p2
Format:	Sinarback 54H, 22 megapixels
Lens:	Rodenstock 150mm Sironar-N
Exposure:	f/16, 1/30 second
Lighting:	Fresnel spot with a light blue filter (1/2 CTB) 8 lamps with wide-angle reflectors
Background:	White infinity cove
Props:	Custom-built tabletop

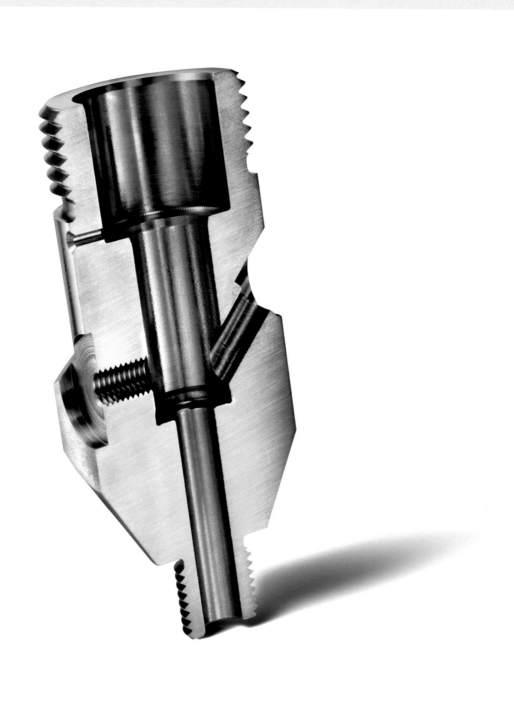

Industry & Technology

Rationality is the defining force in the world of engineers and technicians—a new experience for the visually oriented and a real challenge for a photographer's creative talents.

The Challenge of the Rational

You need a good portion of rationality to feel at home in the world of industry and technology. The ability to think logically makes it easier to communicate with engineers and scientists, and the images we create in this area require a rational approach to find appropriate creative solutions.

Industrial photography demands a stricter sense of aesthetics than any other genre. Creative solutions always have to remain rational and logical.

While the fashion world is dominated by high emotion, the world of industrial photography demands cool aesthetics. People who are ruled by their heads react differently to visual input than those who are ruled by their hearts. We have to learn to speak a different visual language if we want to produce images that appeal to technicians. Let's take a look at the world of rational design and strict logic.

It might seem strange that I am giving so much emphasis to the creative side of industrial photography, but I often find that industrial companies rarely work successfully with large advertising agencies and, when they do, they spend hardly any time dealing with visual concepts. Advertising agencies generally develop a company's entire corporate identity, and the concept often includes some visual ideas or at least some guidelines for the visual language the company wishes to use. However, the development of the concepts behind the images that actually end up getting used is generally left to the photographer, who is, after all, the person who must come to grips with the products in question. This all means more work for the photographer, but also more creative freedom. In contrast to an advertising photographer, who has to adhere to preconceived layouts, an industrial photographer provides more of a comprehensive service. I always enjoy the multiple creative and technical challenges of an industrial job. I have already discussed some aspects of location-based corporate shooting in the section that deals with company reports, so this section will deal exclusively with the studio aspects of industrial work.

Over the past 30 years, I have worked for metal producers, pharmaceutical companies, chemicals companies, logistics specialists, research institutes, and engineering firms. Each industry exists in its own separate world, even if some aspects of their corporate cultures are similar. A basic grasp of things technical has frequently helped me to communicate with my clients and has given me some interesting insights into situations that remain invisible to outsiders. My creative approach has always been based on my attempts to understand what I am photographing, and creative solutions develop almost automatically as a result. A creative solution that bears no relation to the subject at hand—that is, a purely decorative idea—is of no use to me. It is essential to take the viewer and the viewer's intellect seriously. This approach has been successful for me, although I do have to sell my ideas, and engineers are, as already mentioned, intellectually rather than emotionally oriented people. In industry, a coherent, well-argued concept generally bears more fruit than amazing color layouts.

The inherent beauty of industrial products is generally not as immediately obvious as that of consumer products that are designed to appeal in their own right. The charm of a technical subject becomes apparent only when we understand how its form underpins its function, and the resulting symbiosis is often the driving force that enables us to create meaningful photographs.

These two images are from a series for Dow Plastics. They were both part of a brochure that illustrates composite car part designs for the automotive arm of the company. They were both lit using neon and HoseMaster fiber-optic light, which gave them their own special aura.

Sinar p2, 8x10
480mm Apo-Ronar
40 seconds at f/32

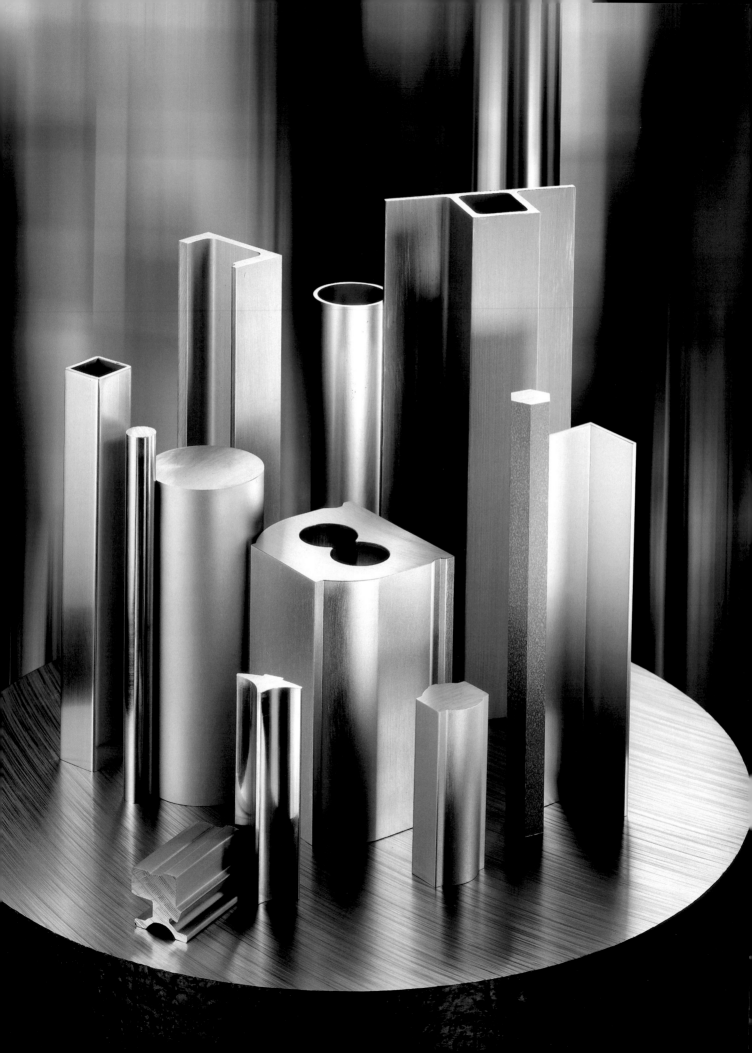

Aluminum Components

This image was the shot for the cover of a catalog. It portrays various aluminum struts and components. The original image was in color, but I prefer this black-and-white version because it more effectively emphasizes the spectrum of tonal values reflected by the material.

Aluminum reflects light beautifully and gives off a wonderful soft shimmer. Many of these components are designed for use in the building industry, so I set up this composition to look like a group of skyscrapers. To keep my lighting effects interesting and varied, I set up a complex wall of lamps, diffusers, and reflectors with strategic breaks all around the subject. I took great care to separate the shapes of the individual components by adding highlights or rotating the components themselves. I used alternate hard and soft light sources and shaded the press blank that I used as a table to prevent any distracting reflections. I also used a soft overhead light to illuminate the profiles of the components and the surface of the blank.

I created the background at the post-processing stage by applying a number of movement blur filters to the original photo. I then selected and isolated the main subject and inserted the blurred background into a separate layer beneath. (The sketch here shows only a selection of the many lamps and reflectors I used.)

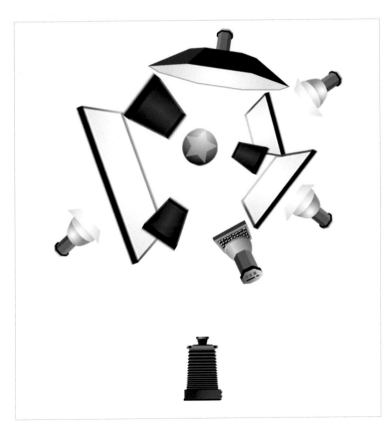

Technical Data

Camera:	Sinar p2
Format:	Sinarback 54H, 22 megapixels
Lens:	Rodenstock 300mm Sironar-N
Exposure:	f/32, 1/30 second
Lighting:	1 large softbox
	2 lamps with standard reflectors
	1 lamp with a honeycomb filter
	1 lamp with a telephoto reflector
Background:	Aluminum press blank
Comments:	Background added during post-production

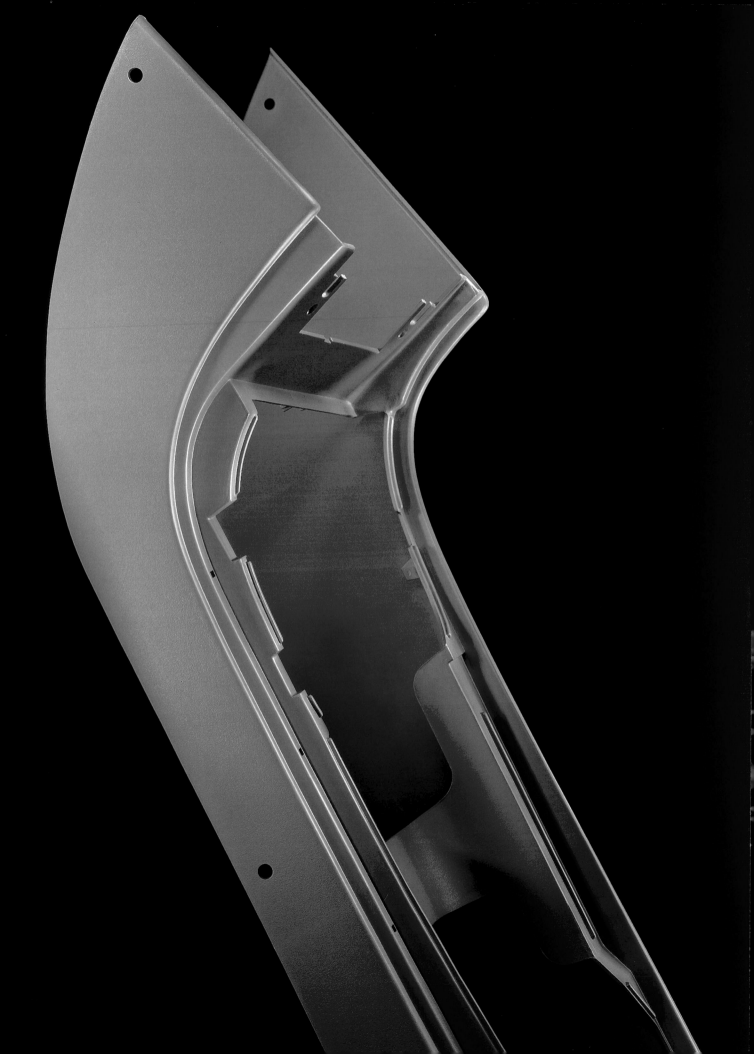

Dow Automotive Plastics

Plastic is strange stuff. It is neither soft nor hard, shiny nor matte, but it is definitely 100 percent man-made. This shot was intended to underscore the artificial nature of the product, so artificial light was the obvious choice.

This shot was captured without any conventional light sources; it was lit with just neon tubes and a HoseMaster. I wanted to include the shimmering look of the neon tubes in the composition, so I deliberately allowed some overexposure to encroach on the right-hand edge of the frame. I shaded the tubes very carefully everywhere else to ensure that no unwanted stray light entered the camera. Mixing red and blue neon light with HoseMaster highlights on the edges of the subject created a unique atmosphere. The HoseMaster is like an oversized flashlight with an extremely bright daylight bulb, and it also has a built-in shutter. With a little tinkering, modern LED flashlights can be used to achieve similar effects.

I was amazed at how well my camera's digital back reacted to the neon light. It captured exactly the kind of bold, bright tones I was after, while giving the finished image a slightly artificial aura. Long exposures of up to 30 seconds are not a problem for digital camera backs, but exposures longer than 30 seconds generate too much warmth in the sensor and result in image noise. The black background emphasizes the shape of the subject and gives the image a feeling of added depth.

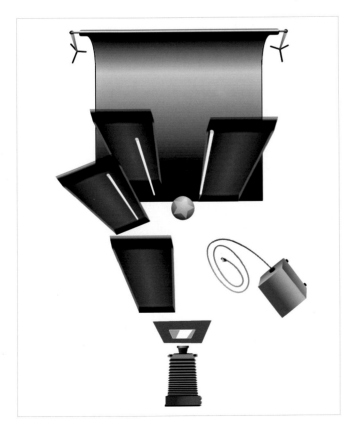

Technical Data

Camera:	Sinar p2
Format:	Sinarback 54H, 22 megapixels
White balance:	Fluorescent
Lens:	Rodenstock 480mm Apo-Ronar
Exposure:	f/22, 30 seconds
Lighting:	3 neon tubes and a HoseMaster Fiber-optic lamp
Background:	FOBA black velour
Comments:	Shades on the left to prevent stray light from entering the lens, no shades on the right to allow stray blue light to be part of the composition

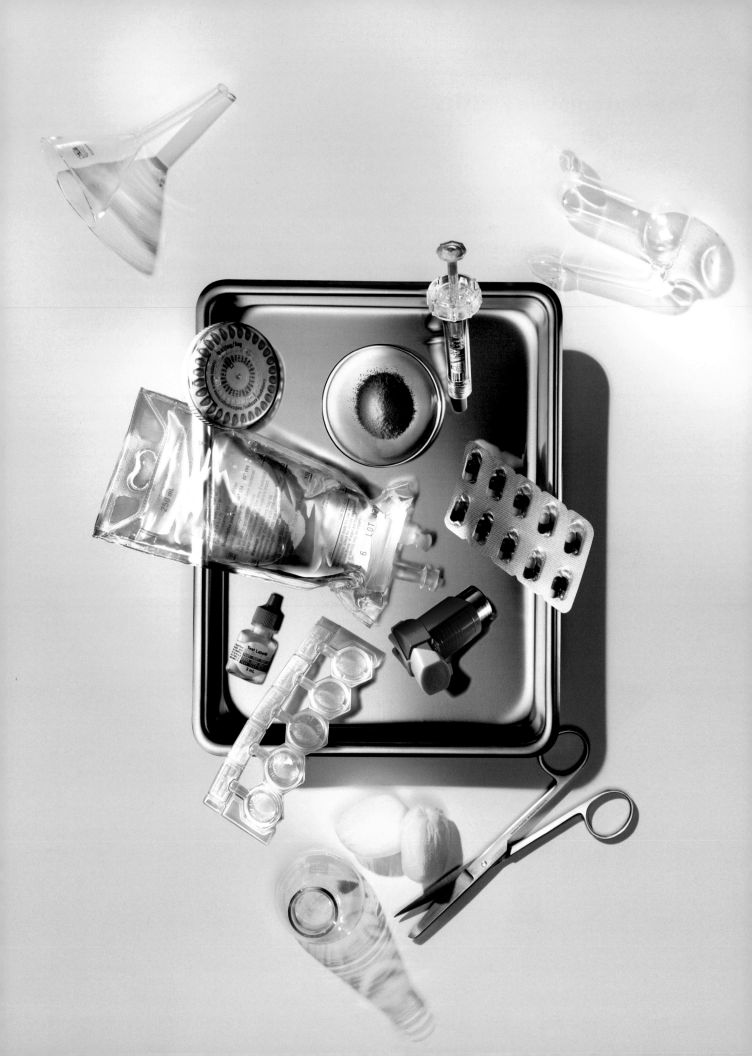

Pharmaceutical Products

The pharmaceutical industry really is a world of its own. End-less aseptic clean rooms make me feel as if I have landed in a science fiction movie, and that is the kind of atmosphere I wanted to capture in this shot.

I used a light, subdued cyan-colored background to hint at the clinical nature of the subject. The objects were lit using a hard Fresnel spot, and I added an indirect blue-filtered highlight with the ceiling reflector to provide blue-tinted shadows. I then added various accents using Dedolights fitted with dense honeycomb filters.

Positioning the camera directly above the dish meant that it was reflected directly into the lens, so I moved it slightly to the side and used parallel shift movements to center the subject. The artificially clean look is deliberate and mirrors the feeling created by a pharmaceutical lab.

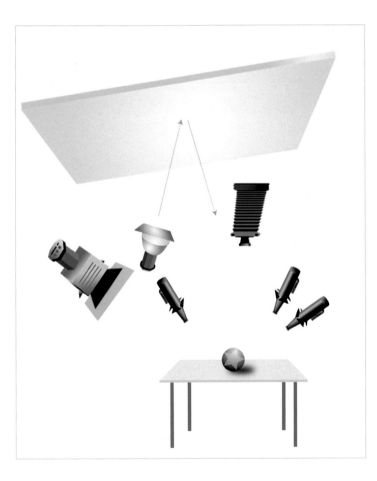

Technical Data

Camera:	Sinar p2
Format:	Sinarback 54H, 22 megapixels
Lens:	Rodenstock 300mm Sinaron-N
Exposure:	f/22, 1/30 second
Lighting:	Fresnel spot with a mild cyan filter
	1 blue-filtered lamp bounced off a reflector
	3 Dedolights
Background:	White FOBA TT Plast
Comments:	Parallel shift camera movement to prevent the camera from being reflected in the steel dish

Sinar p2

This shot shows the Sinar p2 large-format camera, photographed for the manufacturer's 40th anniversary celebrations and set up to look like a kind of monumental cult object. The great thing about this job was the intended audience already knew the product, so I didn't have to include as much detail as might otherwise have been necessary.

This photo shows one of my own favorite tools, shot for the manufacturer's 40th anniversary celebrations. I naturally jumped at the chance, and I just happen to consider the p2 to be the most beautiful and functional tool I have ever used. I wanted to create a monument to this fantastic piece of engineering and decided to emphasize the camera's lines with subtle blue light and to capture the lens as a colored counterpoint. All in all, it is a very subtle composition.

I made this shot way back in the predigital era, and I used my favorite combination of an 8x10 Sinar camera and Ektachrome 100 film. I had to stop down and, because this film tends to produce reciprocity failures, I had to use a very long exposure in a completely darkened studio. I created the shot with a double exposure (one shot for the lens and one for the camera body), so I had to be absolutely certain that nothing would move between exposures. I even had to leave the film holder in the camera. Let me tell you, analog studio photography often feels like a tightrope walk without a safety net!

Technical Data

Camera:	Sinar p2
Format:	8x10
Film:	Ektachrome 100 daylight
Lens:	Rodenstock 480mm Apo-Ronar
Exposure:	f/45, 220 seconds
Lighting:	Neon tubes: 4 blue, 1 red, 1 green, 1 blue 1 projection spot with shades
Background:	Black velvet
Comments:	Double exposure, with the lens covered for the first shot and the camera body covered for the second shot

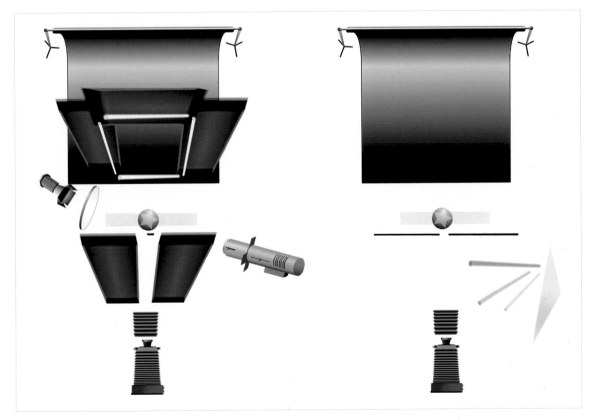

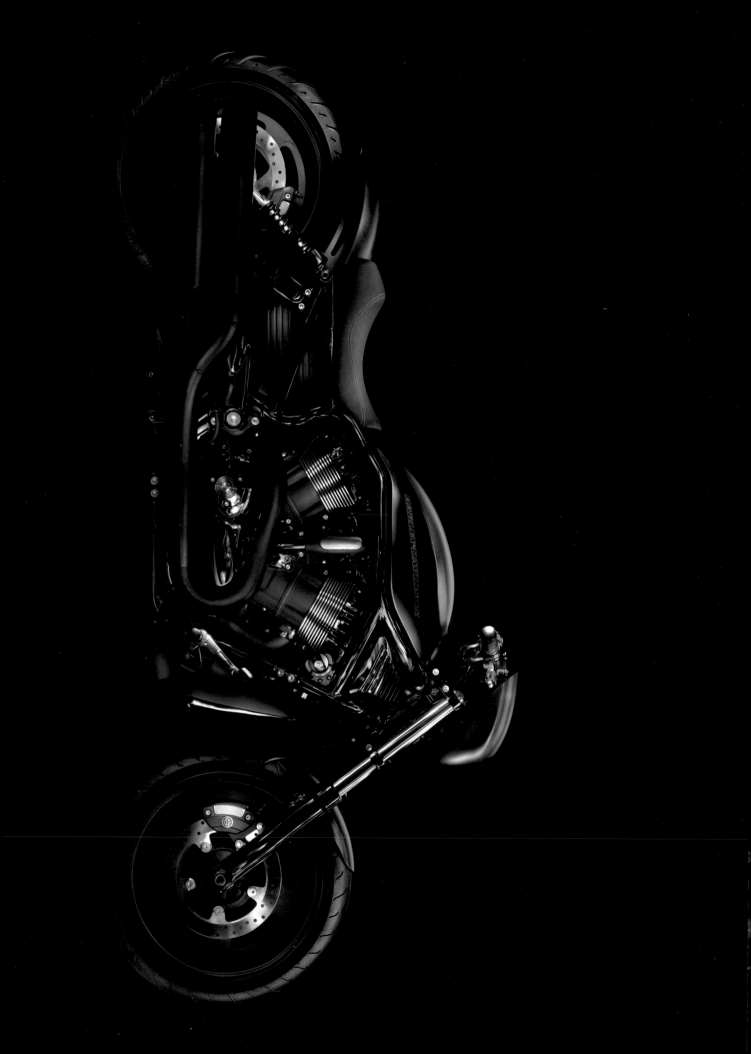

Harley Davidson: Night Rod

The entire neighborhood stopped and stared when a friend of mine rode his latest Harley to my studio. The noise level was hard to ignore, and the machine itself exuded blunt, raw power. Of course, I had to ask my friend if he could leave his photogenic new steed at my studio for a day or two.

I needed an additional low-key photo for this book, and a technique shown to me by Jonas Weibel, a student at the "cap" photo school, gave me the idea for this shot. The technique involves merging multiple black-based source images to form a single, final megaimage. I positioned the bike on a black fabric background, darkened the studio, and used a Hose-Master fiber-optic lamp to paint the bike bit by bit. I kept checking the results and, as soon as I was happy with one section, I moved on to the next. The HoseMaster is like a flashlight with a jumbo remote light source that you can move in any direction you like. Each exposure was 32 seconds long to give me time to concentrate on the details in the current section of the subject. After two hours of working like this, I had captured a series of images that covered the entire bike. I imported 11 of them into Photoshop, saved them on separate layers, and merged them using the Lighten blending mode.

In addition to the unusual and effective lighting effects, the other advantage of this particular technique is the relatively small amount of technical equipment it requires. This enables you to illuminate very large objects using just one small lamp. Larger LED flashlights can be used to create similar effects, freeing you from the need to use a power outlet.

Technical Data

Camera:	Hasselblad H4D
Format:	50 megapixels
Lens:	Hasselblad 120mm HC Macro
Exposure:	f/16, 32 seconds per section
Lighting:	HoseMaster (600-watt xenon lamp with built-in shutter and 5 m/16.4 ft fiber-optic cable)
Background:	Black fabric
Comments:	The subject was exposed in stages, and the individual images were merged in Photoshop

The HoseMaster is a truly unique tool. It allows you to selectively illuminate the finest details in a subject or leave them selectively dark. The extreme flexibility of the light source makes it possible to produce fine-tuned lighting effects that are impossible to achieve with conventional lamps. The HoseMaster is extremely practical and obviates the need for a whole range of subsidiary generators, lamps, reflectors, shades, and other accessories. All you need is a darkened studio and a black, nonreflective background. The HoseMaster has a powerful 600-watt xenon light source; you can achieve similar effects with a powerful flashlight.

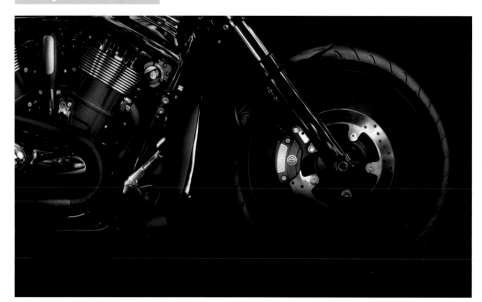

For this particular mask, I placed four pieces of white Styrofoam and a piece of white card behind the bike. Then, instead of lighting the subject directly, I lit the Styrofoam and white card to produce reflected light. This technique left the bike mostly dark with just a few highlights showing where the curves of the bodywork picked up the reflected light.

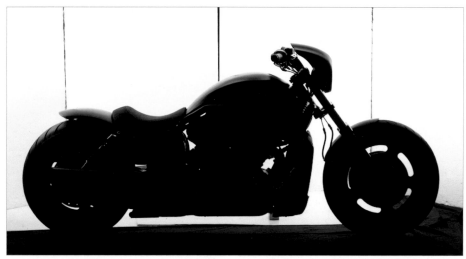

I then used the HoseMaster to expose each part of the bike for a total of 32 seconds. The small directional shape of the light source allowed me to sculpt only the relevant parts of the subject. The studio was blacked out, and all other parts of the bike remained in the dark. Shown here are 4 of the 11 images that I used to construct the final image.

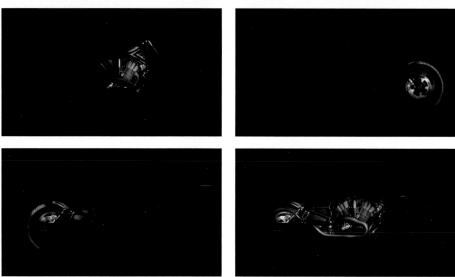

Thanks to shooting in front of a white background, this mask was relatively simple to process. I only had to draw a couple of adjustment paths near the floor and in the places where light shone through the wheels or reflected off the bodywork. I used the resulting mask to darken the background of the main image to deep black.

I placed all 12 individual images on layers above the background shot while keeping the Shift key pressed. This Photoshop keystroke automatically aligns the individual layers (but only if you provide it with congruent source material!). I then blended the layers together using the Lighten blending mode, which ensures that only the bright parts of each layer end up in the merged image.

To avoid producing any gaps in the finished image, it is best to illuminate an area that is slightly larger than the one you want to include. You can then generate masks for the individual layers to eliminate potential overlaps between shots and create fine transitions between the various sections. Any inconsistencies in the surroundings can be masked this way, too.

Finally, I blurred some of the sharper reflections in the tank and removed a couple of irritating cables. I also brightened the Harley-Davidson logo a little. Shiny elements can be tricky to illuminate effectively with the HoseMaster due to its small size and the fact that it is constantly on the move. This makes it difficult to produce even-looking areas of shine, and it calls for a little post-processing.

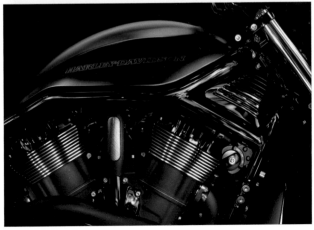

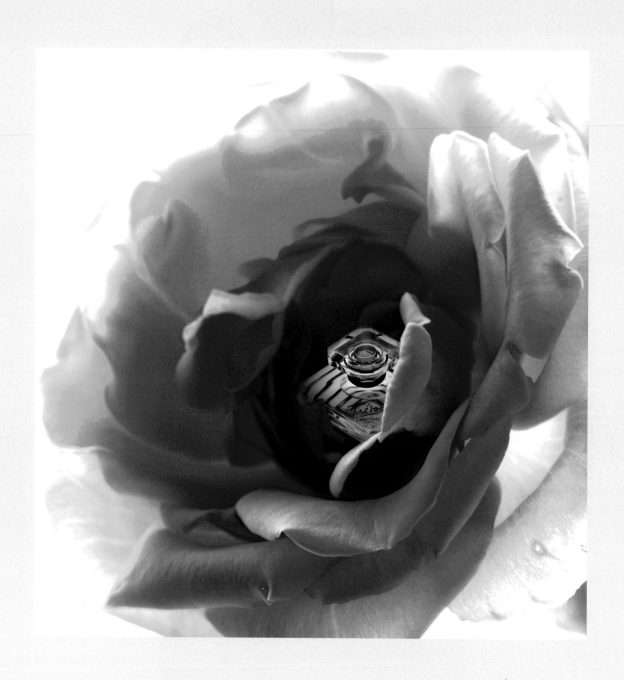

Cosmetics & Accessories

The colors and scents of these products are designed exclusively to tempt our senses! This subgenre is the specialty that appeals most to the aesthetes among us.

The World of Color and Fragrance

It is relatively easy to tempt human beings with scents and bright colors. These things have an immediate affect on our sense of well-being, although the effects themselves usually take place subconsciously and vary enormously from person to person. Sensory perception is not a rational process, and our senses are very good at playing games with us. Photographing cosmetics is not a job for rationalists.

Cosmetics

Photos of cosmetics are designed to sensitize the public by awakening associative emotions. Our sense of smell is the root of many highly emotional experiences, and we respond readily to it. Cosmetics photography is all about translating the feelings generated by our sense of smell into pictures—a process that involves color just as much as shape and other formal compositional tools. For example, pastel colors are often used to illustrate more subtle perfumes, and bold, bright colors tend to be associated with stronger fragrances.

This particular subgenre requires a fine sense of color harmony and an aesthetically driven talent for composition.

Perfumes are composed of a multitude of different essential and aromatic elements that are usually described in terms of base, middle, and top notes. One or another of these notes will dominate a particular perfume, depending on its composition. A fragrance can, for example, be based on a middle note but also incorporate base and top notes to make its effect more complex. Earthy colors (brown and green) tend to be associated with base notes, and warmer colors, such as red and yellow, are associated with middle notes. Top notes correspond to cooler colors, such as blue and cyan.

Color is used deliberately and strategically in the world of cosmetics, and attempts are constantly being made to measure and control the effects of color. Some grassroots knowledge of color theory is a great help when it comes to understanding how colors affect our feelings and how to utilize them to maximum effect.

Cosmetics photography is not only a highly-charged sensual domain, but also one with a distinct sense of aesthetics. In addition to highly emotional advertising, the design of cosmetic products and packaging is always carefully styled and presented, and they have to be photographed in a way that reflects that. The photos in question range from simple product shots to complex dreamlike scenes designed to sell individual perfumes or ranges of cosmetic products.

Accessories

Accessories—such as scarves, bags, gloves, shoes, costume jewelry, and the like—are related to cosmetics and also belong to the category of beautiful and decorative objects that are by no means essential but that we nevertheless covet. Accessories are also sold emotionally and are promoted with techniques similar to cosmetics sales. Accessories are part of the colorful, sensuous world of fashion. You have to be fashion conscious and in touch with modern lifestyles to be successful in this niche. Most of the results will appear in glossy magazines and consequently must be of extremely high quality.

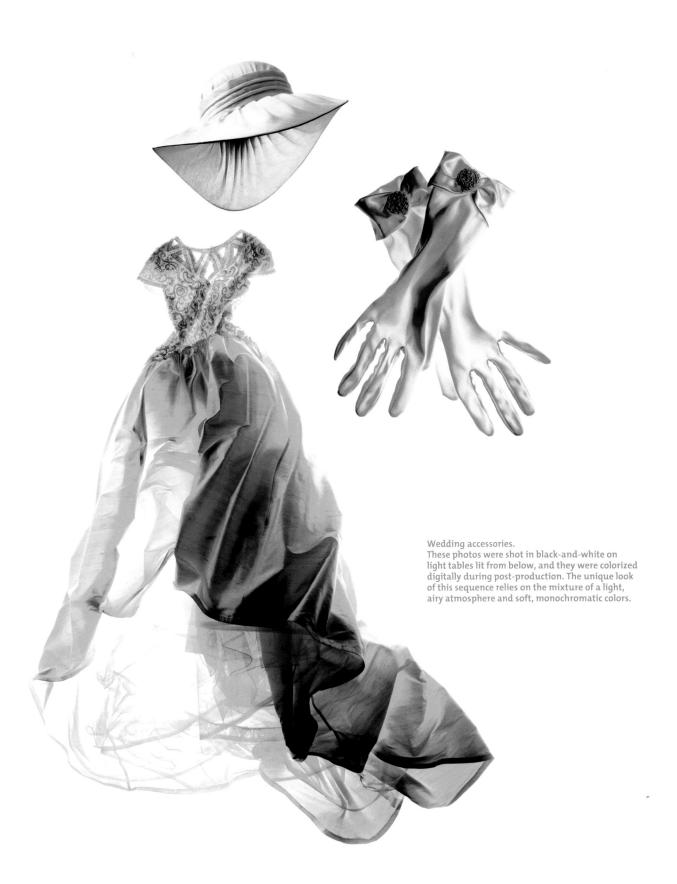

Wedding accessories.
These photos were shot in black-and-white on light tables lit from below, and they were colorized digitally during post-production. The unique look of this sequence relies on the mixture of a light, airy atmosphere and soft, monochromatic colors.

Cosmetics & Accessories—*The World of Color and Fragrance*

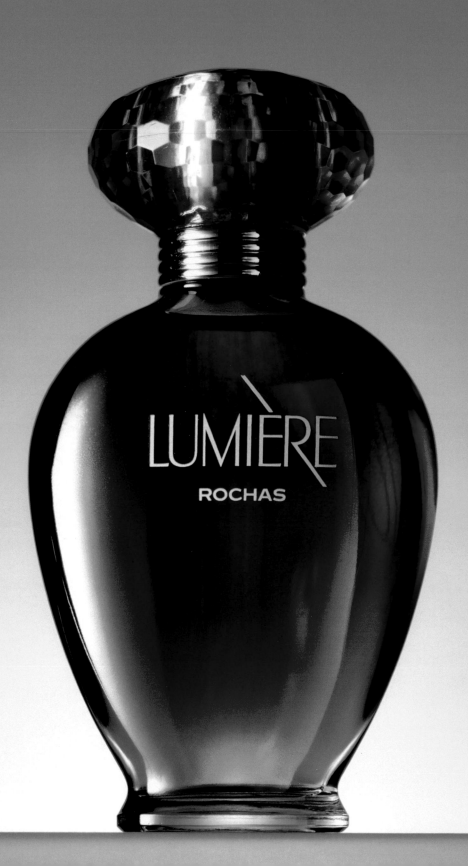

Lumière

This fragrance simply cries out to be photographed in exotic-looking light. The bottle itself shimmers red and blue, so I used multicolored light to underscore it. The overall effect is one of a richly colored aura.

This setup is simple but produced a fantastic effect. Colors and color gradients produced by filtered light are usually quite intense. In this case, the mood was based on a red/blue gradient created using two filtered lamps positioned behind a layer of translucent sheeting. Because these colors are also present in the subject itself, the overall effect is balanced and harmonious. I placed the bottle on an 80 cm (31.5 in) piece of 1x15 cm (0.4x5.9 in) Plexiglas with one end filed off to 45 degrees. The camera was aligned precisely with the top of the stand to produce just one single horizontal line to avoid having to view the bottle from above. I also set up a small sheet of Trans-Lum with a lamp behind it at front left to give me a variable light source. This homemade softbox gave me the flexibility I needed to vary the effect of its light, and I used it to create the gradient on the left-hand side of the bottle. This open light also meant that I had to shield the camera from stray light. I positioned a silver reflector at front right, and the surface of the glass reflected the studio in such a fascinating way that I didn't bother to darken the room before shooting.

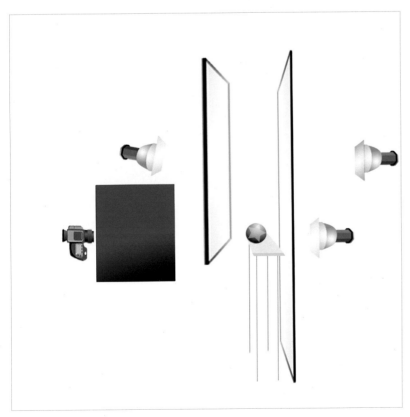

Technical Data

Camera:	Hasselblad H4D
Format:	50 megapixels
Lens:	Hasselblad 210mm HC
Exposure:	f/16, 1/30 second
Lighting:	1 lamp with a red filter
	1 lamp with a blue filter
	1 lamp with a diffuser
Background:	FOBA Trans-Lum sheeting
Comments:	Color gradient created by mixing light from the two filtered lamps. The red component was slightly stronger than the blue one.

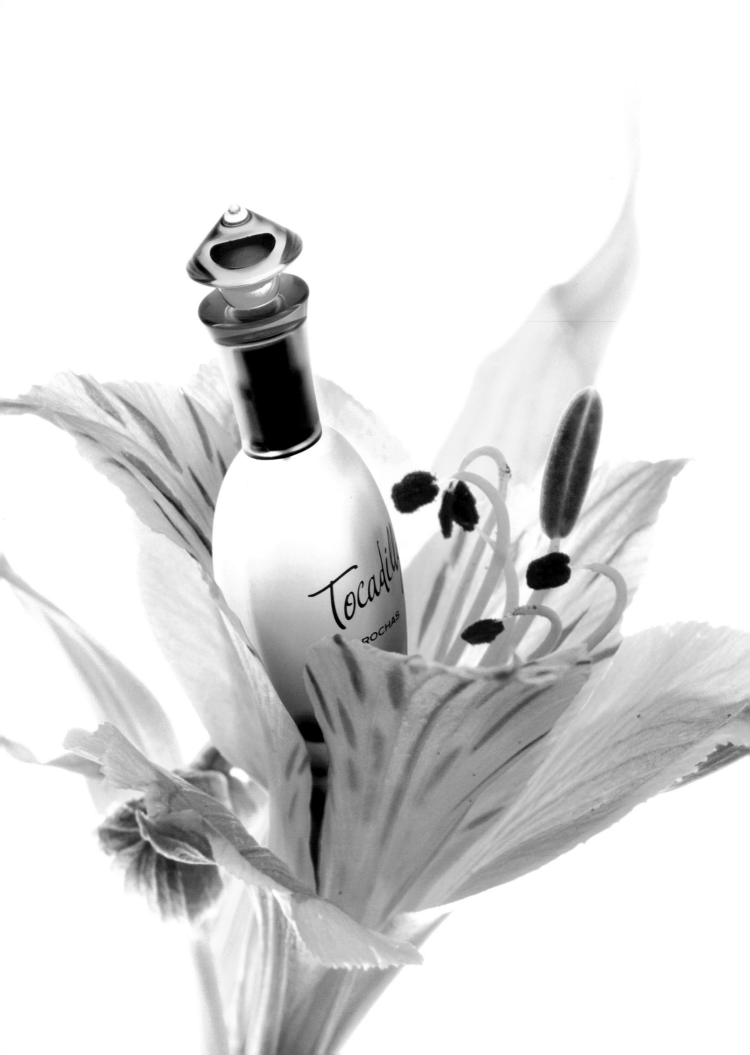

Tocadilly

This photo comes from a privately shot sequence in which I experimented with soft, pastel colors. I combined flowers and perfume bottles and photographed them separately using the same lighting setup. I then substituted the bottle for the flower's spadix during post-processing.

This composition is based almost entirely on backlight and is brightened only slightly from the front with a piece of white card. The backlight makes the colors paler and gives them the pastel look that you get when you mix colored paint with white. This fits well with the fleeting, ephemeral nature of perfume. It was impossible to mount a glass bottle in a delicate flower, so I decided to take the Photoshop route instead. I made the two exposures one after the other using exactly the same lighting setup. I used translucent white Plexiglas for the background and lit it evenly from behind, like a light box. Slight overexposure and deliberate use of stray light nicely accentuated the pastel feel. I didn't use any shades, which meant that stray light brightened the shadows and gave the image a high-key look. If this type of effect is too prominent, you can control the amount of stray light by shading or reducing the size of the light source. As ever, it is all a matter of taste that strongly depends on the effect you wish to achieve.

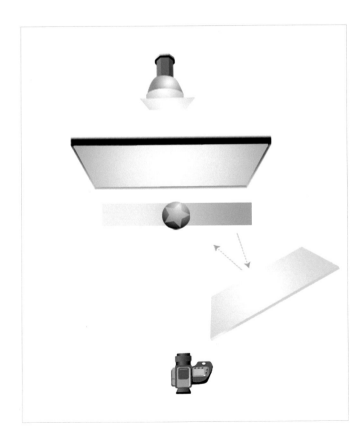

Technical Data

Camera:	Hasselblad H4D
Format:	50 megapixels
Lens:	Hasselblad 120mm HC Macro
Exposure:	f/22, 1/30 second
Lighting:	1 lamp
Background:	FOBA Trans-Lum frosted sheeting
Comments:	One shot of the bottle and one of the flower taken with exactly the same setup. Photomontage created in Photoshop.

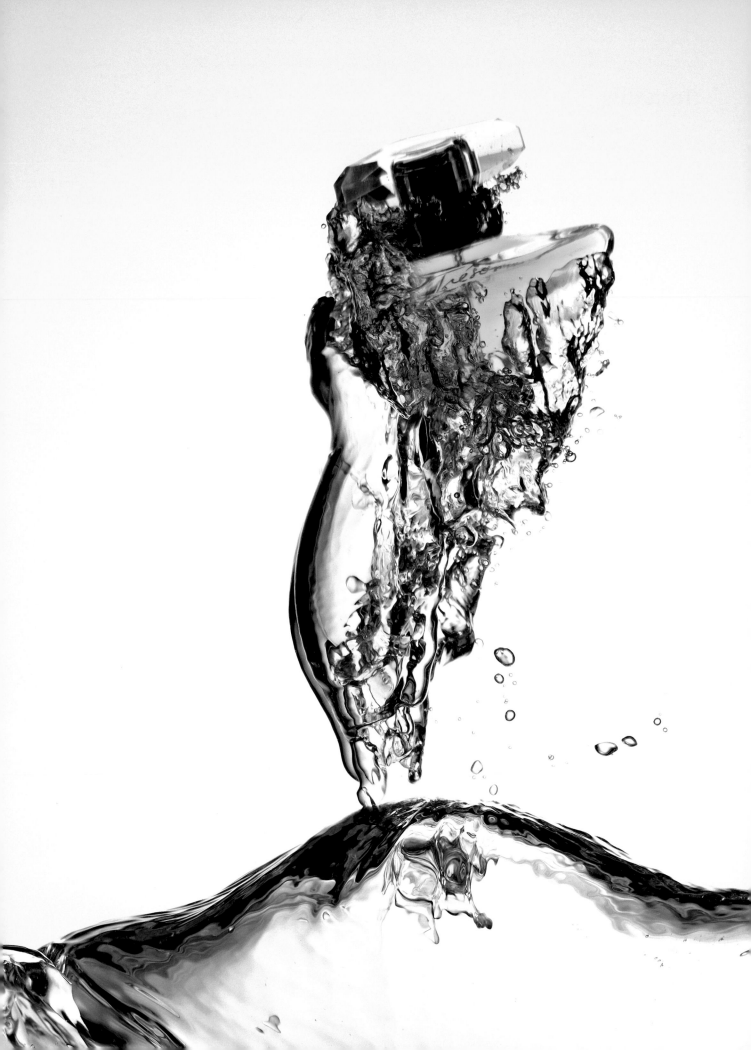

The Wave

Photo sessions that involve water effects are difficult to plan and often require a fair amount of experimentation. You nevertheless need to exclude as many sources of potential errors as you can. Here, we used a custom Plexiglas tank to capture this impressive shot.

In this shot, I wanted to have the perfume bottle shoot out of the water and leave a plume of water, like a comet's tail, behind it. The idea hinges on having the surface of the water as a clearly focused reference point. To achieve this, I designed a custom Plexiglas tank that was only slightly wider than the bottle itself. This gave the wave room to develop without flooding the studio at every attempt. The original tank measured 80x60x8 cm (31.5x23.6x3.1 in), but it produced waves that weren't high enough. I inserted an extra piece of Plexiglas that reduced the tank's width to 40 cm (15.7 in) and gave the wave a boost.

After we performed tests to find the right drop position for the bottle and the best position for the camera, we ended up with nine shots (from a total of about 120) that we felt were good enough to process further. The main effect (i.e., the bottle shooting upward) was achieved with the simple trick of dropping the bottle into the water and inverting the photo. We also lit the scene to make the surface of the water brighter than the surroundings, which further enhanced the illusion of the bottle floating in the air. The narrow shape of the tank limited the absolute depth of the scene and ensured that the entire surface of the water was captured in sharp focus. The short flash duration was an extremely important factor. Studio flash units have flash durations from 1/100 to 1/250 second, which is too slow to capture a scene like this accurately. Instead, we used an Elinchrom Ranger Quadra location flash, which has a flash duration (to.5) of 1/3200 second. This allowed us to freeze the motion of the bottle just as the water slowed its fall. Even the individual water droplets caused by the impact remained in focus.

Technical Data

Camera:	Hasselblad H4D
Format:	50 megapixels
Lens:	Hasselblad 210mm HC
Exposure:	f/11, 1/125 second
Lighting:	1 Ranger Quadra lamp connected to the B channel 1/3200 second flash (to.5)
Background:	FOBA Trans-Lum

Here you can see my assistant filling our custom Plexiglas tank with water. Each of its two halves is 80 cm (31.5 in) high and 60 cm (23.6 in) wide. The tank is 8 cm (3.1 in) deep—just enough to allow us to reach in and remove the subject after each shot. The Plexiglas is 0.5 cm (0.2 in) thick and is glued together at the corners. We had to remove any splashes and remaining drops of water after each shot, which explains the cloth hanging out of my assistant's pocket.

The shortest flash duration of the Elinchrom Ranger Quadra S Head is 1/3200 second at 33 percent power when attached to the 138 watts/second B channel of the power pack. The Quadra even includes the superfast A head with a short flash duration of 1/6000 second, but the S head was sufficient for our purposes.

We established the best dropping point by trial and error. I counted to three, and my assistant let the bottle go while I simultaneously released the shutter. Because my reaction time remained constant, we were able to capture a number of usable images. We also tried using an electric eye, but the glass of the bottle produced inconsistent releases, so we gave up on that idea. The sound of the bottle hitting the water was too quiet to consider using an acoustic release.

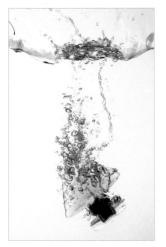 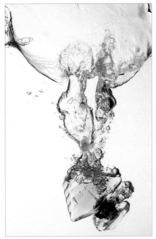 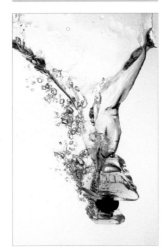

These are three of the best images we captured. Completely by accident, the water in the one we chose to use looks like a hand grabbing the bottle. The turbulence in the water and the bubbles the bottle produced varied depending on the angle at which it hit the water. With a bit of practice, we learned how to achieve the best results while keeping the bottle visible and identifiable. I sharpened the image twice using the Unsharp Mask tool (the first time with values of 30/30/0, and the second time with values of 0.6/200/0) to accentuate the textures in the water.

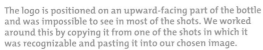

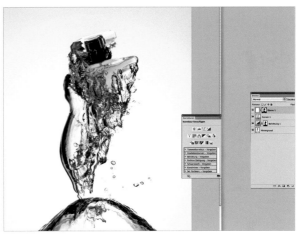

The logo is positioned on an upward-facing part of the bottle and was impossible to see in most of the shots. We worked around this by copying it from one of the shots in which it was recognizable and pasting it into our chosen image.

To get the background looking clean and clear, we masked the subject and then brightened it. We then created a new background with a gradient on a separate layer and inserted the mask with the Alt key.

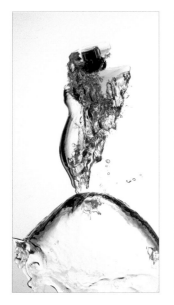

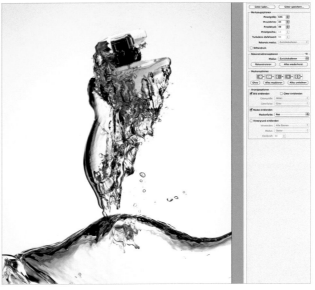

As a final step, we used the Warp tool to transform the surface of the water into a wave and thin out the "hand." These steps gave the image a feeling of motion and, interestingly, made it look more plausible than the original.

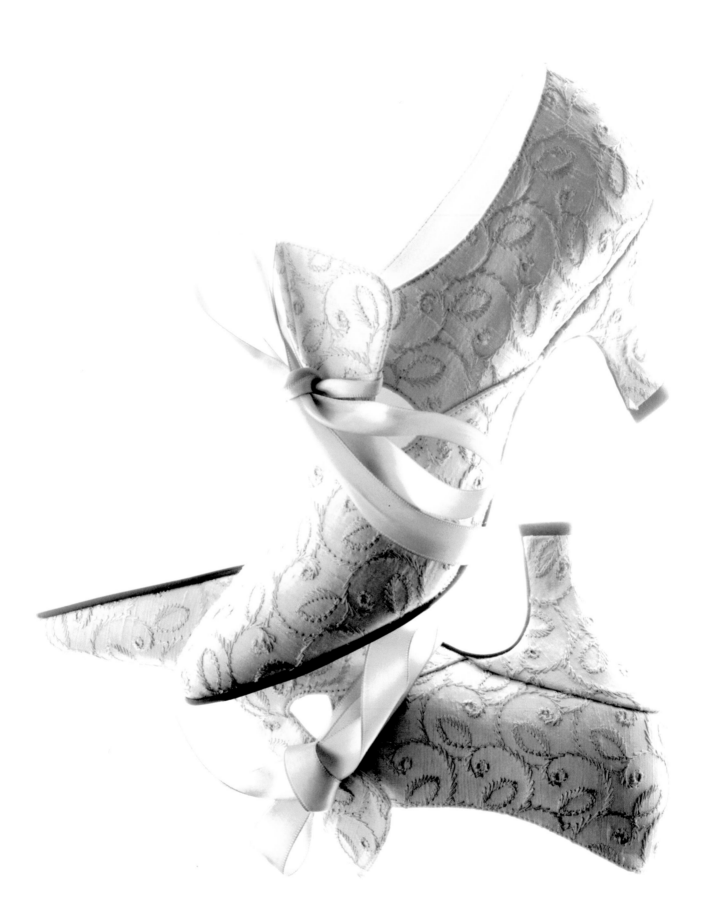

Bridal Shoes

This image is part of a series of wedding accessories shot in the same deliberately overexposed, high-key way as the image on page 130. I wanted the edges of the subject to blend in with the background and for the image to have little detail rendition in the shadows.

The setup for this series was basically always the same, but it had to be varied due to the different sizes of the individual subjects.

The wedding dress had a 2.5 m (8.2 ft) train, which meant setting up a 2x3 m (6.6x9.8 ft) piece of frosted glass to photograph it. The other objects, like these shoes, were small enough to fit on a standard FOBA table. The sketch below shows the smaller version, and the larger version was lit with six lamps to keep the lighting even. Once again, I deliberately overexposed the shots to give the images a high-key look. I exposed for the shadows and opened up the aperture by one extra stop. The combination of overexposure and a frosted glass background caused overexposed edge detail and gave the images the radiant look I was after. A FOBA table is perfect for this type of application because the subject is located directly on the light source. I converted the images to black-and-white and then tinted them with pastel tones while leaving some areas white to give them a common theme.

Technical Data

Camera:	Sinar p2
Format:	Sinarback 54H, 22 megapixels
Lens:	Rodenstock 240mm Sironar-N
Exposure:	f/22, 1/30 second
Lighting:	2 lamps (or 6 lamps for the larger version of the setup)
Background:	Frosted glass
Comments:	FOBA or frosted glass table. Image file converted to black-and-white and then tinted green.

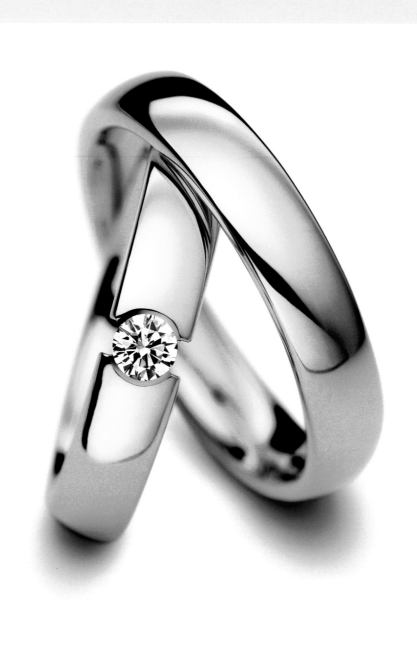

Watches & Jewelry

Reflections and shiny areas are not normally helpful in studio situations, but they are the stars of the show in this chapter. Let them shine!

Refinement and Precision

Watches are one of Switzerland's best-known products. Their refinement and precision makes high-end mechanical watches one of the most fascinating luxury goods in the world, and some brands have managed to attain true elite status. The fact that their highly sophisticated movements are concealed within the case gives deluxe watches an aura of true understated luxury.

You need patience and you have to work accurately when photographing jewelry and watches, but t he reward is a fantastic range of wonderful subjects.

High-end mechanical watches are miniature marvels of engineering. A mechanical movement can take as long as a year and a half to build and can cost a six-figure sum. Logically, great care and precision are required when photographing these masterpieces.

Watches are made from a wide variety of materials that require specific types of illumination and are, accordingly, difficult to photograph. Most watches need to be lit in a different way than their straps, and the case usually requires a different treatment than the face. Highlights give a watch case a vivid look, but they make the face unreadable, and the material of the strap needs to be accentuated in its own right.

Recent developments in digital photography have made it relatively simple to merge multiple source photos into a single finished image. Some images are constructed from three or four source photos, but other images require more, depending on the situation. The different parts of a watch also require different post-processing techniques, and the face is often sharpened more than the rest of the watch to make it more legible. Public relations photos are exempt from some of these rules because they are intended to show a watch in a neutral state rather than in the near perfection of an advertisement.

The most widely used position for watch hands is 10:08, which forms a positive V shape and leaves the top center of the face open, which is where the manufacturer's logo is usually placed. Some manufacturers prefer to use a different position for the hands. Maurice de Mauriac, for example, uses the less conventional 10:38.

Many watch shots are taken with the strap closed around a Plexiglas ring, which emphasizes the size of the watch case in relation to the strap. Some photographs show a watch placed flat on a surface, but this type of shot usually conceals the strap in some way to prevent it from distracting the viewer from the main subject. The watch itself has to be completely still, and the hands shouldn't move during the exposure. If you are photographing a quartz watch, you can simply remove the battery, whereas you will have to stop the balance wheel in a mechanical watch. If this can be achieved only by pulling out the crown, you will have to retouch it back into the correct position during post-production. Most watch manufacturers provide appropriately doctored model watches for photo shoots. It goes without saying that watches for a studio shoot have to be brand new without any signs of wear whatsoever.

Photographing Jewelry

Jewelry photography is very much a job for patient tinkerers. Rings are usually photographed standing up. But, because most rings are not broad enough to stand up on their own, they have to be fixed in place with some kind of putty or instant adhesive. Most adhesives can be

effectively removed from precious metals with acetone. Positioning jewelry involves patience and deftness, especially if you are shooting sequences for a catalog. Setting up necklaces and other jewelry is also painstaking work, and it often helps to mount them on showroom dummies or other appropriately shaped objects to provide tension between the links and preserve the subject's shape. If I am shooting multiple pieces of jewelry for a catalog page, I switch off the telephone and try to concentrate completely on the work in progress. Photographing jewelry requires a high degree of concentration and inner calm.

Lighting

Lighting is an extremely important aspect of jewelry photography. Shiny materials reflect their surroundings, so we have to set up the lighting in the rest of the studio to correspond to the angle of reflection of the subject. This can be especially tricky with rounded subjects because they reflect in all directions at once. One solution to this problem is to use a light tent. This accessory produces a modulated light that gives jewelry a radiant, three-dimensional look. Occasional dark areas provide extra contrast to the highlights and accents and are an important part of every jewelry composition. Generally speaking, jewelry shots contain very few midtones and are dominated by the contrast between light and dark. We usually use soft light and avoid overexposed highlights, except in rare cases when a bright accent is required. But take care—it is very easy to produce images with too little contrast and no well-defined bright and dark zones. Shots like this tend to make jewelry look like it is made of plastic.

On the other hand, precious stones require harder, more frontal light to highlight the sophistication of the cut. This sometimes requires double exposures, but it can also be achieved through the skilled use of lighting, mirrors, and shooting angles.

Lenses

The only real choice for photographing watches and jewelry is a top-notch macro lens. Image sharpness has to be spot-on in a jewelry shot, and the camera has to be capable of reproducing a high degree of detail. It is impossible to replace or retouch missing detail, so I always use a medium-format back for these shots. This gives me sufficient resolution and fine tonal transitions. Digital image sensors, with their relatively small size and high resolution, are perfect for this type of work when they are used with appropriately high-end lenses. Even if they are destined to be published at small sizes, jewelry and watch shots have to look perfect in every respect. Similar to how most of the ingenuity that goes into a watch is concealed in the case, a watch photographer strives to produce images that embody a subtle but tangible degree of precision.

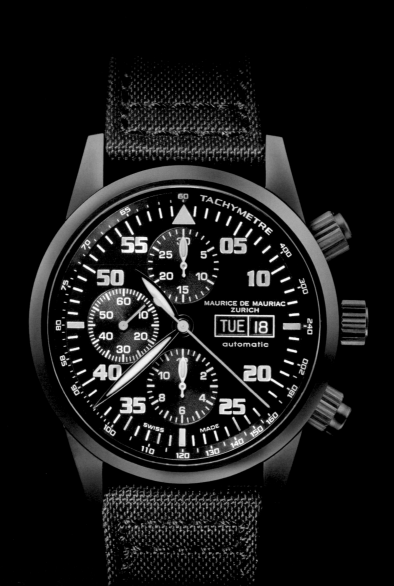

Black Chronograph

This chronograph has a classic black-on-black design. Photographing this particular watch against a black background means shooting each individual black tone separately to keep the contrast clear and suspenseful.

This image might look simple, but creating it was anything but. The materials of the watch-case, face, and strap reacted to light in completely different ways, and I had to take separate photos of each component and merge them into one. Due to the different nature of each material, such an approach is nowadays standard practice for watches.

It is critical to ensure that the watch is securely mounted so it can't move between shots, and it is best to mount the camera on a heavy support to ensure that it also remains static during the shoot.

The first shot was exposed for the background and the shadow, and it served as the base into which I inserted the other images. The second exposure was made for the strap, the third for the metal case, and the fourth for the face. Each exposure was made with slightly modified lighting settings and reflector positions.

I concentrated on optimizing each shot for the specific part of the watch I was dealing with. The distinct shapes of the parts made it relatively easy to select them with paths. The retouching steps I performed to achieve the final result are explained on page 145.

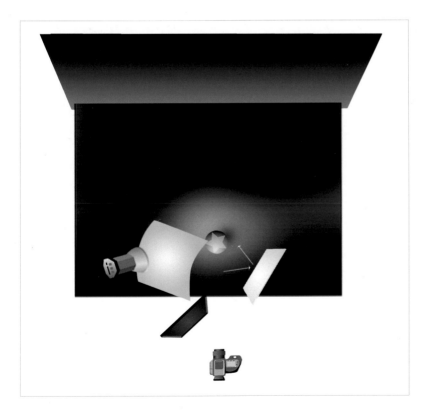

Technical Data

Camera:	Hasselblad H4D
Format:	50 megapixels
Lens:	Hasselblad 120mm HC Macro
Exposure:	f/16, 1/125 second
Lighting:	1 lamp with a honeycomb filter for the shadows
	1 lamp with frosted Plexiglas for the watch
Background:	Black FOBA TT Plast
Comments:	Four merged source images. Various silver reflectors for the individual shots.

Shooting Steps

The watch had to be prepared before the shoot could begin. The hands had to be set to the manufacturer's preferred time, and the screw-down crown had to be unscrewed to prevent the movement from running. I then mounted the watch on a plastic stand that I got from a jewelry store and thoroughly cleaned it to remove any fingerprints and dust.

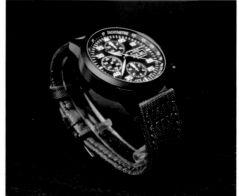

I fixed the watch in place with Blu-Tack to prevent it from moving between shots. After the camera was in position, I took the initial background photo that included the shadow. I used a lamp with a dense honeycomb filter and a diffuser positioned at front left to produce a shadow on the right.

I used the same lamp (without the honeycomb filter) for the other shots. I positioned it frontally for the strap and laterally for the case, and I adjusted the positions of the reflectors accordingly. This way, I ended up with three additional images of the strap, the case, and the watch face that were captured with exactly the same camera position and aperture setting.

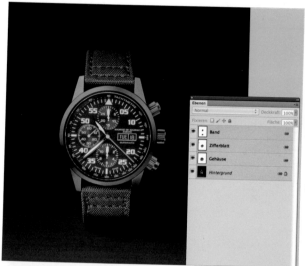

I began by selecting each component with paths. I then mounted the three additional shots into the background. To get the crown back into position, I selected it and copied it onto a separate layer before inserting it in the correct position and merging it with the case layer.

Retouching was necessary in the gaps between the case and the strap, where the plastic stand was still visible. I used the Healing Brush tool to clean up a couple of dust particles that had somehow found their way behind the glass.

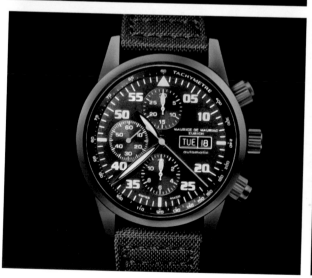

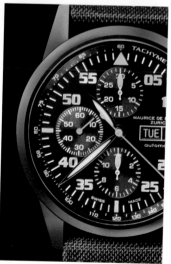

Finally, I did some work on the case to emphasize its curves and to give the dark tones extra contrast. The case still looked a little matte in the original photo. I also increased the contrast in the face and darkened its shadow areas. This makes it look a little sharper, and its complex structure is less distracting. I also increased the contrast for the hands and the smaller dials to give them a little extra presence.

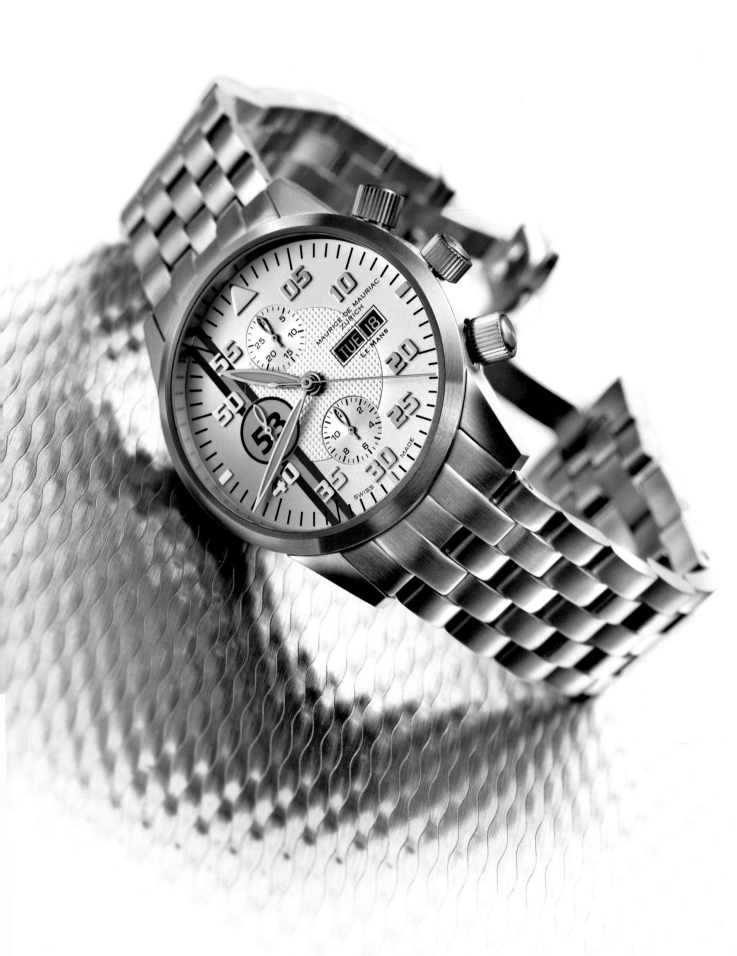

Le Mans by Maurice de Mauriac

This design is dedicated to the famous car race. I wanted to capture the dynamics of auto sport with a diagonal composition, and I used my lights to get the best possible effect out of the chrome case and strap.

The metal sheet I used as a background had an interesting but not too distracting pattern that also reflected the outline of the watch. I used backlight to fade out most of the background, leaving the texture visible only in the reflection and making the rest of the surroundings white. This shot then served as the background for the others.

I used a number of small silver reflectors for the shot of the strap. They reflected the light directly back and produced multiple highlights. I used a similar technique to produce the highlights in the case, while taking care to position them at regular intervals to emphasize the circular shape. For the fourth shot, I used a circular silver reflector to produce a gradient on the watch face, and I exposed the final shot for the winders.

This approach allowed me to capture each separate part of the watch using an ideal exposure without moving the camera between shots. It is important to avoid changing the mood of the lighting too much between shots if the final merged image is to look balanced.

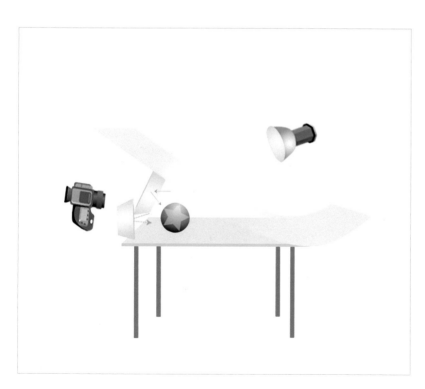

Technical Data

Camera:	Hasselblad H4D
Format:	50 megapixels
Lens:	Hasselblad 120mm HC Macro
Exposure:	f/11, 1/125 second
Lighting:	1 lamp with Folex translucent sheeting
Background:	Textured sheet metal
Comments:	Five source images merged into one. Various silver reflectors used for each shot.

Shooting Steps

The lighting setup in this shot is based on soft backlight, which was produced with a light tent covering the entire table and lit by a single lamp. This basic setup was used to take the background shot of the watch and its shadow.

The remaining shots were then captured without moving the watch or the camera. Using hand-cut reflectors made from shiny, semimatte, and matte silver card from a stationery shop, I reflected the backlight onto the front of the watch for the additional shots of the case, the strap, the face, and the multiple winders.

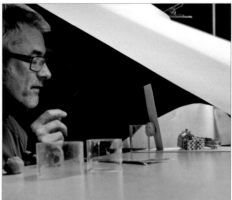 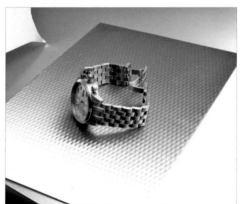

These photos show some of the additional reflectors I used. They produced small-scale lighting effects that are extremely difficult to produce with individual lamps. My homemade reflectors were surprisingly bright and worked like small lamps in their own right. Once again, the winder crown had to be loosened to prevent the hands from moving during the shoot, and it was retouched back into place later on.

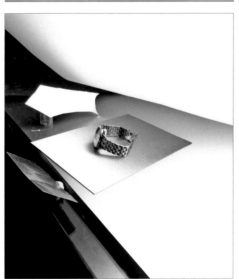 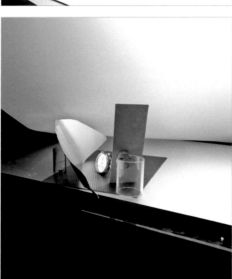

Processing the background shot. The other layers have already been selected with paths and have been inserted, but they are hidden in this screen shot. Because the camera position and the focus setting remained static between shots, all five layers fitted together perfectly.

The image looks quite different with all the layers visible. The basic backlight effect is the same, but the watch itself is much brighter and well defined. Once again, the winder crown was selected, copied, and inserted in the correct position on a separate layer. Here, you can see the second crown in the position it was in while I was shooting. In this case, I had to use the Clone Stamp tool to cover the parts of the strap that were affected by removing the original crown.

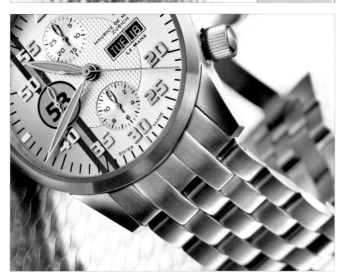

Finally, I copied some of the brighter highlights in the strap and inserted them in places where the original highlights weren't shiny enough. This was especially true in the areas just beneath the case. I then increased the detail contrast in the face and the hands, and I brightened the date display.

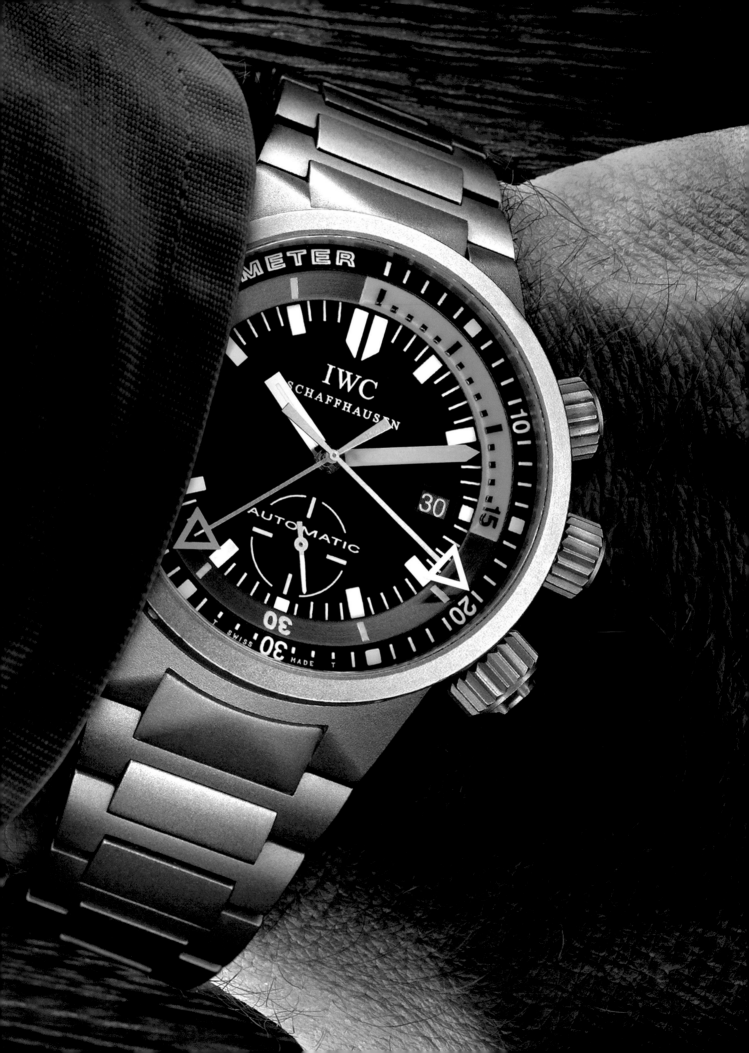

IWC Deep One

I have been working for IWC for several years and have done several public relations shoots for Lange watches. This type of photo is designed to show watches in real-life situations and is deliberately styled to look less sterile than a catalog shot while still showing the watch in the best possible light.

IWC manufactures large, masculine watches with an obvious technical slant. Speaking from personal experience, I can confirm that these watches are of the best possible quality, and it is a great feeling to wear such a mechanical masterpiece on your wrist. This is exactly the feeling I wanted to communicate in this shot of the Deep One diver's watch—a glance at my own wrist, as it were.

I lit this shot with a single circular white neon tube that surrounded the model's hand during the shoot. The light from the tube gave the hand, the shirt, and the watch strap an interesting look, but it left the watch face somewhat in the dark due to its slightly raised position. I was able to work around this problem by taking a second shot with the neon tube positioned slightly higher, which made the case and the watch face brighter without producing unwanted reflections. I admit that the look of the merged image is slightly unusual, but it is an experiment that I think worked out quite well overall.

Technical Data

Camera:	Hasselblad H4D
Format:	50 megapixels
Lens:	Hasselblad 120mm HC Macro
Exposure:	f/22, 2 seconds
Lighting:	1 circular white neon tube (300 mm/11.8 in diameter)
Background:	Wood panel
Comments:	Two shots with the neon tube in different positions: one for the model's hand and one a little higher for the watch itself. Watch photographed using additional reflectors (see sketch). Source images merged in Photoshop.

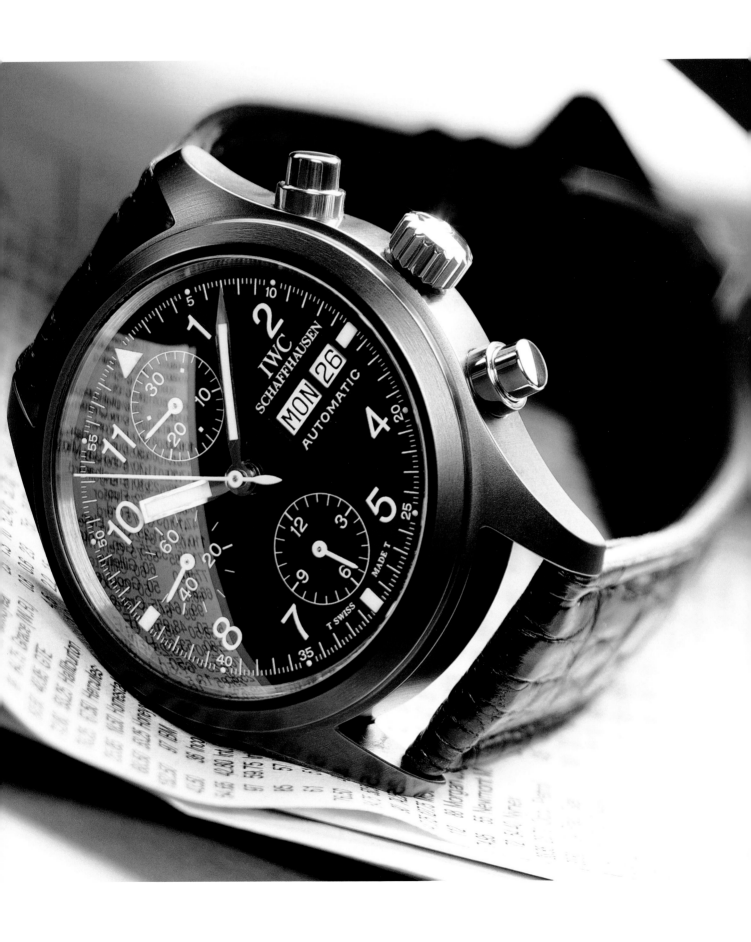

Pilot's Chronograph

This public relations shot shows a titanium IWC watch that has obviously just been taken off and placed on a magazine. Small details, such as the reflection in the glass and the over-exposed highlight on the crown, give this photo an authentic photojournalistic look.

I created this image with the first really usable studio camera, the Sinar p2 with a Sinarback 22 (with 2000 x 2000 pixels of resolution). The photo was used as an 85x85 cm (33.5x33.5 in) poster at the photokina trade show in Cologne, Germany, and the original 12-megapixel image was resized in Genuine Fractals Pro. I am still amazed at the quality of the results, which once again confirms that megapixels alone are not a sure-fire recipe for quality.

I shined my single lamp through some translucent sheeting in which I had cut a random pattern of holes. This allowed direct and diffused light, with a difference in brightness of about 1.5 stops, to reach the subject. It produced a pleasing mix of bright and dark areas with alternating hard and soft light. This allowed me to create accents for important parts of the subject while deadening the light in less significant areas. I couldn't reduce the power of my flash unit enough, so I used modeling light to illuminate the scene. I used a wide aperture combined with lateral and vertical Scheimpflug movements to orient the plane of focus so it would precisely match the plane of the watch face and blur the background. I converted the print file to black-and-white and tinted it with Photoshop's Duotone mode.

Technical Data

Camera:	Sinar p2
Format:	Sinarback 22, 12 megapixels
Lens:	240mm Sinaron-N
Exposure:	f/5.6, 2 seconds
Lighting:	1 lamp
Background:	Finance pages of a newspaper
Comments:	Translucent sheeting with a cutout pattern of holes for mixing direct and softened light

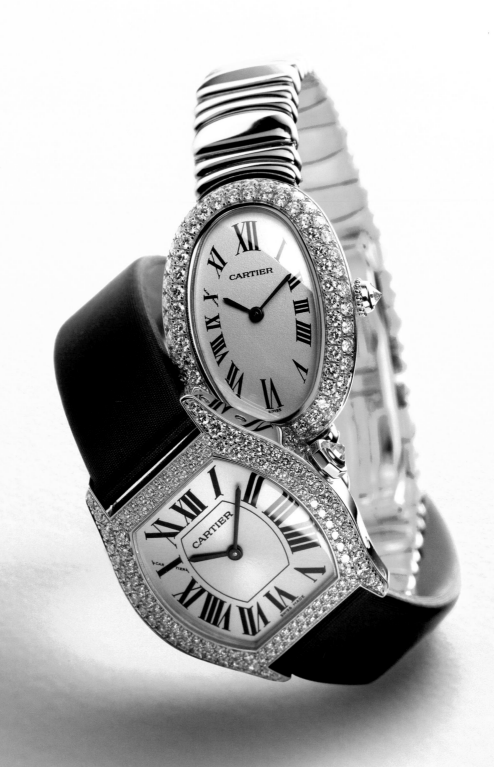

Cartier Ladies' Watches

Watches designed for women often emphasize appearance over telling the time, and these two diamond-encrusted models are no exception. This playful shot with its pastel tones and unusual arrangement looks like a spontaneous snapshot.

Both watches were mounted on plastic stands. It was difficult to position the watches so the stands were invisible, so I used very narrow stands and placed them as far to the left within the watch straps as possible. The other major challenge was arranging the watches to give them a dynamic look. I solved this dilemma by suspending them from silk threads. I wanted the overall lighting to have a soft, warm tone with a slightly blue-tinted shadow to provide contrast.

I used frosted sheeting lit from behind to provide soft backlight. I partially filtered the light source using a Rosco 1/2 CTO tungsten filter. I lightened the overall scene with a piece of blue card and created highlights in the watch faces and the diamonds with small hand-made silver card reflectors. This produced a slight complementary contrast between the light and dark areas within the frame.

I always leave the watch glass in place because the reflections it sometimes produces does not bother me, and I find the look more authentic. It is virtually impossible to prevent reflections in curved watch glass.

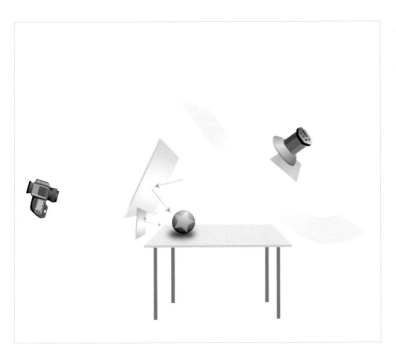

Technical Data

Camera:	Hasselblad H4D
Format:	50 megapixels
Lens:	Hasselblad 120mm HC Macro
Exposure:	f/9, 1/30 second
Lighting:	1 lamp with a wide-angle reflector
Background:	Handmade watercolor paper
Comments:	The watches were suspended from silk threads that were edited out during post-production

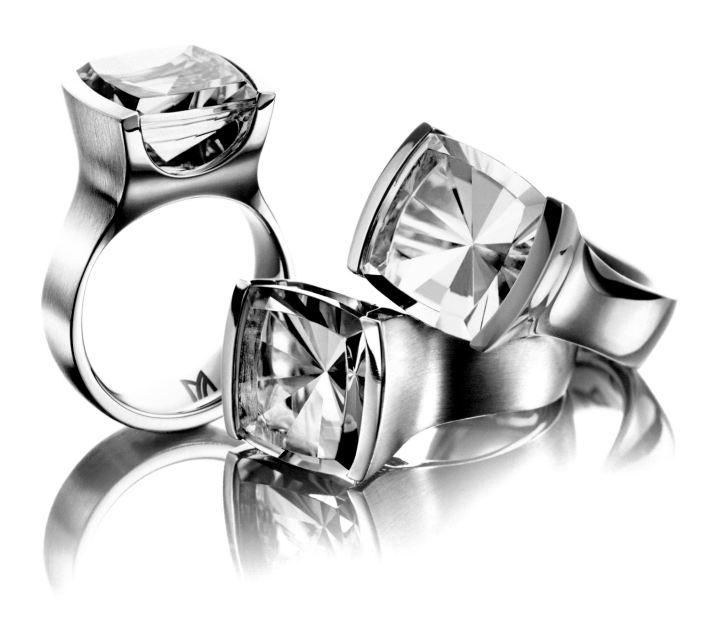

Rings Set with Gemstones

Advertisements that show jewelry at enlarged sizes present a unique challenge. Each piece has to be invisibly mounted, and the lighting has to be coordinated to work with the metal and the stones.

This shoot was a job for one of my most faithful clients, who I have been working with for more than half my career. We have been through a lot together in the field of jewelry photography. This subgenre is tricky to get a handle on and is a continual learning process. We worked on this shot step by step to get the light, the reflections, and the fire in the stones looking just right.

The basic setup is relatively simple, but the real art lies in using the right combination of hand-cut reflectors and positioning them to create perfect reflections in the metal and the facets of the gems. Once again, we had to pay close attention to the Angle of Incidence = Angle of Reflection rule. My hand-cut and hand-shaped reflectors are the key to the many highlights and accents and the effective display of fire in the stones. These are tiny but very important details. Many jewelry clients think that precious metal should reflect brilliantly and evenly, whereas it is the contrast between bright and dark areas that brings photos of rings like these to life. The rings were placed on reflective metal foil that I brightened and softened during post-production. The precise differentiation between the yellow, white, and rose gold pieces and the accurate reproduction of their colors were major parts of post-production.

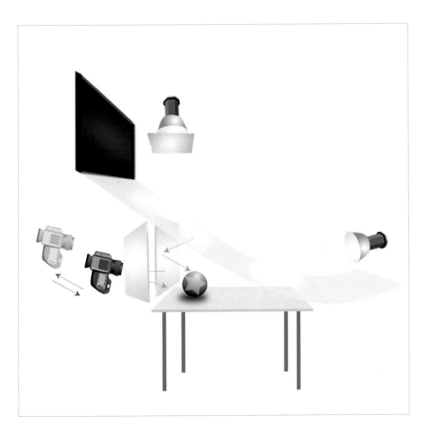

Technical Data

Camera:	Hasselblad H4D
Format:	50 megapixels
Lens:	Hasselblad 120mm HC Macro
Exposure:	f/11, 1/30 second
Lighting:	1 lamp with a diffuser
	1 lamp without a diffuser
Background:	Reflective metal foil
Comments:	Two silver card reflectors to brighten from the front and set accents. Camera positioned on the boom of a FOBA studio camera stand, which allowed it to be moved backward and forward. Two shots (one of the standing ring and one of the two lying down) were merged during post-production.

I used FOBA Trans-Lum sheeting to form a light tent over a glass table. The sheeting is positioned very low and extends beyond the camera position to prevent reflections of the surroundings from appearing in the shiny surfaces of the subject. Hand-cut silver card reflectors create highlights from the light tent at the front. The rings are placed on shiny metal foil, and the camera is located about 20 cm (7.9 in) away on a heavy-duty camera stand.

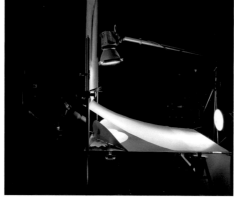
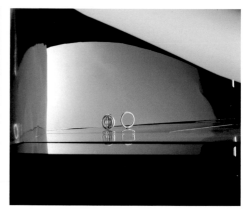

These photos document the mounting procedure against a white background. (It would be too confusing to demonstrate the actual mounting process—which was on reflective foil—because the foil would create reflections.) Here, you can see the tiny balls of Blu-Tack I used to fix the rings in place. I used cotton gloves to avoid leaving fingerprints on the metal, and I used a tool from my dentist to remove excess adhesive.

I then used Dust-Off to remove dust and dirt from the set. The right-hand photo shows how close the camera is to the subject. It is mounted on the boom of my camera stand at full extension, which allowed me to swing it in and out of position when swapping out the subject or making alterations to the set. The camera stand is locked to the studio floor and the head is locked into position so I can mount the camera multiple times in exactly the same position.

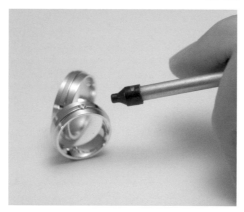
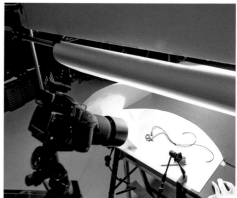

I use special industrial Blu-Tack from a builder's supplier, but conventional Blu-Tack or plasticine does just as well. In emergencies, I sometimes use tiny drops of superglue, which can be removed later with acetone. Dust-Off is a must for this kind of work if you want to avoid a lot of retouching later.

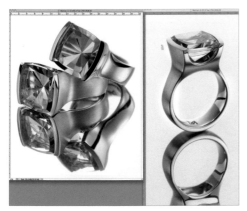
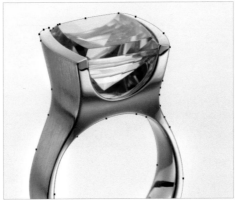

Because of the depth of field, the finished image (page 156) couldn't be captured in one shot. In the two original shots, I selected the rings and their reflections with paths. I used a 6-pixel radius for the reflection paths to give them a softer edge.

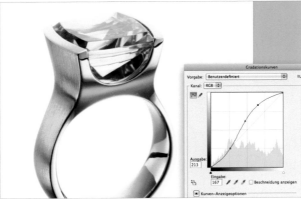

First, I inserted the ring and the reflection on separate layers. I then applied a gradient to the reflection layer and brightened the midtones to soften their overall effect. I gave the ring itself a more vivid look with the Curves tool, and I manually reduced the increased saturation this caused.

I used the Healing Brush tool to retouch the tiny occlusions and dust specks on the surfaces of the rings. The two foremost rings reflect each other's colors, so I selected the one made of white gold separately and reduced the color saturation for the object and its reflection. I then repeated the process for the rose gold ring to give the pair a balanced look.

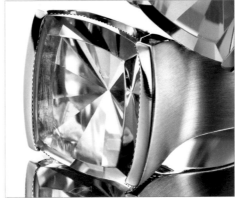

I also selected the stones and used the Curves tool to give them a harder, more luminous look. I removed the slight yellow reflections in the pink stone by using the Brush tool in Color mode. The very last step was, of course, merging the two shots into one.

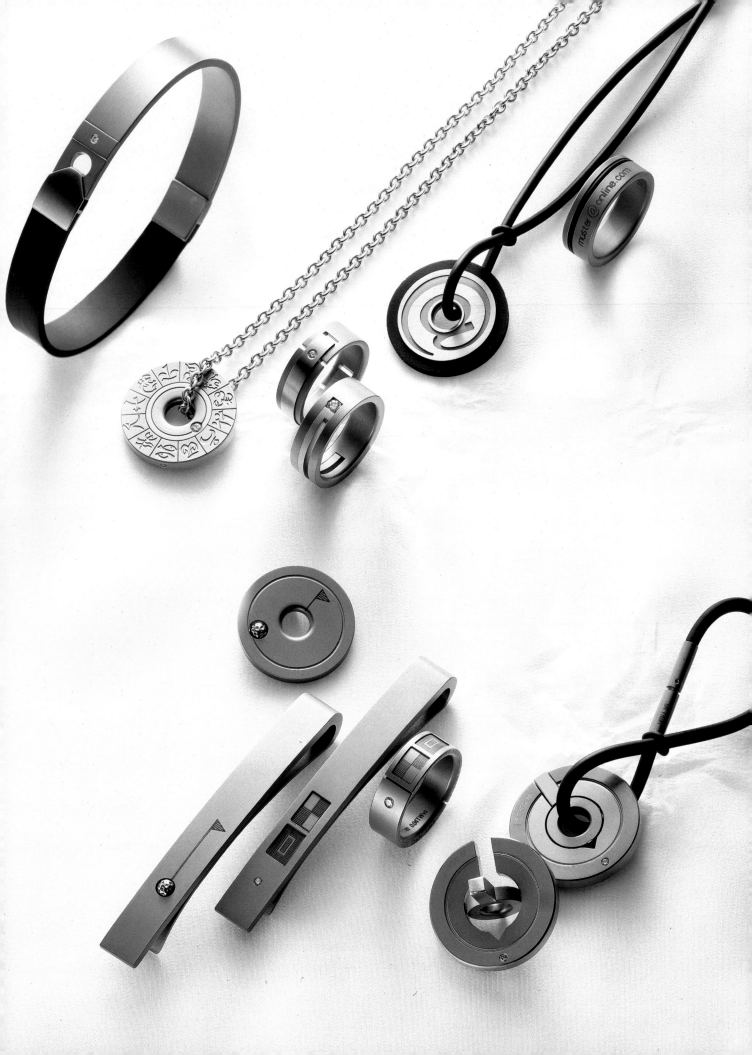

Titanium Jewelry Tableau

Sometimes it is preferable to display multiple pieces of jewelry in a tableau. In such situations, it is impossible to concentrate on each individual piece, and arranging the scene can be a serious test of the photographer's patience.

This image is one of 12 pages shot for a catalog of men's titanium jewelry. This metal has a matte gray shimmer and is very sensitive to fingerprints. It looks best when it has been completely rubbed with oil from the wearer's skin. In its dry state, the inconsistencies in the surface of the material are too obvious.

I smoothed the background fabric before I wetted it and deliberately crumpled it in some places. I slightly warmed the tone of the light with a LEE 1/4 CTO filter, which shifts the color temperature toward orange by about 800 K. I used a LEE 1/4 CTB filter for the highlight lamp, which shifts the color temperature by about 800 K toward blue. This combination produced a mixed cold/warm mood. This men's jewelry is more solid than its counterparts for women, so I was able to position it with just a few needles pushed through the fabric into the Styrofoam underlay for added stability.

I gave the lens standard 6 degrees of forward tilt and stopped down to f/32 to increase the zone of focus to include the bracelet. The overall sharpness is good, but the fine details suffered due to the small aperture. All in all, this shot involved a lot of compromise in both the exposure and the lighting.

Technical Data

Camera:	Sinar p2
Format:	Sinarback 54H, 22 megapixels
Lens:	Rodenstock 480mm Apo-Ronar
Exposure:	f/32, 1/30 second
Lighting:	1 lamp with a 1/4 CTO filter
	1 lamp with a 1/4 CTB filter
Background:	Ecru fabric
Comments:	6 degrees of Scheimpflug tilt in the front standard

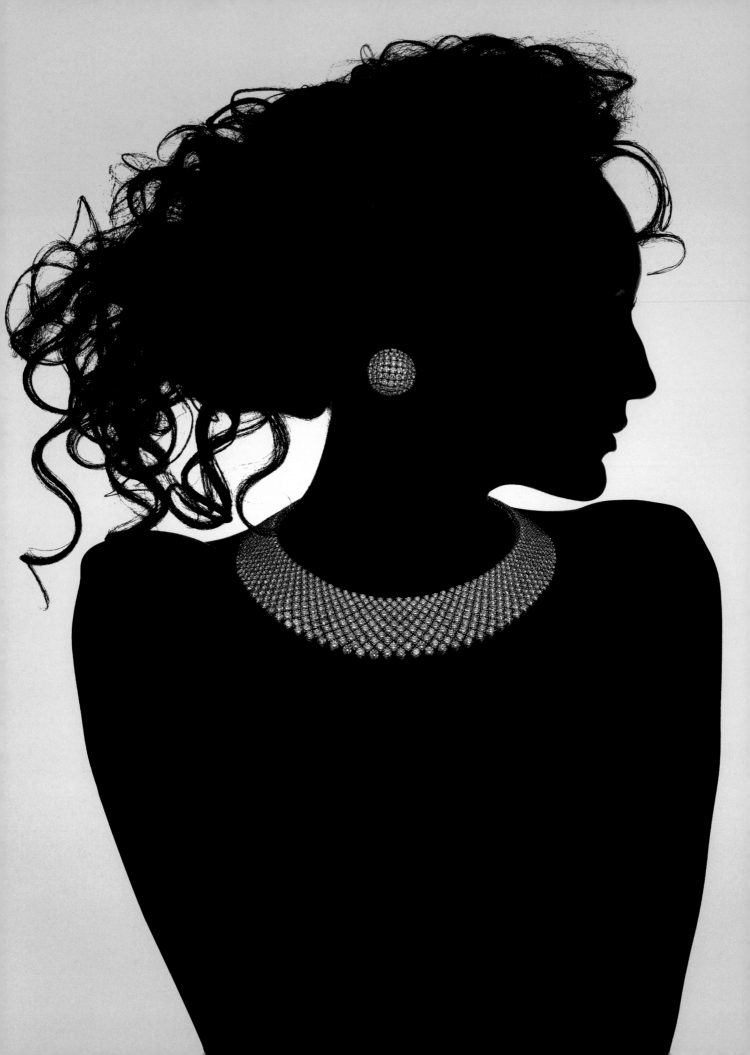

Female Silhouette with Necklace

This series of advertisements for a small, exclusive, high-end jewelry manufacturer uses a silhouette of the model to let the jewelry speak for itself.

This two-day shoot involved 64 different scenes with eight different silhouettes, all portrayed by the same model wearing different wigs. I chose a model with a classical profile, and Maciria Rossi, our hair and makeup artist, brought along a truckload of wigs and a lot of crazy styling ideas. She understood the concept immediately and concentrated on giving the silhouettes as much character as possible from the start.

I built a 4 m (13.1 ft) tunnel out of black fabric and lit the white background at its end with two color filtered lamps. I used a lamp with a honeycomb filter behind the model to create a bright spot in the center of the background. The fabric tunnel eliminated stray light from the background in the model shots, although I was able to introduce and control a small amount of overexposure at the edges of the frame by positioning her farther back. The farther forward she stood, the sharper the silhouette effect.

The art director selected eight images that best matched the proposed layout, then I photographed the jewelry to fit the images in a separate session and merged the pairs of images later.

Technical Data

Camera:	Sinar p2
Format:	Sinarback 54H, 22 megapixels
Lens:	Rodenstock 30mm Sironar-N
Exposure:	f/22, 1/30 second
Lighting:	2 lamps with diffusers and light blue filters
	1 lamp with a honeycomb filter
	2 softboxes (Deep Octa 100 and Rotalux 80)
Background:	White paper
Comments:	Two shots with identical perspective, merged in Photoshop

Shooting Steps

I constructed my 4x3 m (13.1x9.8 ft) black fabric tunnel with four FOBA stands, and I placed the color filtered background lights behind its walls. You can also see the honeycomb filtered spot that I used to brighten the center of the background behind the model.

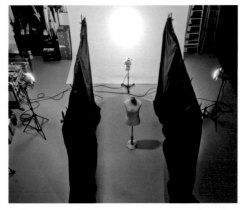
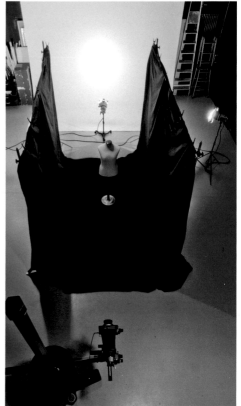

The setup for the shot of the diamond necklace involved mounting it on a bust covered in black velvet. I lit the necklace with Deep Octa 100 and Rotalux 80 softboxes. The background was made of black fabric.

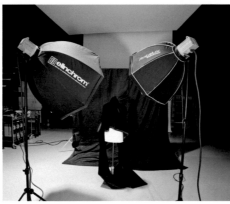

The jewelry shot seen from close up with the camera in position. I used two small shades to prevent stray light from behind from getting into the shot. I used the Scheimpflug principle (i.e., forward tilt in the lens standard) to keep the necklace sharp throughout the frame.

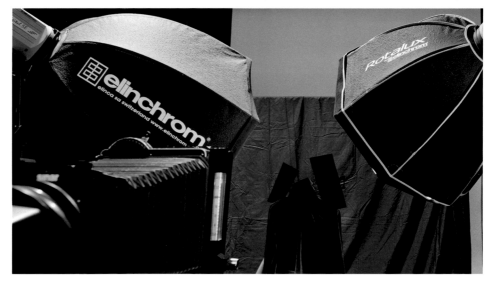

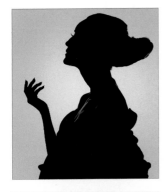
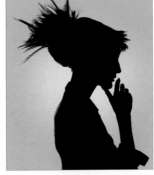
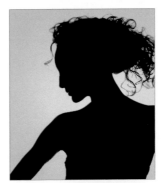

These are 6 of the 64 shots we took of the model with various wigs and styling effects. We kept the basic the setup the same and shot eight versions of each costume to give the art director a choice. We kept the jewelry in mind throughout the shoot and tried to match the styles we created to the different pieces. The four images on the left were taken with rings in mind, and the other two were shot for the necklace shown below.

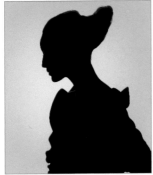

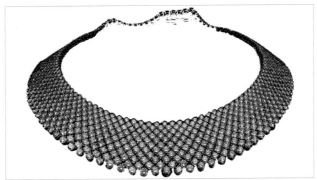

This is the necklace after I selected it in Photoshop for merging with the silhouette. This shot was taken to precisely match the model's position and perspective. To ensure a perfect fit, we used CaptureShop to superimpose the images during the shoot.

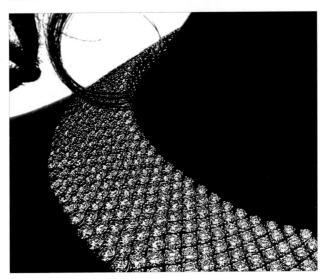

This is the final merged image. The shading that I used while shooting the necklace gives it a realistic, three-dimensional look, and details like locks of hair covering parts of the necklace heighten the realism.

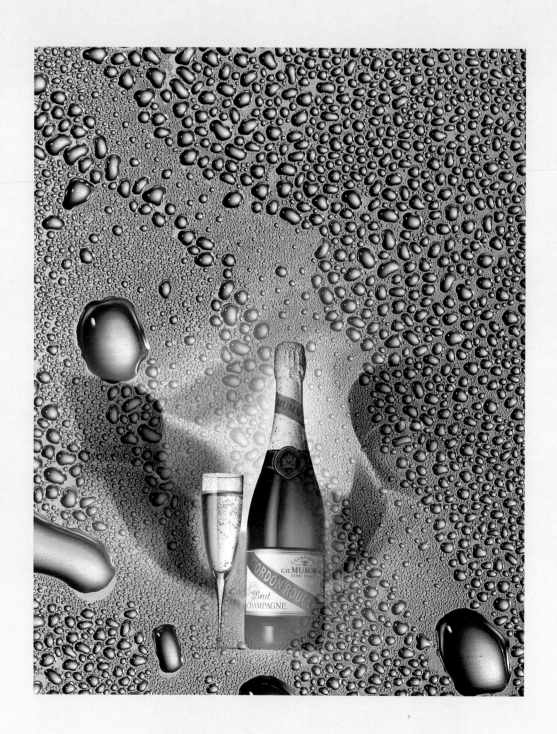

Drinks

Drinks are one of most attractive subjects that a photographer can hope to encounter, but they are also one of the most difficult to portray successfully.

Photographing Freshness

I clearly remember one particular summer afternoon in the Ratskeller in Munich. The Sun was shining through a window, and the light fell directly on the cold beer in front of me, giving it a golden glow and causing the fine drops of condensation on the glass to form larger droplets that slid their way slowly downward, forming intricate paths along the way.

This was an image of delicious freshness that couldn't be beaten. I couldn't resist drinking the beer and destroying it! But there were plenty more images like this that had indelibly engraved themselves on my mind over the years and begged to be reproduced in the studio. Although capturing those images turned out to be a lot more complicated than I thought, it was an interesting and educational journey that paid off in the end. But, once again, let's look at first things first.

Condensation

Successfully portraying natural phenomena requires a thorough understanding of how they arise and can be extremely time consuming.

How are perfect droplets created? The difference in temperature between a cold liquid and its warmer surroundings causes fogging on the surface of the glass, which itself consists of microscopic water droplets. As soon as the two temperatures begin to equalize, the tiny droplets form larger, visible drops. When these larger drops reach a certain size, gravity gains the upper hand over adhesion, and the drops run down the glass, forming wonderful patterns along the way and eventually leaving the glass clear of condensation. These are the photogenic moments that I wait for, but how can I produce and regulate them myself?

Normally, the adhesion on a glass surface is quite weak, but it can be enhanced by applying greasy wax, which causes the droplets to become larger before they succumb to gravity. Using a glass polished with Turtle Wax, I can control the creation and behavior of the droplets virtually at will. The droplets can remain stable for as long as 15 minutes, and I can add more using a spray bottle. If possible, I prefer to spray with an airbrush because I can precisely select the size of the droplets I create, and it allows me to exactly reproduce a certain memory of a sunny afternoon in Munich.

Foam

Foam is a different story. Beer foam is caused by the carbon dioxide (CO_2) in the liquid, which is a volatile gas that quickly disperses, causing the foam to collapse. Unfortunately, I have never found a convincing substitute for beer foam, so I always work with the real thing. The trick I use is to repeatedly inject CO_2 to produce new foam. I use the gas canister for my airbrush and simply attach a hose-mounted head with a small sponge on the end. This device ensures that the gas is distributed very finely within the liquid, and the hose lets me inject gas at the bottom of the glass—I'll tell you why this is necessary later on. You can create foam that lasts longer by pouring beer slowly from an increased height, which is useful if you have to photograph multiple glasses and you can't use a gas hose.

Ice

I typically use artificial ice cubes made of Plexiglas. Real ice doesn't behave reliably and melts too quickly. In fact, I have found that plastic ice cubes often look more real than the real thing in photos, probably because we imagine that ice looks like it does in the advertising world, and the real thing simply doesn't fulfill our expectations. Now and again, we have to resort to creating images of people's fantasies rather than reality.

Smoke and Steam

There are various ways to produce convincing artificial smoke and steam, and the method you choose will depend on the effect you want to achieve. Vapour Effect from Condor Foto is one product that produces consistently good results.

But beer isn't the only drink that has to be photographed, and each individual drink has its own particular characteristics that have to be brought to the fore. Coffee has to have just the right froth, Coca-Cola has to be just the right color, and tea needs a plume of fine steam in order to look authentic. Drinks is a photographic subgenre in its own right, and it gives tinkerers and technicians plenty of opportunity to test their artistic mettle. Drink shoots often take place in studios that end up looking like chemistry labs, but they still have to produce natural-looking images that conjure up feelings like the one I described at the beginning of this section. The aim of the game is to provide the viewer with a purely visual liquid experience.

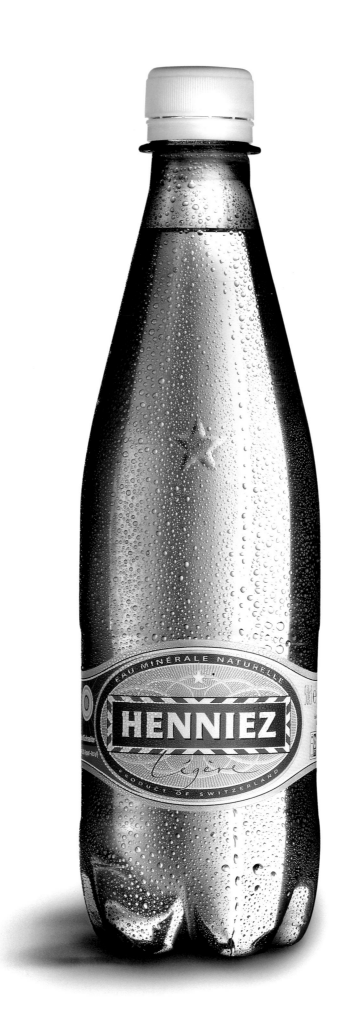

Mineral Water

Normally, package shots play a secondary role in product posters; the main emphasis is on a lifestyle message or an action still. In this case, however, the bottle was the sole star, and it had to look appropriately fresh and inviting.

The main thing to look out for when creating shots like this is the quality of your props. Products that you buy off the shelf simply don't fulfill the necessary requirements. Most bottles have scratches caused by automatic filling machines, and the labels are never positioned centrally or horizontally. This kind of model has to be made by hand, and this means getting absolutely new and unused bottles, labels, and caps from the manufacturer.

The first step is to polish the bottle with car wax (Turtle Wax works well) to give the water droplets some extra adhesion and prevent them from running too quickly. Then use an airbrush or a spray bottle to cover the bottle with fine droplets. Make sure the label doesn't get covered in too many droplets if you want it to remain legible. If necessary, the label can be photographed separately without any droplets at all, as can the bottle's shadow.

Technical Data

Camera:	Sinar p2
Format:	Sinarback 54H, 22 megapixels
Lens:	Rodenstock 480mm Apo-Ronar
Exposure:	f/22, 1/30 second
Lighting:	2 lamps with diffusers
Background:	FOBA Trans-Lum sheeting
Comments:	One brand new plastic bottle photographed without a label. Label shot separately with small droplets and mounted centrally. Shadow photographed separately for subsequent montage.

Rub Turtle Wax into the bottle until the entire surface looks matte and milky. The wax prevents the water droplets from running off too quickly.

 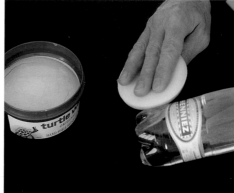

Now polish the wax until the bottle once again looks transparent and shiny. The wax is no longer visible, but it forms a greasy layer that causes large water droplets to form and remain in place.

 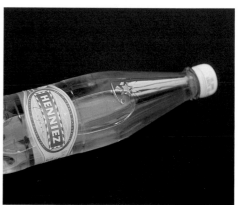

Use a spray bottle with a fine metal nozzle to cover the bottle with water vapor. Spraying produces a somewhat even coverage of droplets. Then use a syringe to create a couple of rivulets that would normally be caused by larger droplets running off.

 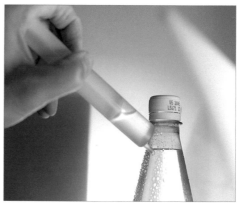

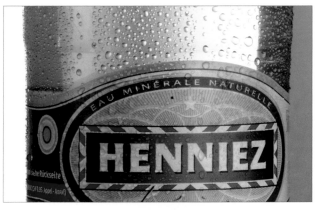

The basic bottle shot. The label is difficult to read because of the droplets that have formed on it. Droplets at the edges of the bottle have been cut off by the selection process. I deliberately kept this shot soft with less detail definition and contrast than desired for the final image. At this stage, the emphasis is on preserving the full range of tonal values.

This is the extra shot of the label, taken before the bottle shot to keep the number of droplets to a minimum and maintain good legibility. I also made a shot of the cap without any droplets for later insertion into the final image.

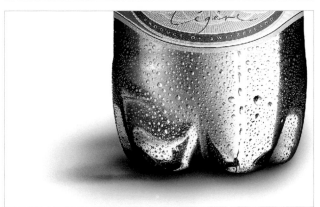

It is extremely difficult to create a realistic-looking shadow digitally, so I took an extra shot of just the shadow for insertion later. I compressed the shadow in the final version and darkened it to enhance the overall effect.

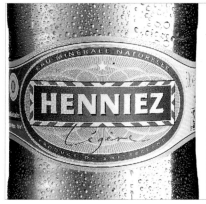

Here you can see the layers that make up the final image. The bottom layer is the shadow, followed by a blue tint mask (for the shadow) and the bottle layer. Next are the label and cap layers. I adjusted the white and black points in the layer with the droplets to increase the contrast and give the droplets a more vivid look. I shifted the colors to create cooler blue tones (especially in the shadows), which gives the whole thing a fresher feel.

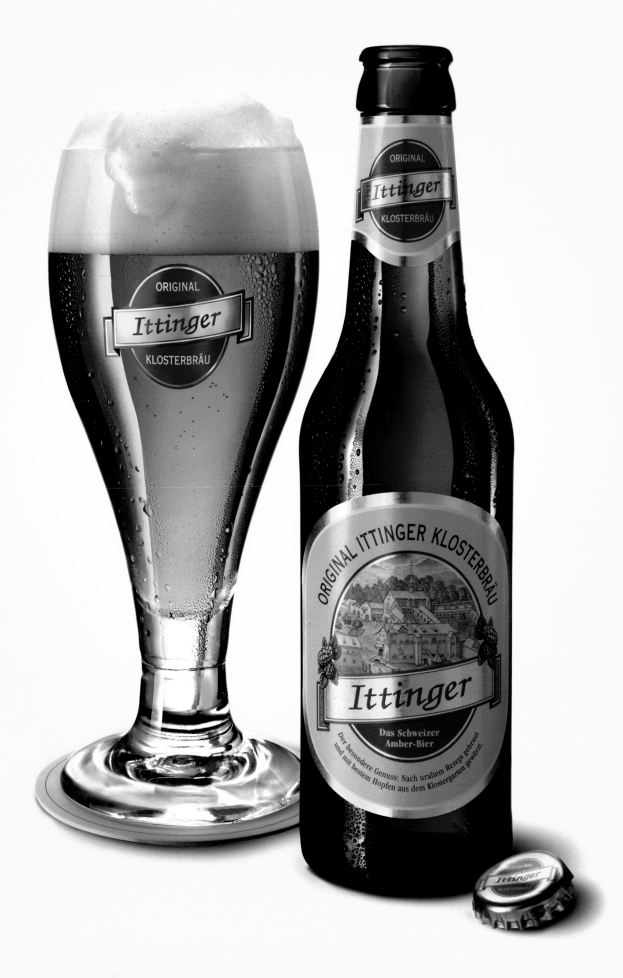

Amber Beer

Beer shots are tricky at the best of times. The droplets on the glass and the foam have to look simultaneously perfect, which requires precise planning. This advertising shot of a gourmet amber beer promises pure enjoyment.

Here too, the bottle and the glass were carefully prepared before the shoot. Rear labels spoil the effect and are not used in shots like this. In this case, the client requested that we produce an image with no droplets at all on the label, so I photographed it first in a dry state for later insertion into the image of the bottle with droplets.

I began by setting up the lighting to bring out the best in the wonderful colors of the beer, from golden yellow through reddish orange to dark brown. Only then did I add droplets with an airbrush while taking care not to damage the foam, which was by this time already collapsing. After I had the lighting and the droplets looking just right, I used my hose-based CO_2 supply to produce fresh foam in the glass. The gas has to be injected as a fine spray, and it must be well distributed within the liquid to produce a realistic-looking foam head. My assistant provided an aquarium aerator that I attached to the hose on my air-brush, which is the perfect tool for repeatedly producing fresh beer foam without having to move the glass from its position on the set. The Turtle Wax that we rubbed onto the surface of the glass before shooting helped the water droplets stick in place and gave me time to deal with the foam between shots.

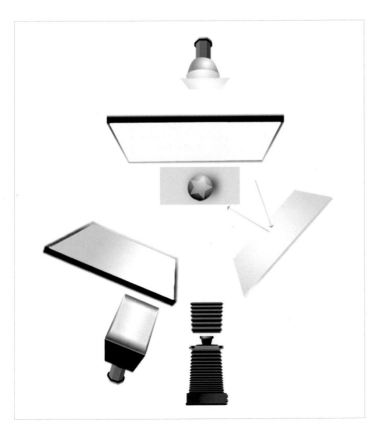

Technical Data

Camera:	Sinar p2
Format:	Sinarback 54H, 22 megapixels
Lens:	Rodenstock 480mm Apo-Ronar
Exposure:	f/22, 1/30 second
Lighting:	1 lamp with a diffuser
	1 overhead strip light
Background:	FOBA Trans-Lum frosted sheeting
Comments:	New bottle photographed without a label. Label shot separately and mounted centrally. Foam, glass, and shadow all photographed separately. Background created digitally in Photoshop.

Shooting Steps

This is the set for the beer shot. The background is constructed of FOBA Trans-Lum sheeting mounted on FOBA stands and struts. The pedestals for the beer and glass (which I photographed separately) are in front of it. I positioned a translucent sheet for the strip light at front left and an accent light on the right. I always try to build my sets at a practical height. This is physically more pleasant and prevents fatigue.

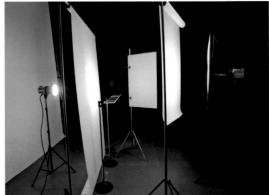

On the left is the device I use for producing beer foam. The aquarium aeration sponge (on the right) ensures that the CO_2 forms fine bubbles in the liquid, which then produces realistic-looking foam with very fine pores. This way, it is possible to repeatedly produce foam without having to move or refill the glass.

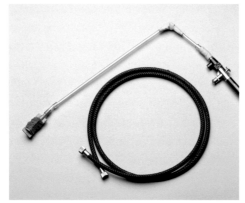

An airbrush is a high-end alternative to a spray bottle for producing water droplets on the bottle. An airbrush allows me to produce various sizes of much finer, more realistic-looking droplets wherever I need them. This approach requires the use of a gas canister with a pressure reduction valve and a hose attached to the outlet. This is a worthwhile investment if you shoot a lot of drinks. The optimum gas pressure is about 1.5 bar.

I then softened the aquarium aerator in a glass of water before attaching the hoses to the gas canister. I sprayed the droplets onto the glass before I created a fresh head of foam (on the right).

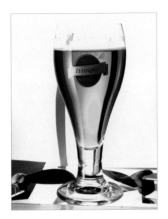 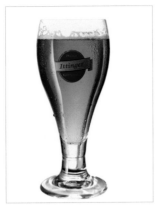 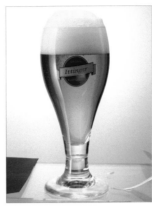

The lighting setup without droplets and the base shot for the glass with droplets. The droplets behave like an additional diffuser on the surface of the glass, so the light I used had to be harder than I needed in the final image. The foam required separate lighting to prevent it from looking too dark.

For this shoot, the client wanted the labels to appear without any droplets, so I photographed them dry in the correct position before selecting them and inserting them into the droplet image. This approach allowed me to optimize the lighting exclusively for the labels without having to worry about causing unwanted reflections in the glass.

The illustration on the left shows the layers that make up the final image file. I grouped the layers to give myself a clear overview. The glass, bottle, and bottle cap all had to be available as separate layers. I also needed a version of the glass without the beer mat, as well as open and closed and wet and dry versions of the bottle. This resulted in 14 separate layers. On the right, you can see the finely differentiated droplets that I was able to create with the airbrush setup described earlier.

Drinks—Amber Beer

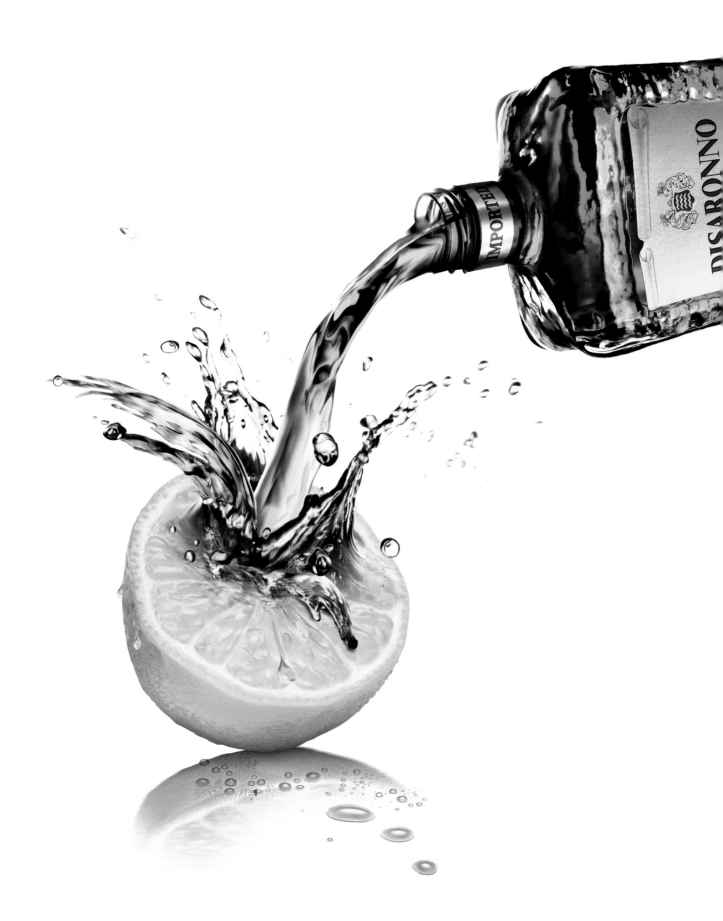

DISARONNO on . . .

This series of posters and magazine ads for an Italian liqueur was designed to show in a spectacular way that the drink is also great for making cocktails. The stars of this show are a coffee bean, an ice cube, and a lemon.

As is often the case in advertising, this campaign was designed to provide an over-the-top image of the product. This campaign followed in the spirit of an earlier, successful one that showed the product placed next to the additional ingredients. The new campaign was designed to show a dynamic stream of the drink hitting the additional ingredients and causing a splash.

This was a tricky shot, and I spent a lot of time trying out various ways of creating and capturing a splash. In the end, I created the effect I was looking for by pouring the liquid out of a glass and suddenly stopping the pouring motion the moment my assistant released the shutter. The real DISARONNO is a sticky, syrupy liquid, so I replaced it with water and food coloring for the shoot. I shot several dozen splash images to give myself choices at the post-processing stage. I then photographed the bottle neck with the stream of liquid, which also required a number of attempts to get the right look. The client wanted a full bottle, so I shot it separately, too. The final step was to capture the lemon with its reflection and the extra drops of liquid.

The final image was built from 12 separate photos. I followed the same procedure for the remaining two ads, with a coffee bean and an ice cube as the key ingredients.

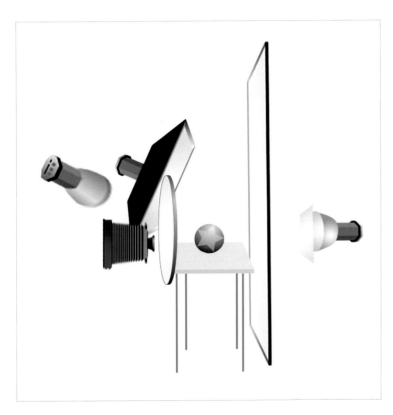

Technical Data

Camera:	Sinar p2
Format:	Sinarback 54H, 22 megapixels
Lens:	Rodenstock 75mm Grandagon
Exposure:	f/22, 1/30 second
Lighting:	1 lamp with a diffuser
	1 lamp with a telephoto reflector
	1 softbox as a small accent light
Background:	Glossy white Plexiglas
Comments:	12 individual shots merged in Photoshop

Shooting Steps

To begin, I used a razor blade to remove the labels from the backs of the bottles. I then filled the bottles and brought them into position. The first shot was of a full bottle—logically, with its cap!

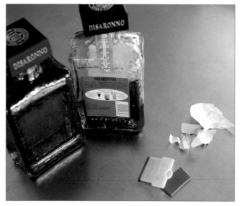
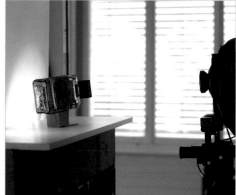

The second shot was of the bottle neck and the stream of liquid. The original bottle didn't produce a very nice looking stream, so I used a different bottle for this shot. In turn, this meant I had to take a separate shot of the original bottle neck for inclusion in the final montage. I also photographed the lemon separately and retouched it to remove the small seeds.

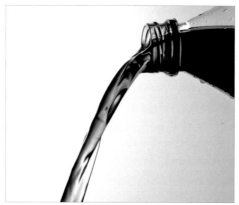
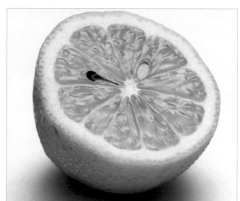

The next stage involved creating the splash. I shot three sets of 40 shots each. For the first set, I tipped liquid out of a glass; in the second set, I used compressed air to eject the liquid from a bowl; in the third set, I shoveled the liquid out of the bowl with my fingertips. I needed shots that included movement to all sides, so I constructed the final splash from 8 of the 120 source images I had captured. It wasn't easy finding a compromise between the art director's brief and my own ideas.

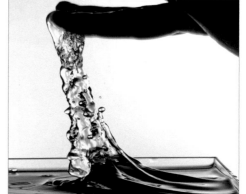

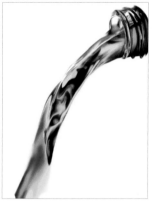

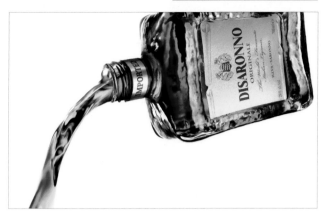

The first stage of post-processing involved merging the bottle, the bottle neck, and the stream of liquid. This was all because the client wanted the shot to include a full bottle, which involved a lot of retouching and perspective fine-tuning.

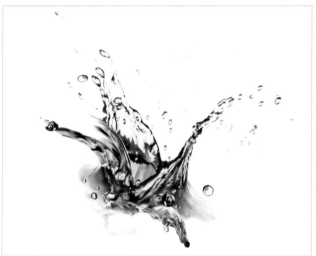

I then built up the splash from my source images and added the stream of liquid. I used wide-radius masks and the Warp function in Photoshop's Transform tool to smooth over the transitions. The Liquify tool, introduced with Photoshop CS5, produces similar results, but it opens a separate processing window that obscures the other parts of the image, making it difficult to work with accurately.

This illustration shows the 21 layers of the final image file in their final state before flattening. The uppermost layer is the layout layer, which I constantly used to ensure that my adjustments fit into the overall image/text concept. I always keep the layers versions of files like this in case any adjustments have to be made later. For this project, post-processing took about 12 hours.

Drinks—*DISARONNO on . . .*

Macallan Whisky

Whisky connoisseurs—and especially lovers of single malt—
tear their hair out when they see their favorite drink served
on the rocks. However, the American way of serving whisky is
still the most popular in the world and, as a consequence, it
is often used in advertising.

Whisky develops its special aroma during years spent maturing in wooden casks, so as-
sociating it with wood in a photo like this was a logical step. The dark wood also provided
a wonderful contrast to the golden color of the drink itself. The major challenge in this shot
was getting the whisky to appear to glow. The glass and the bottle were placed on a wood
panel directly in front of another piece of wood. The single lamp lit the scene from the left
through a small sheet of Plexiglas shaded to prevent stray light from reaching the rear wall
of the set. I used a small mirror to reflect a tiny highlight onto the label from the right to
make it legible.

I positioned two tiny hand-cut reflectors behind the glass and the bottle to reflect light
through them, giving them the glow effect I wanted. Although I used only one lamp, a
clever use of reflectors and mirrors produced the effect of a multiple-lamp setup.

Real ice melts too quickly and, curiously, doesn't look like we imagine it does in a drink, so
I used ice made of Plexiglas instead. Real ice is transparent only as it just beings to melt,
and it is full of bubbles and occlusions that can easily spoil the effect of a shot. Melting ice
cubes also become rapidly smaller and dilute the whisky.

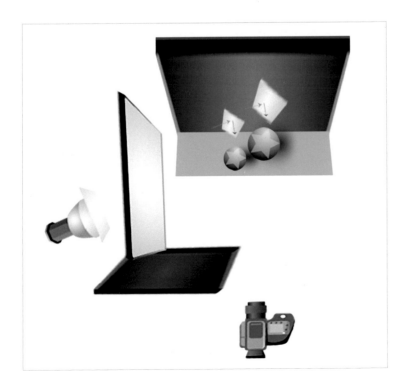

Technical Data

Camera:	Hasselblad H4D
Format:	50 megapixels
Lens:	Hasselblad 120mm HC Macro
Exposure:	f/22, 1/30 second
Lighting:	1 lamp with a diffuser
Stage:	Wood
Background:	Wood

Food

If nothing else, food photos should
make you feel hungry!
Freshness and a natural look
are important factors if you want to
stimulate the viewer's taste buds.

Whetting the Viewer's Appetite

Food photography is a lot of fun. Virtually everyone reacts positively to great food photos, and it is an appetizing genre that is full of variety. If, like me, you are a hobby cook, food shoots can be really exciting, and educational too.

A love of cooking and all things culinary will give you the necessary drive to photograph food well. In food photos, it is easy to tell whether the photographer loves the subject or not.

The ingredients for a studio shoot have to be fresh, so you will need to have good, reliable contacts in the delis and food shops in your region. Many magazine articles are produced one to three months in advance of publishing, so if you live in a region with well-defined seasons, you will have to be sure that you can get the right ingredients at the time of the shoot. Getting in touch with wholesalers and food importers can help.

Even if you have a food stylist or cook to help you, it is a good idea to have some basic knowledge of food and cooking before you start on this type of job. Foreknowledge of your subject gives you an edge when it comes to discussing a job with a client, and it helps you influence the decisions that are made during the production process. You will need to have some kind of cooking facility in your studio or, if you plan to do regular food shoots, a full-scale kitchen. A food stylist or a cook is just as important as the photographer if a food shoot is to be a success.

In addition to showing an inherent love of food and cooking, all great food photos radiate natural freshness and simply make the viewer want to eat. Food shots are often taken in daylight or natural-looking artificial light and, due to the similar nature of many of the subjects, they are usually taken from the same few viewpoints with the same perspective. The three most-used food shot viewpoints are vertically from above, diagonally from above, and horizontally with a slightly raised camera angle. The first and last of these represent a more graphic approach, while the second more closely represents our own view of food that we are eating. What this all boils down to is that in food photography, the creativity lies in what happens on the plate rather than in the lighting or the setup in the studio.

As already mentioned, freshness is essential, making it impractical to spend hours arranging a set. I sometimes use an old prearranged plate while setting up a shot and replace it with a fresh one for the actual exposure. This way, the lighting and camera position are already set up, and I have to make only small adjustments—if any—before pressing the shutter release.

Smooth teamwork is essential. A food stylist has to account for the perspective and the intended position of the plane of focus, as well as the type and direction of the light, while setting up a dish. In addition to their styling and compositional skills, good food stylists also need to have wide-ranging culinary knowledge on tap, and they have to know how to prepare all types of food in a photogenic way. Last but not least, a food stylist also has to know all about cutlery, crockery, and table accessories. It's a tough job!

Food and accessory styling is often performed by separate, dedicated specialists. I often work with a cook and a stylist. However you divide up the work, it is important for each member of the team to understand the other people's jobs. For example, the choice of ingredients and the method of cooking influence the ways in which the finished dish can be styled, which influences how the finished photo will look. It is impossible to build in details that haven't been planned from the start, so it is vital for everybody involved to know exactly

what is expected of them. I consider the stylist to be the most important person on a food team. Food photos are all about delicious-looking food, and even the most sophisticated lighting cannot compensate for food that doesn't look good. A very small number of food photographers act as their own stylists and work with just a cook—an enviable combination of talents.

Many outsiders still think that food photography involves a lot of artificial primping and preening to get the subject to look right. This was probably true 30 years ago when photographers had to work with hot lamps, low-resolution film, and a general lack of specialist cooking knowledge. Nowadays, if you stick to a few basic rules, you really can't go wrong. For example, to keep vegetables looking fresh, don't boil them for too long, and let meat cool down before cutting it to keep it from losing color. There are very few tricks that are necessary in contemporary food photography. Everything I photograph gets eaten after we are finished!

The few props that are still essential include:
→ A spray bottle or an airbrush to keep vegetables fresh, add water droplets, and keep meat looking juicy, or to add moisture exactly where you need it
→ Brushes to moisten surfaces or add oil
→ A long pair of tweezers for making fine adjustments to the individual elements of a dish
→ Cling film to use as an invisible float to keep the ingredients in a soup from sinking to the bottom
→ A set of sharp knives to make clean cuts
→ An electric whisk for making coffee froth
→ A meat thermometer
→ A refrigerator and a freezer with sufficient space for all the ingredients on the set
→ An electric mixer, if you do a lot of work with dough that has to be mixed or kneaded, to get the job done more quickly than a hand whisk

Apricot Gratin

The feeling of sitting outdoors in summer and enjoying a light meal is a difficult one to beat, especially in regions where the summer is short. That is the feeling I wanted to evoke with this shot.

The set consisted of a few untreated spruce planks along with blue and white tableware arranged by the stylist to look informal, just the way it would in a garden. I shot from almost vertically above to underscore the graphic nature of the setup on our table. A Fresnel spot provided hard, sunlike light, and a Styrofoam reflector brightened the shadow detail and reduced the overall contrast, thus enhancing the sunny mood.

The red napkin and the gratin's yellow and brown tones provided a counterpoint within the frame, which was created by the blue and beige tones in the surroundings.

A good food stylist has to be a master of form and color and has to know exactly how a dish will look before it even goes in the oven. The photographer's job is to use light to capture this idea in a lively, mouth-watering photo.

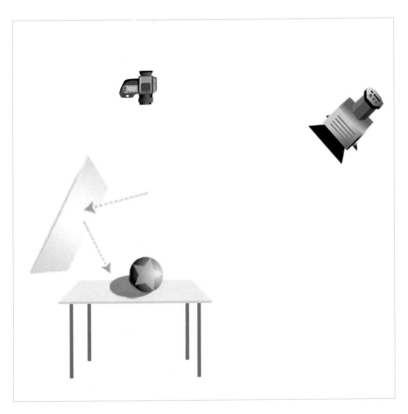

Technical Data

Camera:	Hasselblad H4D
Format:	50 megapixels
Lens:	Hasselblad 120mm HC Macro
Exposure:	f/16, 1/30 second
Lighting:	Fresnel spot
	White reflector
Background:	Untreated blond wood

Beef Noodle Starter

Braised meat is one of my personal favorites. I love the mixture of tastes created by braising meat, vegetables, and herbs.

For this shot I used the unique Briese Focus lamp. Its flash tube is attached to a bracket that can be moved backward and forward within the built-in parabolic reflector. This allows it to be adjusted from soft to hard without losing definition and shape. In this case, I used a soft setting, with the tube located at the front of the reflector.

I produced the brighter light toward the edge of the frame with an additional lamp and a honeycomb filter, as well as a number of small mirrors to reflect its light onto the linen tablecloth. This produced a slightly speckled light that had virtually no effect in the center of the frame but brightened its edges. I could have produced a similar effect by adding a vignette during post-production, but I think the slightly random feel of the transition produced by the lamp is more natural looking. I often use a cold dish identical to the one I am photographing while I am setting up a shot, and I replace it with a fresh one when everything is ready. Generally, more food is prepared on a food shoot than is actually used in the photos, so keeping an extra plate on hand is usually not a problem.

Technical Data

Camera:	Hasselblad H4D
Format:	50 megapixels
Lens:	Hasselblad 120mm HC Macro
Exposure:	f/8, 1/30 second
Lighting:	Briese Focus 100, set to soft
	1 lamp with a honeycomb filter
	Mirrors
Background:	Brown linen tablecloth

Fried Sbrinz Potatoes

A table-level view is a popular food photo viewpoint. Combined with reduced depth of filed, this angle produces images with a feeling of great spatial depth.

The colors play an important role in this image. The blue and cyan tones of the surroundings frame the complementary golden yellow tones in the fried potatoes. To use this contrast to its fullest, I added a cool blue filter to one of the lamps reflected from above. This created a blue gradient on the surface of the table, on the cutlery, and in the metal tray; the other lamp produced neutral accents and held the overall light in balance. In the setup, the blue lamp acted as a backlight and the neutral one was aimed frontally, which kept the two tones separate and prevented the final image from looking too blue. A viewpoint like this requires a composition with spatial depth and background elements—such as a table edge or a wall—to underscore it. This approach often requires more props and more complex sets, but the results speak for themselves. Especially for editorial shots, this approach gives a shot a more authentic, real-life feel than one shot from above.

Technical Data

Camera:	Hasselblad H4D
Format:	50 megapixels
Lens:	Hasselblad 120mm HC Macro
Exposure:	f/5.6, 1/30 second
Lighting:	2 lamps with wide-angle reflectors (1 with a blue filter) Stage: Violet stone slab
Background:	Blue and white glazed wood

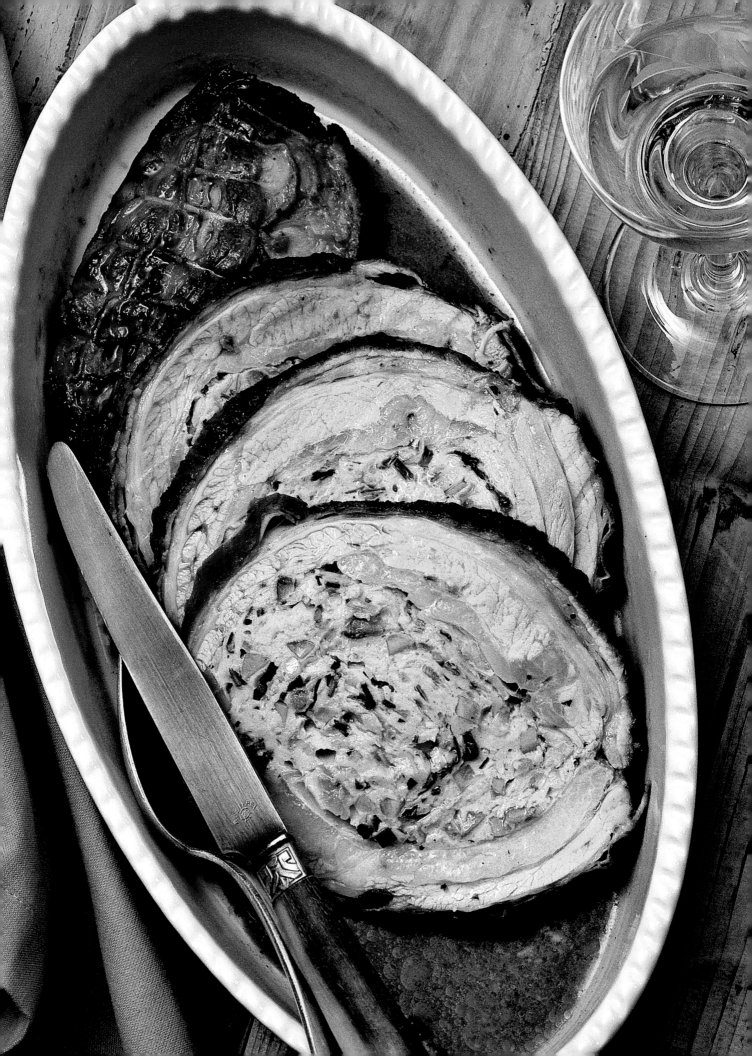

Stuffed Breast of Veal

Meat has a reputation for being difficult to photograph, although this is a view I don't share. All you have to do is stick to a couple of basic rules to get meat looking as appetizing as it does in this shot of a traditional dish.

This shot comes from a book of traditional Swiss recipes. The photograph was shot with simulated daylight and a Nikon D3 set to ISO 1600. My Hasselblad's detail rendition and hyperaccurate color reproduction would have been too much of a good thing for this job, so I deliberately introduced some image noise along with desaturated colors and a non-neutral color temperature. I wanted the cool daylight to contrast with the warmer room lighting, and I achieved this effect by using a backlit FOBA Trans-Lum sheet brightened with a blue card reflector.

We selected some old wooden tables, traditional linen napkins, stone slabs, and metal sheeting with patina as our props. We got the used tableware from thrift stores.

When photographing meat, it is important to let it cool before cutting it, otherwise it loses its juice and its color too quickly. If you let a roast like this one go completely cold, it won't lose color when it is exposed to the air. Cut meat has to be brushed with water every now and then to keep it looking moist. The sauce has to be hot so it will retain its color and consistency.

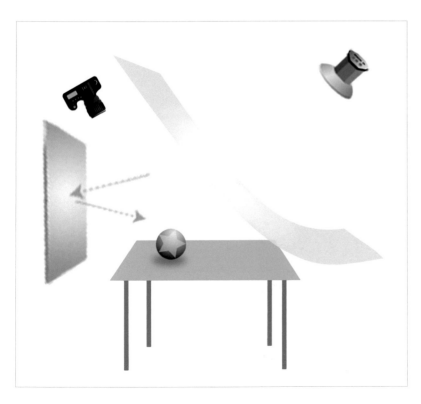

Technical Data

Camera:	Nikon D3
Format:	12.3 megapixels, full frame
Lens:	105mm f/4 Micro-Nikkor
Exposure:	f/16, 1/400 second
White balance:	4000 K
Lighting:	1 lamp with a wide-angle reflector
	FOBA Trans-Lum sheeting
	Blue card accent reflector
Background:	Wood panel
Comments:	Shot at ISO 1600

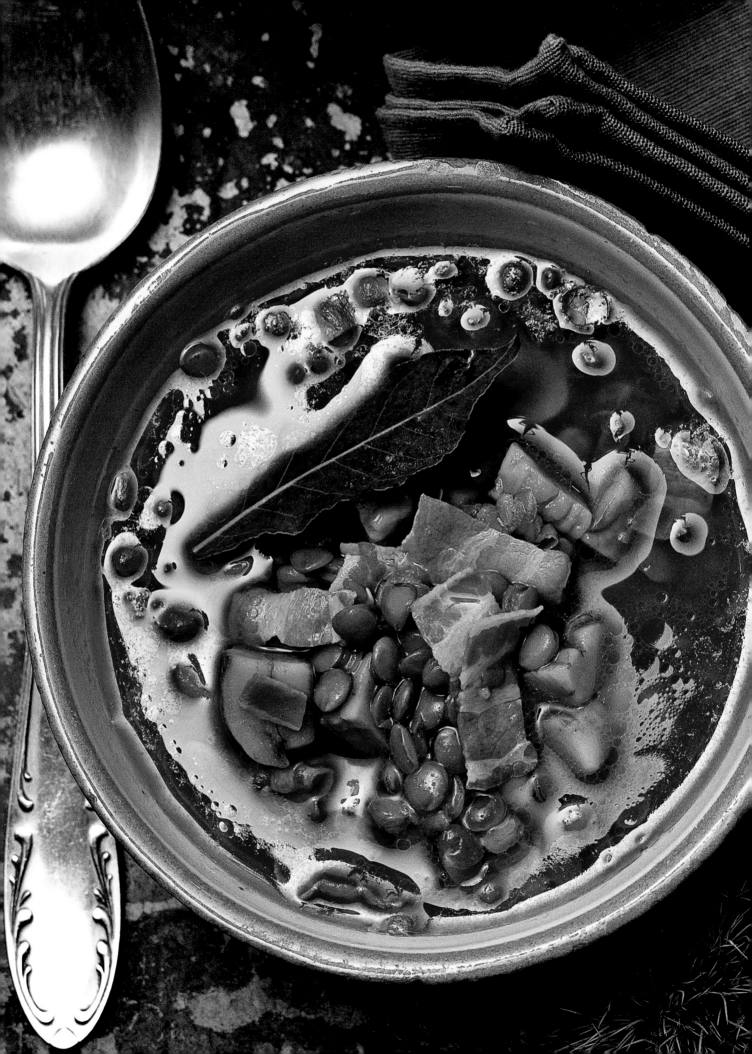

Ticino Lentil Soup

Photographing soup involves unique challenges. Reflective surfaces and ingredients that simply sink to the bottom make a soup photographer's life quite tough. However, as we know, challenges demand solutions.

Some slight reflections and highlights on the surface of a soup are fine as long as the ingredients below remain visible.

The ingredients in thin soups sink immediately, but you can use a layer of cling film cut to shape and laid carefully on the surface to prevent this from happening. You can then lay the ingredients on top of the film and add some soup to cover the film without sinking it. The rich soup in this image is full of ham, lentils, and chestnuts, and it required no trickery to get the ingredients to poke above the surface of the liquid.

Because the shoot was for a book of traditional recipes, the stylist decided to use old tableware from a thrift store and traditionally rustic background materials. As in the previous example, I used my Nikon D3 set to ISO 1600 to give the image a natural look with a little deliberate noise to simulate film grain.

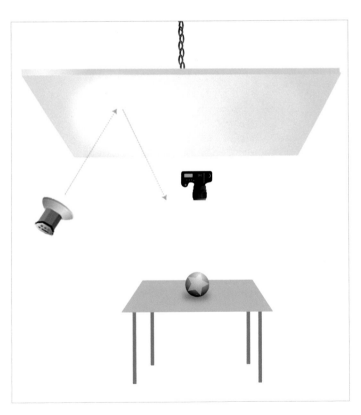

Technical Data

Camera:	Nikon D3
Lens:	105mm f/4 Micro-Nikkor
Exposure:	f/16, 1/30 second
Lighting:	1 lamp with a wide-angle reflector
	Ceiling reflector
Bakground:	Sheet metal
Comments:	Camera set to ISO 1600. White balance toned down for cooler color rendition.

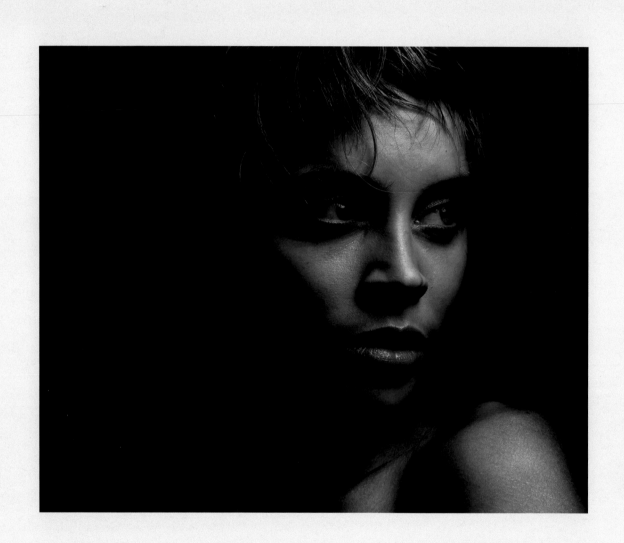

Portraits

Portraits is a wonderful genre for photographers who don't covet the limelight. The star of a portrait shoot is the person in front of the camera, not the one behind it.

The Star Is the Person in Front of the Camera

Successful portraits rely on the photographer's interest in people and the desire to learn something about the subject. Curiosity regarding a person's personality, character, and appearance provides the creative input necessary for fascinating portrait shots. And remember—interesting doesn't have to mean beautiful.

People often look their most interesting and display real character when they don't try to show their best side. A photographer is often more interested in aspects of a subject's character that he or she wouldn't normally want to reveal. A portrait photograph embodies the photographer's own subjective, external view of the subject, but it is nevertheless capable of revealing characteristics that accurately describe the person being portrayed. If we are honest, we will see that there is no such thing as an objective view of a person because everyone has their own personal view of themselves and those around them. This situation gives the photographer a lot of artistic freedom, restricted only by the respect that should always be shown to others.

Portrait Styles

Portraits of inexperienced subjects require not only photographic skill, but also a little psychological talent on the part of the photographer.

Many different approaches to taking portrait photos have been well documented in the work of the greats of the genre. During a lecture that I was lucky enough to attend, Richard Avedon said that he was heavily influenced by an exhibition of paintings by Austrian painter Egon Schiele that he visited in his youth. Schiele became famous for the incisive portraits of working-class people and prostitutes that he painted in the early years of the 20th century. His portraits presented a radical counterpoint to the ideals of beauty of the time and portrayed society's lower classes with a hitherto unknown clarity and brutality. This honesty made a lasting impression on Avedon, and from that moment on, he knew exactly how he wanted to work. His photos of his dying father and his famous In the American West sequence follow these ideals and communicate their messages in an inescapably direct fashion.

In contrast, Irving Penn was the great aesthete of his time. In his famous 1950s photos of ordinary people in their work clothes, Penn meticulously posed his subjects to convey perfection and dignity. His photos of his wife, Lisa Fonssagrives, are formal compositions designed to portray flawless classical beauty.

Annie Leibovitz often portrays her subjects in complex surroundings and uses her photos to tell stories about them. Leibovitz manages to show unknown facets of her subjects' personalities by photographing them in unusual surroundings. These are just three examples of the radically different approaches taken by some of the world's best-known portrait photographers.

Commissioned Work

Portraits are usually commissioned privately by the client or as part of a job organized by an agency in a client's name. The differences between these two types of situation are obvious, and commercial interests are very different from privately motivated shoots. With regard to

privately commissioned portraits, I am not talking just about the countless studios you can find in every town, with their painted backgrounds, standard lighting, and kitschy soft-focus effects—private portraits often require extremely high quality work, too. Both types of commissioned portrait require the photographer to produce results that serve the client's interests. This can be a tricky mission to fulfill if subjects are to be photographed on the strength of their position in society rather than their photogenic qualities. Portrait subjects are often photographically inexperienced, and showing them in a good light requires not only technical know-how, but also a little psychological skill and insight into human nature.

Technique

The first thing to do is create a relaxed atmosphere that helps the subject forget any tension induced by the unusual situation. Approaching a subject openly usually provokes openness in return and helps you analyze a person's facial expressions and bearing. This way, you can gain an impression of a person's strengths and weaknesses without having to approach the person directly. Most people have asymmetrical facial features, and I shoot full-frontal portraits only of subjects who have truly symmetrical faces. It is usually beneficial to shoot asymmetrical faces to emphasize one side or the other. The shape of a subject's face also influences the style of lighting you can use; the more character in a face, the softer the light you can use to illuminate it. Soft-featured faces require harder light to better accentuate their contours. Deep eye sockets are impossible to photograph using overhead light, whereas people who wear glasses have to be lit with overhead light to prevent unwanted reflections in the lenses.

Portraits of inexperienced subjects require not only photographic skill, but also a little psychological talent on the part of the photographer.

The subject is the star, and you have to make sure that's how the subject feels during a session. The technical side of things has to be organized in advance so it doesn't get in the way, and it is essential to remain relaxed if you want your subject to relax too. The start of a session is the phase during which cooperation between the photographer and the subject is established, and an open approach to communication is key to the success of the shoot. Showing the subject the photos that have already been captured and asking for an opinion makes your subject a willing accomplice. In my sessions, I lead the dialog, but I always listen carefully to feedback because it is the person I am photographing who has to feel good about the results. As a portrait photographer, you have to switch between keeping the subject interested but relaxed, and applying your own photographic skills to get the best possible results out of the situation this cooperation creates.

The opportunities to capture a subject looking truly interested are few and far between, so you have to be ready to capture such moments when they occur. When I feel that a session is approaching its high point, I intensify my contact with the subject to maximize feedback while doing my best to keep the situation relaxed. Regular, constructive comments during a session help keep the atmosphere positive and prevent moments of embarrassing silence. Don't command your subject, and avoid physical contact, if you want to preserve a productive working atmosphere.

The distance between the photographer and the subject should be sufficiently large so the subject doesn't feel crowded, but the photographer should be close enough to retain contact. I shoot with the camera at eye level so I am looking at the subject neither from above nor below. Direct eye contact helps the subject feel involved in what is going on.

If you have the chance to find out a little about your subject in advance, you can steer the conversation toward a topic of known interest. If you are shooting cold, try to find out what interests the subject during the shoot so you can keep the subject involved while you work.

As already mentioned, your equipment should be set up in advance, and the setup should be simple enough that it doesn't require constant attention during the shoot. Use complex lighting only if you are shooting with experienced models.

A sample model release form. This is where a model agrees to the type and duration of usage of the images captured during a shoot.

Model Release

In consideration of my engagement as a model, upon the terms herewith stated, I hereby give to _____ [photographer] his/her heirs, legal representatives and assigns, those for whom the photographer is acting, and those acting with his/her authority and permission:

a) the unrestricted right and permission to copyright and use, re-use, publish, and republish photographic portraits or pictures of me or in which I may be included intact or in part, composite or distorted in character or form, without restriction as to changes or transformations in conjunction with my own or a fictitious name, or reproduction hereof in color or otherwise, made through any and all media now or hereafter known for illustration, art, promotion, advertising, trade, or any other purpose whatsoever.

b) I also permit the use of any printed material in connection therewith.

c) I hereby relinquish any right that I may have to examine or approve the completed product or products or the advertising copy or printed matter that may be used in conjunction therewith or the use to which it may be applied.

d) I hereby release, discharge and agree to save harmless [photographer], his/her heirs, legal representatives or assigns, and all persons functioning under his/her permission or authority, or those for whom he/she is functioning, from any liability by virtue of any blurring, distortion, alteration, optical illusion, or use in composite form whether intentional or otherwise, that may occur or be produced in the taking of said picture or in any subsequent processing thereof, as well as any publication thereof, including without limitation any claims for libel or invasion of privacy.

e) I hereby affirm that I am over the age of majority and have the right to contract in my own name. I have read the above authorization, release and agreement, prior to its execution; I fully understand the contents thereof. This agreement shall be binding upon me and my heirs, legal representatives and assigns.

Print Name: _____

Signed: _____

Dated: _____

Address: _____

City: _____

State/Zip: _____

Phone:Email: _____

Legal Considerations

Personal rights are an important aspect of any photo that has a human subject. Even if the photographer owns the copyright of the image itself, this doesn't automatically grant unlimited access to the personal rights of the person being portrayed.

Portraits in which the subject is also the client can normally only be used by the photographer for advertising purposes, and usually only if this is agreed to by the subject. If, on the other hand, the client is a company, the resulting images will normally be used for a specific purpose for a specific period of time, and we have to deal with both the model and the client as separate entities.

Any human subject has to agree to the use of images in which their likeness is used, and this usage should be specified as accurately as possible in advance of a shoot. The accepted way to do this is to get your model to sign a release form in which the intended methods and duration of publication are detailed in writing. If you are working with a model provided by an agency, a standard agreement with the agency is usually sufficient, as the agency represents the model legally. If an appropriate agreement is not reached in advance, the person being photographed may be able to prevent publication, so be sure to resolve any potential ambiguities before going ahead with a job.

It is also essential to check your liabilities and obligations with respect to your client. The client has different requirements from the model and will usually request unlimited access to the images you create. Once again, you should agree in advance (in writing) how the images will be used and for how long. Normally, a year's usage from the date of first publication is included in the price charged by a model or model agency. If a year is not sufficient, an additional fee will usually have to be paid.

Exclusivity on the part of the client is another consideration. Banks and insurers often stipulate that a model who appears in an advertising campaign shouldn't appear in a competitor's campaign, and consequently demand industry-wide exclusivity for an agreed period of time. These kinds of requirements can be quite expensive, as the model concerned cannot be hired out to a customer in the same industry for the agreed period. Exclusivity clauses have to be agreed in writing with the model or the model's agency in advance of a shoot.

Portrait photography can be something of a legal minefield in which the photographer plays the role of intermediary. Always make doubly sure that you know your legal position in relation to your client and your model if you want to avoid being called to account in case of any disagreements. Use of portraits for your own advertising or marketing material is generally accepted, although common decency requires you to ask permission first. The sale of images to other agencies or clients is, of course, prohibited, unless you have written permission to do so.

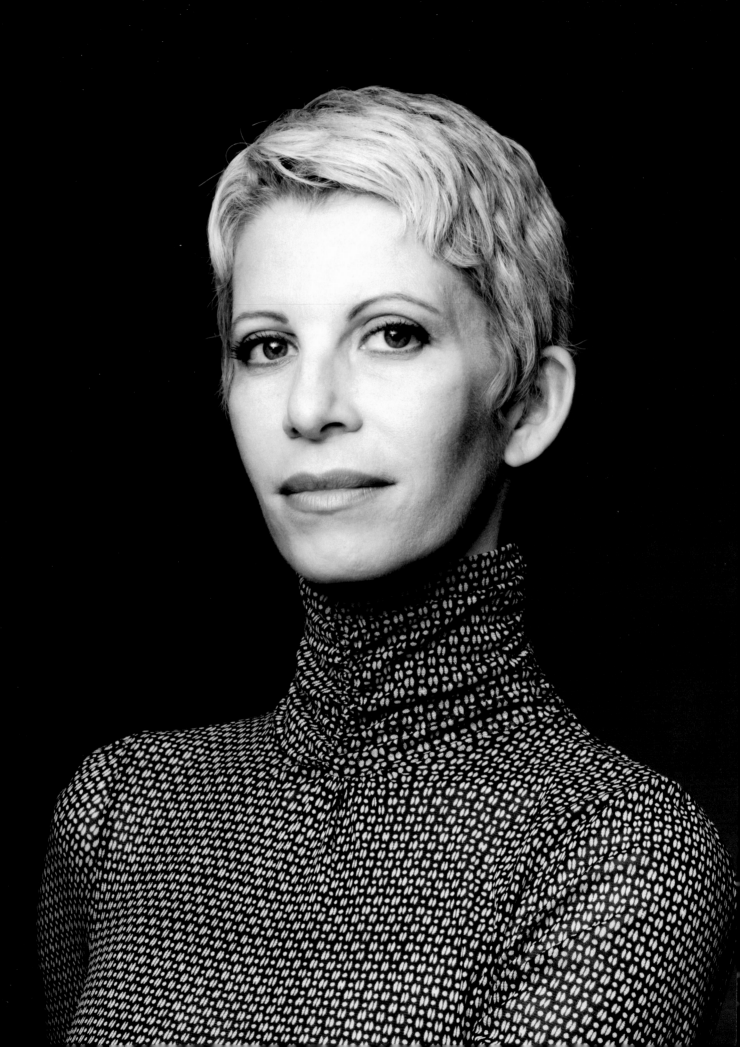

Lisa

An interesting face virtually guarantees a fascinating shoot.
I particularly like the clear lines of the subject's face and the
fine tones in this shot.

In addition to her main occupation as a dancer and performer, Lisa also works as a model
and a photographer. She immediately felt at home in front of the camera.
I wanted to combine her serious look with a stern bearing to produce a portrait whose
strength lies in its charismatic sense of calm. The lighting was designed to steer the view-
er's attention toward the subject's face without the use of distracting highlights. I used a
dark gray background that I brightened slightly from the right with a lamp and a honey-
comb filter, and I bounced the main light off my ceiling reflector, which was suspended
directly above the camera. I enhanced the ivory skin tones during post-production to cre-
ate a porcelain effect. The overall effect of this image stems from the subtle colors and the
contrast between the model's blonde hair and dark green eyes.

Technical Data

Camera:	Hasselblad H4D
Format:	50 megapixels
Lens:	Hasselblad 210mm HC
Exposure:	f/16, 1/30 second
Lighting:	1 lamp with a wide-angle reflector bounced from the ceiling
	1 lamp with a honeycomb filter
Background:	Gray paper

Polaroid Transfer

Nude portraits represent a fascinating and, of course, intimate photographic challenge. The Polaroid transfer technique softens the potentially erotic atmosphere and helps us view the human body in a purely aesthetic light.

I shot several sessions with Ottilia using 8x10 Polaroid film. The camera's huge focusing screen made me feel almost as if I were painting.

Using Polaroid film enabled us to watch the results develop before our very eyes and allowed us to look for the best possible composition, light, and pose during the shoot. The model was just as fascinated as I was and got thoroughly involved in the creative process. We used Rodin books for inspiration and to find the right sculpted pose, rather than using a traditional photo studio look.

I used filters to adjust the color of the lamps, and I shone them through tracing paper with holes cut in it to produce a mottled soft/hard effect. Transferring the Polaroid Type 809 negatives to watercolor paper produced the results you see here. The damp paper, the speed with which the negative is separated from the positive, and the pressure of the transfer have an immediate effect on the results, so we had to make several attempts before we came up with the right technique. The resulting texture makes an interesting alternative to the texture of human skin.

Unfortunately, Polaroid film is no longer manufactured, but you can produce a similar effect by blending an image with a separate texture layer using Photoshop's Soft Light blending mode.

Technical Data

Camera:	Sinar p2
Format:	8x10
Film:	Polaroid Type 809
Lens:	Rodenstock 480mm Apo-Ronar
Exposure:	f/22, 1/30 second
Lighting:	Projector spot
	Fresnel spot
	Diffusion through tracing paper
	with holes that create a partial
	alternating soft/hard effect
Background:	White paper
Comments:	Polaroid transfer to wet paper

Shooting Steps

I used my trusty 8x10 Sinar to create these Polaroid transfer images. The huge focusing screen sometimes makes photography feel like painting. A heavy-duty camera stand is essential when using a camera of this size. The main Fresnel spotlight is on the left, and the background lamp is on the right. I often use a showroom dummy to set up the lighting for a portrait.

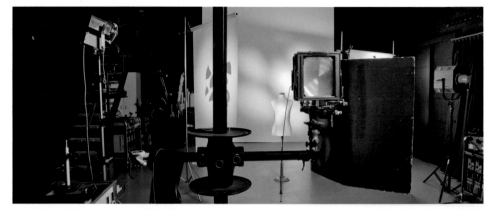

Viewed from above, you can clearly see the tracing paper sheets with hand-cut holes positioned in front of the lamps. The sharpness of the shadows cast by the holes can be regulated by altering the distance between the lamp and the sheeting, or between the sheeting and the subject. I used gobos to shade the background lamp and prevent any stray light from reaching the subject.

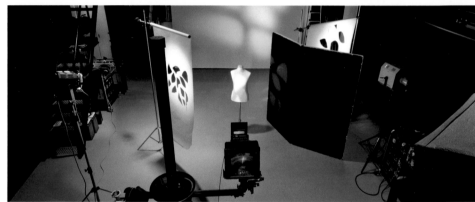

This is the view from behind the set. The large-format negatives made it possible to work in detail with instant film.

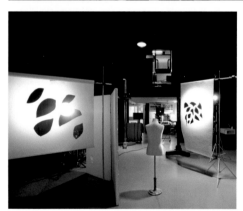
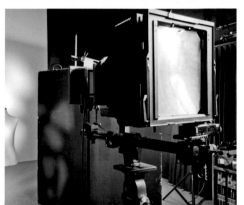

This image clearly shows the distances between the lamp, the tracing paper, and the model, as well as the effect produced by the holes in the diffuser sheeting. The overall effect relies on the shadows of the holes having blurred edges.

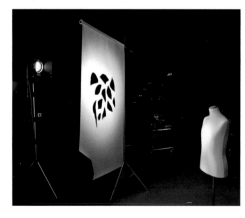
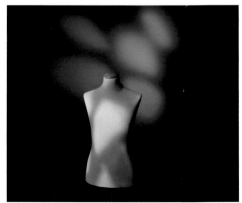

Left: Because of its absorbency, watercolor paper is great for making Polaroid transfers. Gloss paper is more difficult to handle and produces less satisfactory results.

Right: The Polaroid 8x10 developing machine is on the left, the water tray for wetting the paper is on the right, and our work area for transferring the Polaroid negatives to the paper is in the center. The paper needs to be damp, but not really wet.

Left: The Polaroid developing machine and a film holder.

Right: The rubber roller we used to squeeze the peeled negative onto the paper. A spatula like the one shown here can be used to do the same job.

Applying a Polaroid negative to paper has to be done quickly and carefully. You need to apply pressure slowly but firmly over the entire width of the negative. After two or three minutes, you can peel back the negative and admire your print.

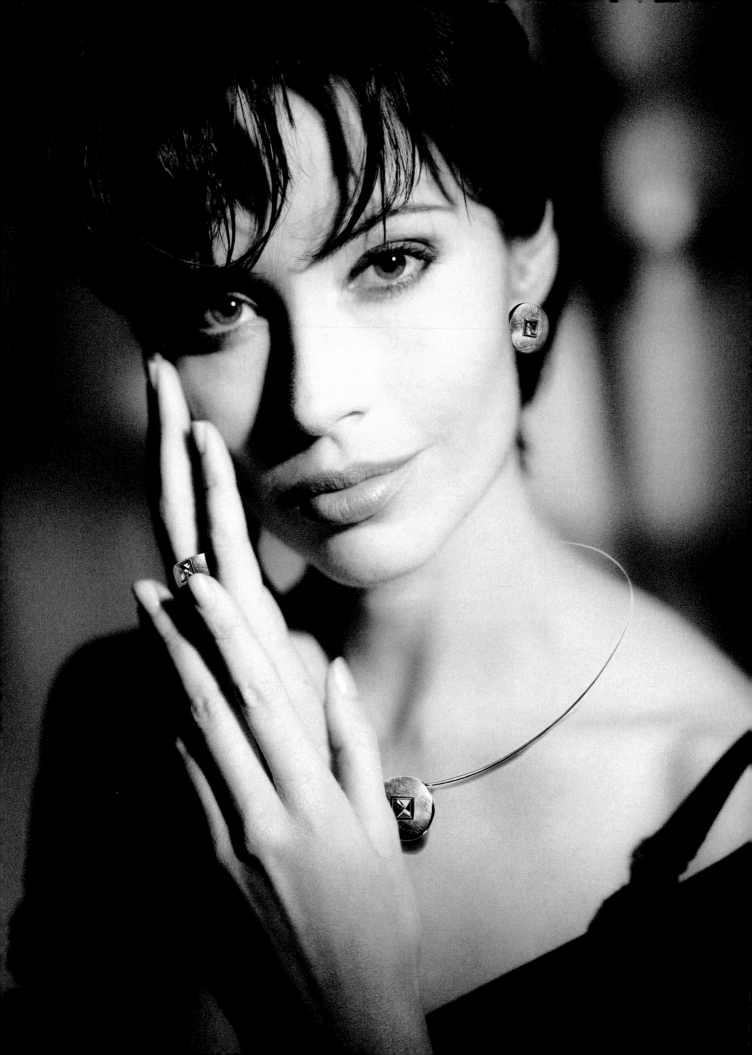

Italian Woman with Jewelry

This is a combined portrait/jewelry shot for the cover of a catalog. The jewelry is pretty, but the Italian model's face attracts all of our attention.

This is a very hard lighting setup for a portrait. The atmosphere was created with a LEE White Frost 220 filter to slightly soften a Fresnel spot combined with a lamp that shone through a hand-cut black mask for the background.

Studio light often looks artificial or sterile; I wanted to avoid that effect in this shot. The card mask with its hand-cut holes was designed to suggest a room in the background, and the pose was more or less prescribed in advance due to the type of jewelry and the limited number of options available for positioning it. I used a Sinar p2 and a Sironar-N lens at its widest aperture to limit depth of field. The resulting images were too smooth and detailed, so I added a digital grain effect to make the images look as if they were shot on Polaroid 54 film. The cyan tint gives the combined portrait and jewelry a more homogenous look and still allows the color and detail in the jewelry to shine through.

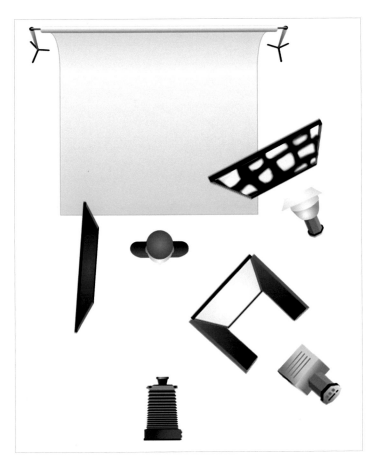

Technical Data

Camera:	Sinar p2
Format:	Sinarback 54H, 22 megapixels
Lens:	Rodenstock 240mm Sironar-N
Exposure:	f/5.6, 1/30 second
Lighting:	Fresnel spot
	Diffusion with LEE White Frost 220 filter
	1 lamp with a diffuser
	Patterns created with hand-cut holes
	in a card mask
Background:	White paper
Comments:	Image files with added grain and blue tint. Jewelry photographed separately and inserted digitally.

Miss Fifties

The 1950s were all about rock and roll and the sexual revolution, and for many they were a frivolous and fun time. The joyful mood of the era was the inspiration for this shot of Miss Fifties.

Right from the start, I had an idea of a kind of faded yellow background tone that I wanted this shot to have, so I had to shoot with a bright background that I could fade later.

The stylist had brought along a whole load of fifties-style clothes and props; in the end, we settled for the outfit you see here with the Eames chair, the colorful tote bag, and the umbrella, all with red patterns. The hair and makeup artist gave our model a real fifties makeover, with authentic makeup and loads of curls in her hair.

While our model was being prepared, we set up the lighting and tested the camera settings and the mood of the set. Our model took time out from makeup to allow us to test our setup. We used a Briese Focus 100 as our main light. The Focus is a lamp that can be adjusted to provide varying amounts of hard core light and softer base light.

I had researched some typical 1950s poses on the Internet and was able to give Noemie, our model, appropriate instructions. When I developed the RAW image files, I used a Lightroom Bleach Bypass preset adapted to fit this particular shoot.

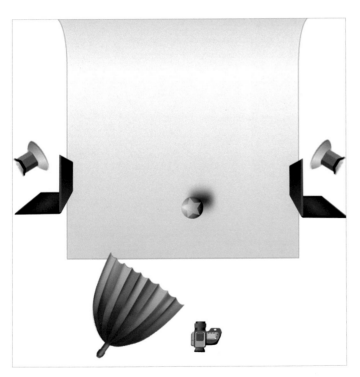

Technical Data

Camera:	Hasselblad H4D
Format:	50 megapixels
Lens:	Hasselblad 120mm HC Macro
Exposure:	f/22, 1/30 second
Lighting:	Briese Focus 100 set to hard
Background:	White-painted infinity cove
Comments:	The flowers were shot individually and inserted later digitally. Bleach Bypass development in Lightroom.

Shooting Steps

The lighting setup for this session was very simple. I used two lamps that I shaded toward the front to illuminate the white background. I then used my Briese Focus 100 setup to illuminate the set frontally and slightly from the side at a hard (number 2) setting. I mounted my Hasselblad on my studio stand and connected it directly to my laptop.

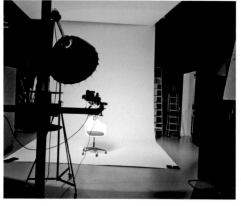 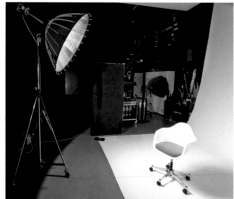

This photo shows Gori, the makeup artist, working on Noemie's look. I used the time this took to set up my lights, and I had Noemie take a break from makeup to test my settings. I also used the test phase to study how Noemie moved and to discover some of her strengths and weaknesses as a model. After the set was ready and Noemie was made up, the stylist fitted her with the right clothes and props.

This is where I start giving the model instructions to bring the setup and my concept to life. We viewed the images on the computer after each set and discussed how we could improve things for the next sequence. It is important to me to motivate models by involving them in the creative process.

Post-production

I developed the RAW files in Lightroom with a specially tweaked Bleach Bypass filter preset. I strengthened the preset orange tones and slightly reduced the default brightness setting. The result was a look that could have come from an old postcard.

I then transformed the image into a smart object and used the Photoshop High Pass filter in Soft Light mode with an amount setting of 1–2 to sharpen the image. Repeating the effect using the Alt key produces a more subtle increase than simply entering a higher value. I then attenuated the blue channel a little with the Curves smart filter to create the slightly yellowish faded look I was after, and I desaturated the skin tones with a Hue/Saturation adjustment.

I captured the artificial flowers between sets. I selected them individually and inserted them into the main image. I created the falling movement effect by using a long (1/150 second) flash duration. I also inserted a shadow beneath the flower on the floor to give it an authentic look.

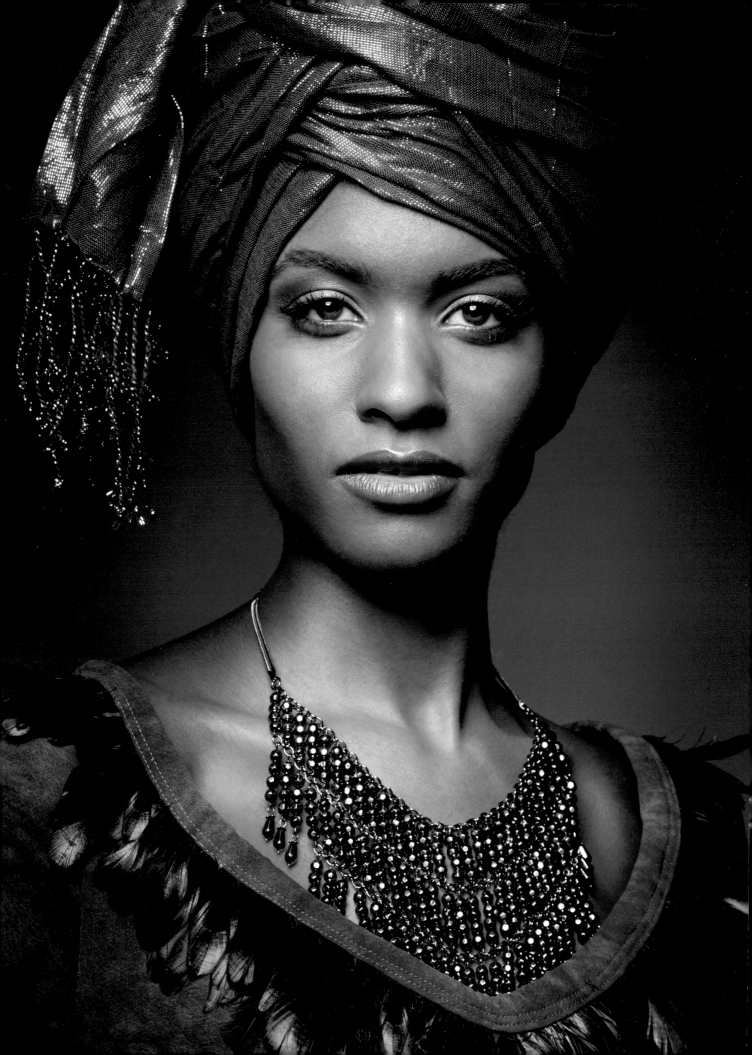

Exotic Royalty

Royal blue in contrast with the model's wonderful dark skin give this portrait a mysterious, exotic look. Brown and violet blue are complementary colors, although the contrast between them is moderated in this shot by the overall dark mood.

Our model Josephine was new at the agency and took part in this test shoot. Tests are sessions in which everyone involved—model, makeup artists, stylists, and photographer— all work for free to generate new material for their portfolios. Such projects are great for trying out ideas that would otherwise have to be adjusted to fit a preset layout or a client's specific requirements.

New models are often inexperienced and require more instruction than their experienced colleagues during a shoot.

In this case, I wanted to create a simple but powerful image with just light and color. The components that gave the image its regal look were a slightly stiff but proud-looking pose and lighting that enhanced the dark tones within the image. I made sure there was plenty of detail throughout the tonal range, and I reduced the saturation at the RAW development stage to enhance the dark, distinguished look. I performed a second development step to brighten Josephine's dark brown eyes and used slightly reduced saturation and vibrance values in Lightroom to make the colors less vivid.

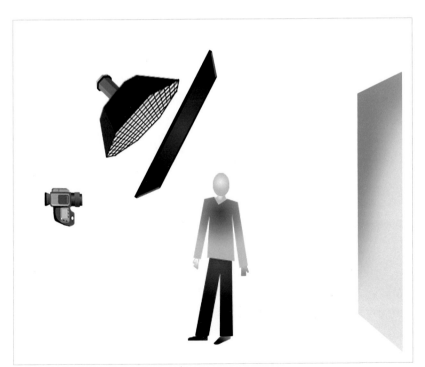

Technical Data

Camera:	Hasselblad H4D
Format:	50 megapixels
Lens:	Hasselblad 120mm HC Macro
Exposure:	f/16, 1/125 second
Lighting:	Rotalux Deep Octa 100
Background:	White paper
Comments:	Saturation reduced, shoulder area darkened

Shooting Steps

The atmosphere in the makeup room was relaxed and helped the model come to grips with the job at hand. We are surrounded by a great number of props that we used for the Miss Fifties and Exotic Royalty shoots.

The lighting for the Exotic Royalty shoot is even simpler than the setup we used for Miss Fifties. We used just one Rotalux 100 softbox fitted with a honeycomb filter to keep the light from diffusing too much. A shade was located in front of the softbox to dampen the light coming from the left.

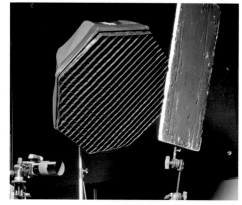

We started with a test shoot to fine-tune the styling and makeup. Hard light like this reveals much more detail than you can see in the makeup room. The model's arms and hands had to be darkened too, in case they were visible in any of the shots.

Josephine's skin wasn't perfect and required a little retouching here and there. To do this, I used the Healing Brush tool on a new duplicate layer. It is important to use the tool in Content-Aware mode, and make sure you select the Sample All Layers option when applying this type of correction. I used a fine brush tip and a small radius. The illustration on the left shows the adjustment layer that was eventually merged with the others.

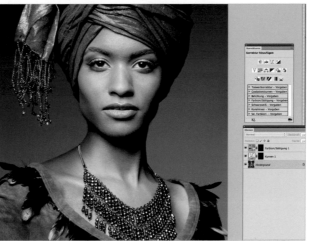

I then retouched various places on the model's face and neck to round out the overall look. I masked her left cheek and darkened it with curves and hue/saturation adjustment layers. The next step involved masking the neck and shoulder areas and darkening their edges using the Burn tool with large, soft settings (300 px, 0% Hardness, and 10% Exposure). Finally, I selected the pupils and increased their brightness and contrast before adding a green edge to give the eyes more glow.

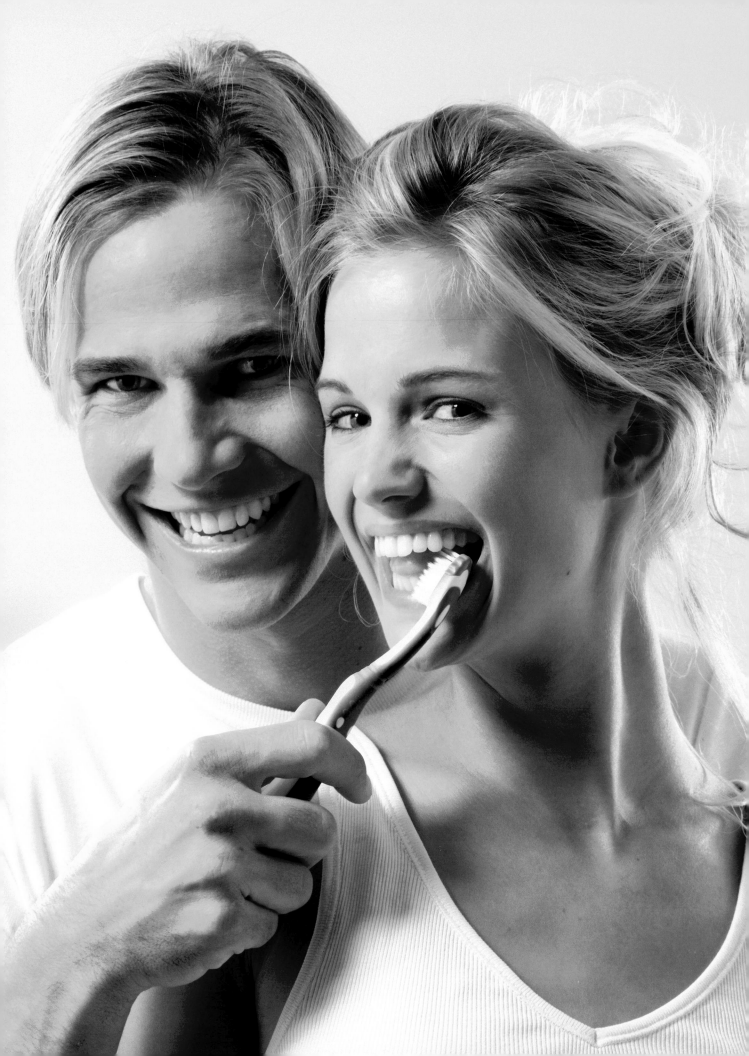

Young Couple with Toothbrush

This poster campaign for a new Sonic Power toothbrush manufactured by Trisa demanded perfect white teeth and a refreshing laugh from the models.

The layout had limited space, so the models had to stand very close together. This is a typical poster layout, with a reduced composition designed to bring the message across quickly. The photographer has to take this into account, and the models for a shoot like this have to be professionals who are used to working with precise instructions.

The light had to be bright, warm, and enveloping, so I selected a warm white balance setting in the Sinar CaptureShop interface. I used a spherical Broncolor Balloon reflector as my main light, a strip light placed to the right, an indirect fill light, and two additional lamps to light the models' hair from behind. As a final touch, I added an amber-filtered lamp behind the white Plexiglas background.

The available depth of field at f/22 was just enough to keep both models in focus, although I did have to keep reminding them to stick close together. We had a large team in the studio for this shoot, and the barrage of opinions everyone offered didn't really help us to create a lighthearted atmosphere! We simply had to concentrate hard to keep the creative team working smoothly. We left the models' hair and makeup virtually untouched to underscore the look of being in the bathroom at home.

Technical Data

Camera:	Hasselblad 2000 FCW, Sinarback 54H
Format:	22 megapixels
Lens:	Zeiss 150 mm Sonnar
Exposure:	f/22, 1/30 second
Lighting:	Broncolor Balloon
	1 strip light
	1 fill lamp
	1 lamp with a diffuser
	2 lamps from behind
Background:	Frosted Plexiglas, 2x2 m (6.6x6.6 ft)
Comments:	White balance set slightly warmer

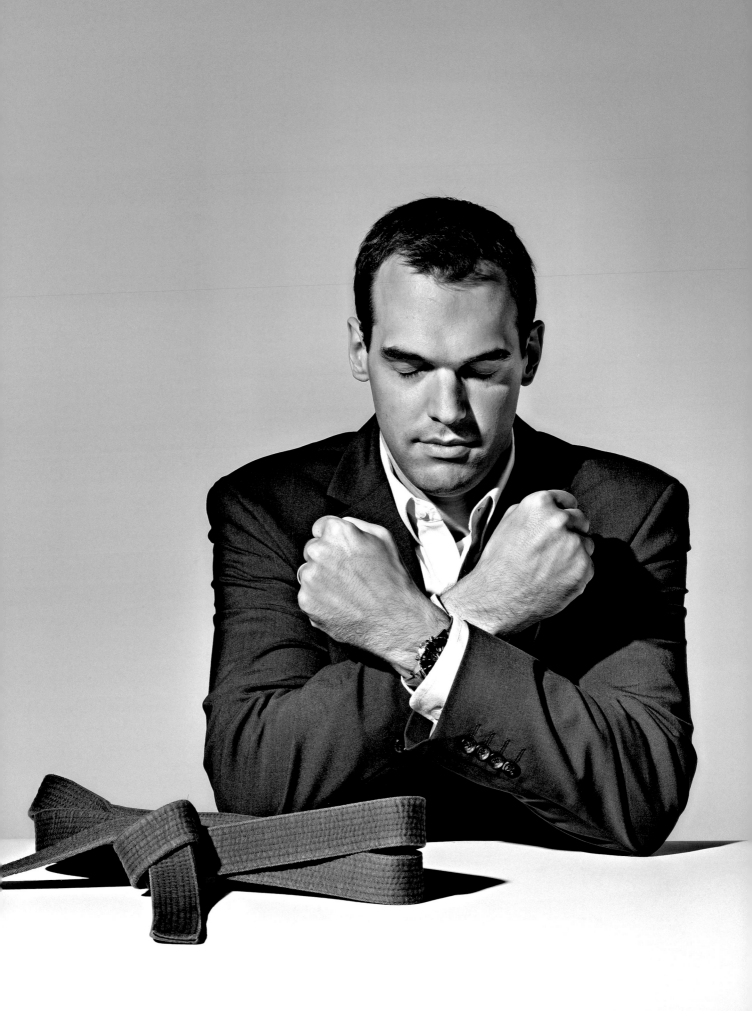

Testimonial Portrait

This shot is one of a series of 23 portraits of young public trustees just starting out in their careers. The subjects talked about their hobbies and pastimes in their CVs, so I used this opportunity to find a characteristic on which I could build a scenario.

This portrait is of an impressive-looking man whose hobby is karate. He brought his brown belt with him to use as a prop. While talking to him to find out a little about his favorite sport, he mentioned that karate experts live according to the maxim "Strength lies in inner calm." The Kyokushinkai karate pose that he struck is one used to focus the participant's strength while preparing for a fight.

It is highly unusual to shoot a portrait in which the subject's eyes are closed, but the exception to the rule seemed appropriate for this shot. In spite of his closed eyes, the subject's powerful presence makes direct contact with the viewer. I used a very basic setup for this series, with a white table in front of a white background and clear, punchy light. The Fresnel spot lit the scene from about 3 m (9.8 ft) away, above and to the left, producing shadows that I brightened a little with Styrofoam reflectors. The background was evenly lit with two lamps with diffusers to make it appear slightly darker than the foreground.

Makeup played a significant role in this shot. The model's face and hands had to be made up to give them the same skin tone and a very slight shine.

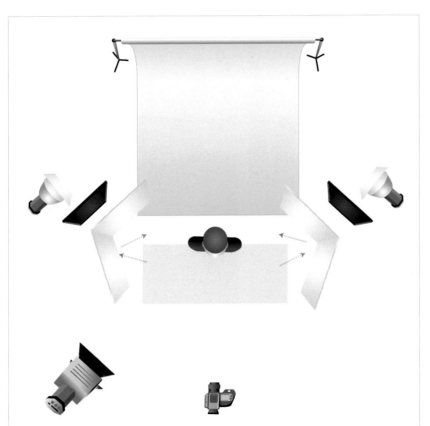

Technical Data

Camera:	Hasselblad H4D
Format:	50 megapixels
Lens:	Hasselblad 120mm HC Macro
Exposure:	f/22, 1/30 second
Lighting:	Fresnel spot
	Fill light
	2 lamps with diffusers
Background:	White paper

Shooting Steps

We had already made some test shots and performed some trial post-production steps, so Frank, our hair and makeup artist, knew exactly how to produce the look I wanted. All 23 subjects were career trustees, not models, and Frank made them all up using a high-contrast approach that emphasized their strength of character rather than their looks. These behind-the-scenes shots are of a different subject than the main image on page 222, but they demonstrate the process perfectly well.

I had to spend more time finding the right pose with these subjects than I would have with a professional model. We arranged which props they wanted to bring in advance of the shoot. The props were all related to the subjects' hobbies, and they helped us portray the subjects not just as career people, but rather as well-rounded people.

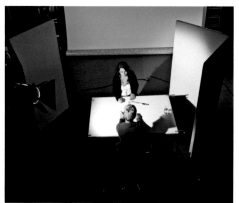

This is the setup in the studio. The Fresnel spot main light is on the left, and the two fill-in reflectors that also serve to prevent stray reflections can be seen at the left and right of the subject. The background was set up about 3 m (9.8 ft) away to prevent the main light from illuminating it directly. You can see me and the camera (mounted on my studio stand) in the foreground. My laptop with the Hasselblad Phocus live capture software installed is set up beside me. These photos illustrate how I gave the subject instructions and how we viewed the results together. It was extremely important to me that the subjects were able to identify with the results. At the end of the day, the images I produced were to be published in the subjects' names along with a personal statement.

These screen shots demonstrate the chronological post-production process. On the far left is the final selection of portraits loaded into Lightroom. The first Photoshop processing step involved creating a duplicate layer and transforming it to black-and-white using the Image > Adjustments > Black & White command. I then set the new layer to Multiply mode.

These steps show the adjustments I made to the individual color channels with the Black-and-White dialog. These changes kept the skin tones light and brightened the midtones. I also brightened the midtones on the color layer beneath.

The image now has more contrast and a black-and-white overlay. To accentuate the overall effect, I desaturated the color layer and applied a two-stage Unsharp Mask effect. The first stage increased detail contrast with a broad radius and a low Amount value (approximately 30/30). I corrected the white halo that this step produced with the History Brush.

I then repeated the previous step for the other layer before applying the second stage. This involved heavy sharpening with an Amount setting of 178 and a radius of 0.8. I applied this step to both layers. Finally, I used the Dodge and Burn tools to adjust the shadows and highlights. The end result is a very illustrative, almost hyperreal image. The detail in every pore, hair, and fold in the fabric has been accentuated to the maximum, giving the subject a look of extreme vitality.

Appendix

These are the tools I use, along with some essential (and some nonessential but useful) accessories.

List of
Materials

Hasselblad H4D-50 >
This medium-format camera has 50 megapixels of resolution, which is sufficient for virtually all applications. I use the ISO 50 setting whenever possible because it delivers the best-quality results.

Hasselblad 120mm f/4 HC Macro >>
This is the lens for product and portrait photography. It is extremely sharp at closeup and midrange product shot distances.

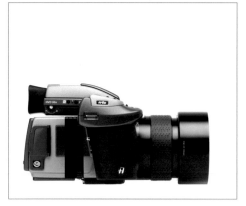

Hasselblad 210mm f/4 HC >
This lens is the best alternative to the 120mm when I need to shoot from farther away. It is also excellent for product shots.

Hasselblad Extension Tubes >>
The H13mm, H26mm, and H5mm extension tubes cover all closeup situations and are compatible with all my other Hasselblad lenses. The tubes contain no additional optical elements and do not affect the optical quality of the lens they are used with.

Hasselblad HTS 1.5 >
The HTS adapter enables shift and tilt movements with compatible lenses. The adapter is mounted between the camera and the lens and acts as a 1.5x teleconverter.

Hasselblad HTS 1.5 >
This photo shows how the HTS adapter is constructed. Using it at wide apertures produces optical aberrations, making it necessary to close the aperture down by two or three stops to produce usable results.

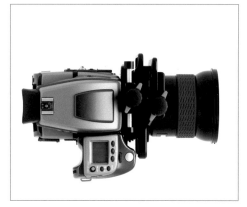

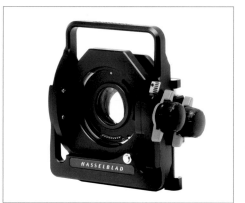

Nikon D3 >
I sometimes like to use my 12.3-megapixel D3 to get away from the super-clean studio look of my medium-format images (pages 194 and 196).

85mm f/2.8 PC-E Micro-Nikkor >>
I use this tilt/shift lens to control the plane of focus when I use my D3. It is perfect for taking documentary photos like the one shown on page 43.

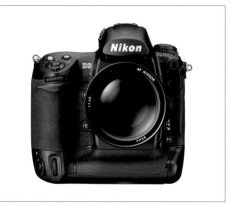

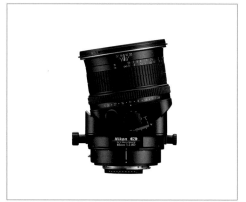

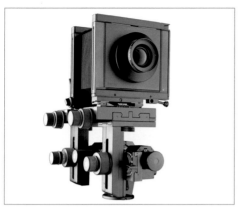

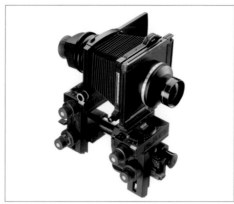

< Sinar P2/P3
This is the combination I use, with the p2 standard at the front. It allows me to use all of my p2 lenses (right up to the 480mm Apo-Ronar) and the p3 slider adapter at the back. A special tapered bellows connects the two ends.

<< Sinar p2
This is the camera I used to shoot all of the analog images reproduced in this book (4x5 and 8x10).

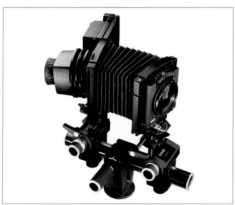

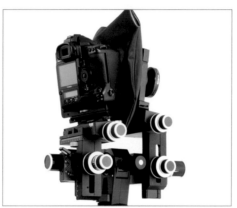

< Sinar p3-SLR
This model is for photographers who want to use view camera movements with a DSLR body and lenses.

<< Sinar f3
This is a beginner's view camera with less complex mechanics and a smaller, lighter body than the p3. I prefer to use a camera that I can look through rather than having to use a live view image, which is why this camera is shown with the slider adapter.

< Sinar Carrying Case
This waterproof case on wheels is perfect for transporting Sinar cameras to location shoots.

<< Sinar Slider Adapter
The slider adapter allows you to switch quickly and easily between a bright focusing screen and a digital back for shooting.

< iPhone App
This intuitive interface is for operating Sinar shutters via iPhone, iPad, or iPod.

<< Sinar eShutter
The electronic version of the p3 shutter offers high-end precision and shutter speeds up to 1/250 second.

Elinchrom 3000 AS >
This is a powerful 3,000-watt generator. Flash power can be asymmetrically distributed in increments of 1/10 of a stop to three flash heads. This is my standard studio flash generator.

Elinchrom Digital 1200/2400 RX >>
These generators are extremely robust and deliver constant power. Both support the wireless EL-Skyport system and are great for use on the road.

Digital S Flash Head >
Whether for short flash durations or full-power flash, the Elinchrom digital flash heads for the RX and AS generatorsoffer stable color and flash performance in a relatively compact package.

Pro HD Zoom Head >>
By the time you read this, the Zoom head will have replaced the Digital S in the Elinchrom product line. This head has variable spread settings.

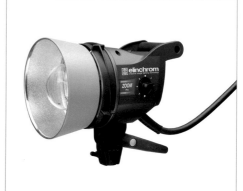

Reflectors >
Reflectors come in all shapes and sizes. Whether wide angle, spot, beauty dish, or background, you can usually find the right solution for a wide range of applications. I often use wide-angle reflectors with indirect bounced light.

Rotalux Softboxes >>
These softboxes have practical removable inner and outer reflectors and a virtually circular shape that produces an even light cone and natural-looking shadows.

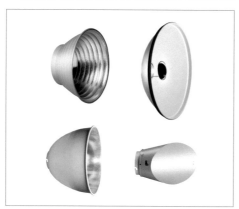

Honeycomb Softboxes >
Elinchrom honeycomb filters and strip diffusers are great attachments for producing soft, targeted light with Rotalux softboxes (page 216).

Honeycomb Grids and Light Shapers >>
Honeycomb grids are available with a range of different mesh grades and can be used to place individual accents within the frame. Honeycomb grids used with tubular light shapers enable you to precisely target your accents and highlights.

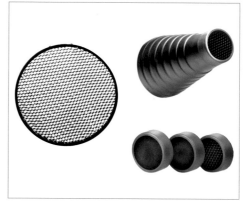

< Ranger Quadra RX
This is the perfect portable flash system with 400 watts of power and extremely short flash durations (down to 1/6000 second). I use this system mainly on location but also for producing short flash durations in the studio (page 133).

<< Ranger RX Speed
This system has 1,100 watts of outlet-independent flash power in a compact package.

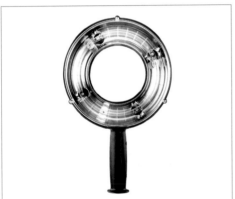

< EL-Skyport
This is a wireless remote control for the RX series of flash gear. Additional flash units can be added, and all devices can be controlled directly from a computer or an iPhone.

<< Elinchrom Ring Flash 3000
Elinchrom ring flashes are available in a range of power outputs from 400 to 3,000 watts.

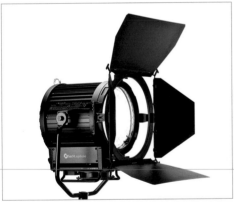

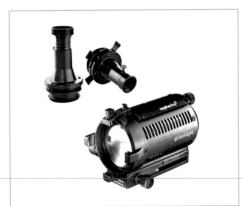

< Dedolight
Dedolights are compact halogen spotlights that produce highly targetable light (pages 105 and 117).

<< Fresnel Spot
This spot is for sunlight effects and all situations in which sharp, vivid light is required. The light has an adjustable spread from 10 to 50 degrees (pages 85 and 207).

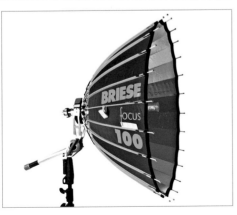

< Broncolor Balloon
This is a spherical Plexiglas diffuser that mounts directly on the lamp head and produces soft, even light in all directions. This is a good compromise between hard and soft light (page 221).

<< Briese Focus 100
This unique lamp produces targeted light that can be focused from soft to hard. It provides great highlight definition (pages 191 and 213).

Appendix—*List of Materials*

FOBA Studio Camera Stand >
This robust studio stand with an optional long boom is a worthwhile investment. The model shown has ball-bearing vertical and horizontal movements and offers extremely fine positioning tolerances.

FOBA Tripod >>
The ASNIO mini tripod is a light and flexible pro-grade tripod designed for low-level shooting.

FOBA Dolly >
This small dolly is perfect for positioning low lamps and accessories. It is compatible with the FOBA COMBITUBE system, making it a universal mobile stand.

FOBA CESRA Baseplate >>
This very heavy baseplate is compatible with the COMBITUBE system. The underside is coated with felt, and it's great in situations where a tripod would get in the way. It can be weighted down if necessary with the CESRA weighting plate.

FOBA COMBITUBE >
These tubes are available in 6, 20, 40, 80, and 160 cm (2.4, 7.9, 15.7, 31.5, and 63.0 in) lengths. They are made of metal and have a three-eighths inch tapered male thread at one end and a three-eighths inch female thread at the other. They can be used in virtually endless combinations.

FOBA Tripod Stands >>
This is a COMBITUBE system stand for stable positioning of COMBITUBE components and clamps.

FOBA Articulated Clamp >
This clamp provides 360 degrees of rotation with 52 click stops. It allows you to attach COMBITUBE sections to each other at multiples of 7-degree angles.

FOBA Flexible Mounting Arm >>
This flexible mount has a built-in crocodile clip for mounting card reflectors, Styrofoam, filter gels, and so forth on COMBITUBE sections.

< FOBA Right Angle Connector Clamp
This clamp is for combining COMBITUBE sections at right angles.

<< FOBA Stepless Rotating Clamp
This clamp is for attaching COMBITUBE sections to each other at any angle.

< FOBA COMBITUBE Clamp
This clamp is for fixing cards, paper, fabric, and so forth in place. It has an extremely strong spring and a mounting hook at one end.

<< FOBA Articulated Mounting Arm
Gradual joint locks make this arm useful for many different jobs. It is also very robust—it can support lamps and cameras, too.

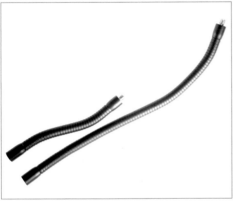

< FOBA Studio Table
This is a medium-sized table with a rear element that rotates through 90 degrees. It has a five-position upper rear crossbar and a three-position lower rear crossbar. It allows lamps to be positioned all around and beneath the table.

<< FOBA Flexible Swan Neck Mounting Arm
This arm is available in 20 or 40 cm (7.9 or 15.7 in) lengths.

< FOBA DITRO Diffuser Sheeting
Width: 1.37 m (4.5 ft)
Length: 5.4 m (17.7 ft)
Thickness: 0.26 mm (0.1 in)
Inner Roll Diameter: 54 mm (2.1 in)
Weight: 2 kg (4.4 lb)
(see pages 129 and 153)

<< FOBA DITRE Matte Black Velour Sheeting
Width: 1.32 m (4.3 ft)
Length: 5.9 m (19.4 ft)
Inner Roll Diameter: 54 mm (2.1 in)
Weight: 1.7 kg (3.7 lb)
(see page 115)

Compressed Air Spray >
Air spray can be used for removing dust from the subject and the set. The additional hose makes it easier to remove dust from hard-to-reach places. It can be finely dosed with the built-in trigger.

Gaffer Tape >>
This is the best universal fixative there is! It doesn't leave any traces, and it is easy to tear. It's available in black and white.

Plexiglas Tubes and Blocks >
These objects can be used for invisibly raising objects. I have a selection with different heights and diameters. Metal blocks are sometimes useful, too.

Instant Adhesive >>
Use small drops of this adhesive for securing jewelry and other small objects into place. It can be used sparingly and aimed precisely, and it dries quickly.

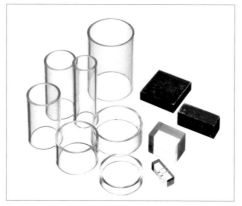

Magnifying Glass/Loupe >
A magnifying glass or loupe can be used for checking closeup details when your eyes (or eyeglasses) can't focus close enough.

Eyeglass Cleaning Cloth and Cotton Gloves >>
Eyeglass cleaning cloths are great for cleaning jewelry. Cotton gloves prevent fingerprints on sensitive surfaces, such as silver, glass, steel, etc. Take care—they generate fluff of their own!

Silver Polishing Cloth >
A silver polishing cloth is good for glossing up silver that has lost its shine.

Acetone and Benzine >>
Acetone is for removing excess adhesive from jewelry, and benzine is for removing stubborn adhesives and labels from bottles.

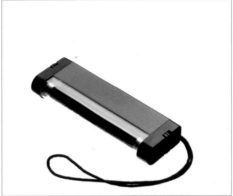

< UV Lamp
A UV lamp reveals where bleach has been used (for example, in fabrics) to help you void false color rendition.

<< Face Powder and Lint Roller
Face powder is used to cover up shiny skin if you don't have a makeup artist on hand.
A lint roller is used for removing dust and dirt from clothing—it is easier than digital retouching.

< Silver Reflective Card
Silver and gold cards in matte and gloss versions serve as highlight reflectors. They are easy to use and to cut to any shape. These cards reflect without losing light.

<< Magnifying Mirror
A concave mirror is good for concentrating accent and fill light.

< Watch Stands
Plexiglas rings from a jewelry store can be used for shaping and position-ing fastened watch straps.

<< Curtain Weights
These weights are good for keeping watch straps in shape when they are not fastened. You can cut them to shape and affix them with Blu-Tack.

< Paintbrushes and Q-Tips
Paintbrushes are great for clean-ing hard-to-reach places and keeping meat moist. Q-Tips work well for remov-ing water drops and fine dirt.

<< Tweezers and Dental Tools
These small tools can be used to position small objects, such as jewelry and precious stones. They are a great help when your fine motor skills aren't up to the job!

Spray Bottle >
A spray bottle can be used for creating a fine mist of water droplets on bottles and glasses and to keep vegetables fresh.

Syringes >>
Syringes are used for creating rivulets on bottles and glasses or adding and removing small amounts of liquids without splashing.

Airbrush >
An airbrush works well for precisely applying very fine droplets. You can determine the precise size of droplets. It requires its own carbon dioxide (CO_2) supply, available as a canister or cartridge.

Aquarium Aerator >>
An aerator is great for creating realistic-looking beer foam. Use it attached to an airbrush and a CO_2 supply.

Turtle Wax >
Instead of polishing cars, I use Turtle Wax to give droplets on bottles and glasses extra adhesion. Silicone paste can do the same job.

Plexiglas Ice Cubes >>
These ice cubes look more realistic than the real thing! They are available in various shapes and sizes.

Droplet Spray >
Droplet spray is an alternative to real water. These artificial droplets stay in place longer than water droplets.

Ice Effects >>
These various ice effects are available from Condor. The Grated and Frosted types are particularly effective.

< Matte Spray
This spray prevents unwanted reflections by adding a slight matte coating to shiny objects.

<< Pro Easy Shot Support Plates
This set of three matte black or white metal plates have three-eighth inch threads for mounting objects on studio stands with a minimum of protrusions.

< Blu-Tack/Plasticene
This product can be used for securing small objects in position.

<< Blu-Tack/Plasticene
Blu-Tack never hardens and remains tacky over long periods of time. This industrial version is gray, and tiny blobs of it hold jewelry and other objects securely in place (page 158).

< CO2 Canister
I use CO_2 canisters for powering my airbrushes. The pressure reduction valve reduces the 200 bar output to about 1.5 bar.

<< Aircraft Trolley
When Swissair went bankrupt, I bought a used aircraft trolley and adapted it for my studio. I use it to store just about all the accessories listed here in custom homemade drawers. I also use it as a computer table for my laptop.

I have attempted to provide a complete list of the tools and accessories I use in hopes that it will help you select the right things for your own shoot. I probably forgot to mention some accessories. Sorry!

This is, of course, a highly personal selection, and all of the items listed here can be replaced by other similar products that you prefer to use for whatever reason.

Index